THE
GLOBAL
ART
COMPASS

THE GLOBAL ART COMPASS

● NEW DIRECTIONS IN 21ST-CENTURY ART

ALISTAIR HICKS

150 illustrations, 131 in color

Thames & Hudson

First published in 2014 in hardcover in the United
States of America by Thames & Hudson Inc.,
500 Fifth Avenue, New York, New York, 10110

thamesandhudsonusa.com

Library of Congress Catalog Card Number
2013950849

ISBN 978-0-500-23919-3

Printed and bound in China by Toppan Leefung
Printing Limited

PREFACE

She did not return my gaze, but it did not matter. I knew immediately that I had been looking for her all my life. On the street I might have missed her. She was not what I considered 'my type'. She was not a blonde. She did not have blue eyes; indeed, I could not make them out. I half-remembered some old wives' tale about failure to recall eye colour being a sign of love. One ear seemed small, the other elephantine. I could not see her legs. There was no bosom. I had never seen such proportions. Her giraffe neck jutted forward. Her nose was long but did not look big, as it linked with strong eyebrows and lips that promised a kiss to any passing god or any stray, hormone-filled teenager who could somehow steal one.

When, at the age of seventeen, I saw *Nefertiti* in Berlin, I instantly knew she was from another world, but as I walked around her glass case I recognized in her things that were missing from my life.[1] I was a two-timer, as I had just fallen in love with my first true girlfriend, but I could not resist the Egyptian queen. I fell for her and gradually realized that I loved art.

These personal confessions will get worse before they get better. I want you to understand your guide's prejudices and bigotry so that together we can celebrate artists' freedom to give us new visions of the world, no matter where they are located, no matter where they are positioned in the 'market'. The aim of this book is to encourage people to activate their own innate bearings to the exciting developments in the art world.

Post-colonialism is a main theme among artists, which makes it relevant that I am the grandson of British imperialists. I don't

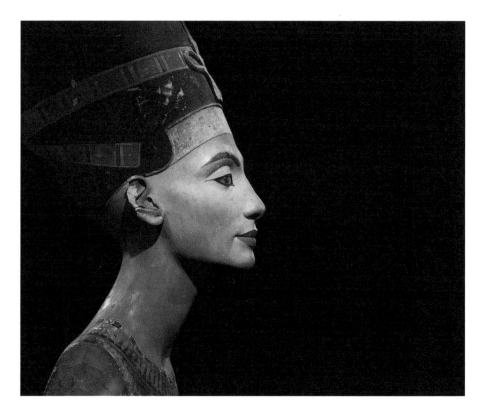

share my grandparents' opinions, but I was born in their London house. My comments on how artists deal with the legacy of colonialism – whether it is British, Russian, Spanish or American – are built on a knowledge of the past seen at least partly from this perspective. Some might say I have over-compensated – certainly Grandmama would. Others will maintain that I am totally incapable of understanding the present because of my ancestors – generations of servants to the British Raj. I can vividly recall an argument, when I was about ten, between my paternal grandfather, who had served in the British army in India and Egypt and through two wars, and my father, a modern professional soldier. 'The trouble with you,' my grandfather said accusingly, 'is you don't believe in the Empire.'

What would Edward Said, whose definition of Orientalism hovers over so much art, have made of my adolescent encounter with the exotic Egyptian queen? Certainly I was attracted to her 'otherness' as I had never experienced beauty along those lines. She led me into another world. I had been conditioned to fall in love with her: I had enjoyed the 'standard privileged' classical education, sent away at the age of eight to an all-boys boarding school. After nine years of being segregated from women, I came across my dream escape route on a pedestal in a

Thutmose
Nefertiti
New Kingdom, 18th Dynasty, c. 1340 BC, limestone, gypsum, crystal and wax, 50 x 17 x 40 cm (19 ⅝ x 6 ¾ x 15 ¾ in.).

This limestone sculpture of the Egyptian queen Nefertiti was made by her court sculptor, Thutmose, over three thousand years ago. Her beauty converted me to art.

darkened room. Her face glowed under the spotlights. My memory fibs, telling me she was as gold as Tutankhamen. On a school outing as a fourteen-year-old I had queued up to see Tut's blockbuster exhibition at the British Museum, but it had been a mere fifteen-second wonder.

Nefertiti still has me enthralled, but at the time I thought two other events from that Berlin weekend more significant. A month earlier I had finished school for good. A friend had come to join me in Germany to celebrate our release into the world and we were determined that hot-house Berlin would show us a good time. I thought I was an adult, but when a woman with cropped hair in a strip club caught my eye, I was like a rabbit caught in the headlights. She knew I was shocked to the core and that she had me hooked. I hated myself for being there. My guilt was not a patch on Søren Kierkegaard's total self-disgust after his student visit to a brothel, just a niggling echo, but I did not want to be there.

This book is about rejection and repulsion as well as discovery. I never actually had to say no to the stripper, but we find our bearings as much by negative experiences as by positive ones. The preference for *Nefertiti* rather than the lady in the club was practically made for me, but if I had been better looking or richer my life might have gone in a different direction. One cannot be a good collector without being open to new ideas and sensations, but one of the hardest lessons to learn is how to say no.

Nefertiti did not instantly transform my life, but a year later my girlfriend's mother, remembering my infatuation with the goddess of the elongated neck, advised me to take an art history course at St Andrew's University. Lectures started at 10 a.m., which meant I usually only just managed to get my dozy head into the hall to gaze in reverie at the daily dose of new slides. My professor, John Steer, had the mannerisms of a matador, so it was difficult to sleep as he constantly prodded us into life and made us plan a summer trip to Italy. My addiction to art was confirmed over those rainy few days in Florence. At night the water ran through our tent in the campsite behind Piazzale Michelangelo, but during the day we charged around the grid of cobbled streets to see masterpiece after masterpiece. My art compass had kicked in.

As I hurtled through those narrow streets, I was propelled by some internal satellite navigation. I had a new north and south, based on my thirst both for harmony and its opposite: the need to stir up the chaotic imbalance within me. My poor friends learned not to get in the way of my quest for my next art fix.

My conversion to contemporary art came three years later at the hands of two artists, Ann Bergson (b. 1928, Sweden) and her husband, Conrad 'Dick' Romyn (1915–2007). Ann is a cousin of the French philosopher Henri Bergson, whose theories on multiplicity have influenced many of today's artists through Gilles Deleuze, who in turn made philosophy much more fluid and generous to our differences. Taken to Dick and Ann's home and studio near Hampton Court on the edge of London by their daughter, I entered a different world. Sat in the candlelight round their refectory table on many a long evening, they told me what they had gained by becoming artists and what they had given up, and they described the world from their astute perspective. I learned that however carefully I trod up the stairs into their picture-packed attic studio, it was always an invasion. I was bound to make mistakes in their world, but it made me feel very alive.

Artists and writers have been the main influence on my life with one exception: my wife, Rebecca. When we married, she was working for Marlborough Fine Art, so she introduced me to my heroes: Francis Bacon, Frank Auerbach and R. B. Kitaj. This led to my first book, *The School of London*.[2] We also started buying art together, which I assumed would be a very different process from buying on my own. Yet the only major disagreement was over our first purchase. We agreed on the artist, Andrzej Jackowski (b. 1947, England), but I won through on the particular work. Its title, *Love's Journeys* (1983), may have helped. Ever since then we have agreed far more times than we have disagreed. Buying with someone else teaches one quickly that the appreciation of art is not a one-way relationship. Now that art is primarily used as a tourist attraction, there is a danger of giving ourselves imaginary suitcase stickers as we tick off exhibitions, paintings and installations. Yet art offers a lifelong affair, as mine with *Nefertiti* (and Rebecca) shows.

I have to declare a vested interest, as my wife runs a gallery and represents several artists whom I count among my closest friends.

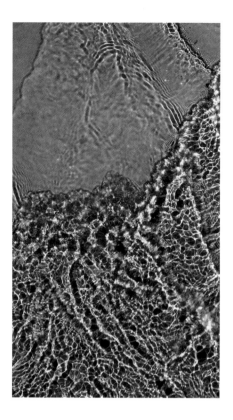

Susan Derges
Recycling Lucifer's
Fall 6 (detail)
2008, dye destruction composite
print, 170 x 61 cm (66 ⅞ x 24 in.).

Derges uses the patterns of
water as a metaphor for the
way we think and feel.

I wish to mention one, as her work helped reorientate me. Before I came across the photograms of Susan Derges (b. 1956, England), I had a tendency to dismiss photography as a lesser art form than painting and sculpture. I was first attracted to her studies of water. Then I heard how she made her work, how she was tired of looking at her surroundings through a lens, so she returned to the basics of photography and simply passed light through a stream at night to get a direct print of the current. As I have been writing this book, I have started thinking about these same works in a different way, as the redefinition and orientation of the self in relation to society. Derges's process is scientific, a method of documenting nature, but although she has a modest view of the self, her deeper subject matter is human thought. The way the water flows is a metaphor for the way we think and feel. Her recent work involves more interference with the purity of process: she is constantly adjusting the balance between internal and external, body and intellect. She lets this friction ask the fundamental questions about how we fit into the universe.

For the last fifteen years I have worked for Deutsche Bank as a curator and adviser. My job has effectively turned me into a human art compass. I am meant to locate art, but also to help others relate to it. Perhaps the first serious preparation came in

that trip to Berlin in 1974. For not only did *Nefertiti* convert me to art. My father had also arranged for an American colonel to take my schoolfriend and me along the Berlin Wall. It was a truly disorientating experience, for as we passed mile after mile of fortifications, barbed wire and desolate no man's land, the colonel showed us albums of photographs of Berlin at the beginning of the twentieth century. The bustling centre of civilization in the photos contrasted starkly with the weeds coming out of the once well-trodden cobblestones along the Wall. It was a savage lesson in the cost of war and division, the horror of boundaries.

Friedhelm Hütte, the Global Head of Art at Deutsche Bank, first employed me to help him write a catalogue of the Bank's collection in London twenty years after I first visited Berlin, but those memories gave me an early insight into German art.[3] Most collectors don't have to justify their purchases to anyone more terrifying than their families – not that I am underestimating that restraint – but the art team at Deutsche Bank have to justify every action to global and regional committees, to their managers and, ultimately and most importantly of all according to the Bank's philosophy, the staff. This book is largely about the relationship between my ever-changing 'self' and others, as witnessed by a conversation I had very recently with a friend who works at Deutsche Bank, Preeti Udas.

We were standing in front of *12 Harmonics* (2011) by Keith Tyson. 'Tell me!' Preeti said, 'Why I should like this?' This was part of a continuous dialogue in which she complains that her brain takes her to a certain point with art and then dumps her unceremoniously. I had thought that *12 Harmonics*, which is about the harmonic series and many other systems that govern our lives, would be a perfect painting for her, as it has so many possible explanations, but none totally convinced her. Indeed, Tyson would not want her to be convinced by a single explanation. 'I have been reading Heidegger about the rejection of words in

Keith Tyson
Studies for the 12
Harmonics (in 12 parts) (detail)
2008-10, mixed media on
watercolour paper, 12 parts,
95.1 x 85.1 cm
(37 ½ x 33 ½ in.) each.

For Tyson, maths is just a way
of seeing patterns in the world.

getting to the essence of things,' Preeti continued. 'Apparently, the true nature/thingness of things can only be experienced away from verbal/intellectual analysis. I have an awful feeling that they are ruling me out!' Hopefully this book will comfort her, as a considerable number of the artists included are influenced by Deleuze, Heidegger and Henri Bergson. Their philosophical legacy is witnessed again and again as artists wrestle to make art that reflects an open and more diverse society, one that encourages multiple explanations, running side by side. There is a desperate need to have time to think rather than just acquire knowledge. This combines with the contrasting acceptance that a single 'truth' is not enough.

Expectation is a killer. 'Why should I like this?' *The Global Art Compass* is not trying to answer this question, but rather seeks to encourage you to use artists to help you understand yourself and those around you. I don't read much philosophy anymore, unless I am led to it by an artist's work. We used to steer our path using the stars. I use the artists as my stars: I am more of an Ann Bergsonian than an Henri Bergsonian.

No one needed an art compass in the past. Instead we had Goethe, Ruskin and Greenberg, who not only told everyone what to think, but also had the power and gall to dictate to artists themselves.[4] Artists have rebelled. They no longer have to follow one prevailing theory or head to any particular city: for the first time ever they can make their careers without moving to a major art centre. New York, London, Paris, Berlin and Beijing are great places to make art, but none of them has a stranglehold on creativity. We all should be following the artists' examples: we should not let any single curator, critic or dealer monopolize our view of what is happening. This book aims to let its readers steer their own way with the aid of the flickering light from the stars of the art world, the artists themselves. Ultimately we can't do much better than heed Ernst Gombrich's sixty-year-old advice: beware of seeing what you expect to see. The title of his 1950 classic, *The Story of Art,* may anachronistically appear to be limiting as it implies a single line of thought. *The Global Art Compass* is riddled with competing stories, but I gladly repeat Gombrich's opening salvo: 'There really is no such thing as Art. There are only artists.'[5]

WEST
● THE AMERICAS

If New York did not have such power over the collective imagination of artists and the art world, Mexico City would be the logical centre of emerging art in the Americas. It's more geographically central, it's intellectually more lucid and positive, and its rhythm and understanding of time are more conducive to making art. Yet Gabriel Orozco (b. 1962, Mexico), the very artist to champion the idea that art does not need a centre, the artist who derided the immaturity of North American art, now spends much of his time in New York, leaving his one-time friend cum-rival Francis Alÿs (b. 1959, Belgium) to rally the rebel cause in Mexico City.

I understand the lure of America. As soon as I could watch television, I was hooked. I am not sure whether it was *Lassie* or *Top Cat* that converted me to the American Dream, but my pampered existence meant it came in a very diluted form compared with the hunger of some Mexican children, who could see the possibility of a 'better life' lying tantalizingly across the border.

Orozco was brought up 'off-centre' in Mexico and this led him to question the way stories are told. 'The beginning is the centre,' he claims. 'When we think of a beginning we often think of a straight line – you start from a point and you go somewhere. But if you think of a centre it can go and grow in multiple directions.'[1] I borrow this technique to try and relate what is happening around the world, but as the artist also points out, finding the centre is a never-ending task, so I leap from one centre to the next. The artists are my centres, my stars.

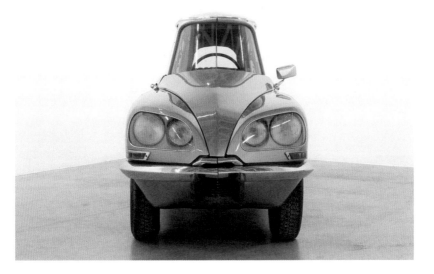

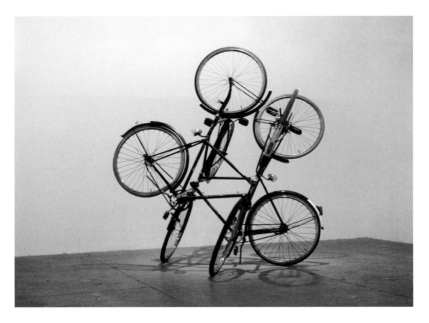

top
Gabriel Orozco
La DS
1993, modified Citroën DS,
140.1 x 482.5 x 115.1 cm
(55¼ x 190 x 45¼ in.).

Orozco cut up a car and removed
its centre to produce a model
of the world as empty as the
proverbial onion.

bottom
Gabriel Orozco
*Four Bicycles. There
is always one direction*
1994, bicycles, 198 x 223.5
x 223.5 cm (78 x 88 x 88 in.).

Welded together and unable to
move in any one direction, these
bicycles are going nowhere.

To make *La DS* (1993) Orozco cut a Citroën car in three, only to reassemble it with the middle section missing. 'The idea of construction is very important,' he declares. 'It is not enough to cut a car in half. You have to build it up again.'[2] His work frequently repeats the question: where is the centre? Is there such a place?

Most of the artists in this chapter engage with a world revolving around the USA: if they were not brought up as Americans, then American popular culture came to them down the wire, as it were, through television, film and music. While some make the effects of these media their subject matter, others dissect America's relationship with the rest of the world. The results of such a self-centred culture are examined intimately by Cindy Sherman, Nan Goldin and Elizabeth Peyton.

Orozco seizes on self-obsession, attacking American culture as being 'based on the teenager. It is decadent, self-indulgent.'[3] If I were to dwell on the top-selling artists in the Americas, it would illustrate his point again and again. As this is an art compass, I need to give you some examples, as negative forces steer us just as powerfully as positive ones. Accepting art as a bad influence is just as important as recognizing it as a good one. Invidiously, I select three New York-based painters plying their trade at the accepted epicentre of the market – George Condo (b. 1957, USA), John Currin (b. 1962, USA) and Cecily Brown (b. 1969, UK) – as between them they epitomize nearly all the faults of a market-led art world, which loves nothing better than to re-dress up old models in vintage clothes.

Condo's art is more pubescent than fully teenage. He steals old compositions and turns them into brutish cartoon characters with spiky uncontrollable growths. According to his admirers, he draws with the skill of an Old Master, but there is more life in caricatures. Currin's figurative paintings are even more derivative. He does not even attempt to disguise his sad rip-offs of Lucas Cranach. Brown is cannier in having her cake and eating it. Her paintings ape the work of the macho giants of the great American movement and the apex of the market, Abstract Expressionism, but dilute it with a faux-feminist angle. Sadly the results are just inane Willem de Kooning.

What is the point in producing poor imitations of great art? The dealers know they can sell it! The veneer of artistic reference lets the pseudo-cognoscenti praise these draughtsmen as if they are the very reincarnation of the grand maestri. These artists don't add one jot to our knowledge of the world. They do not illuminate; they just reflect our superficiality and our willingness to be deceived by our longing for something great.

The photographic work of Cindy Sherman (b. 1954, USA) and Nan Goldin (b. 1953, USA) brutally shows the results of our self-centred lives. Goldin's nightmare is drug-assisted, but walking into New York's biggest show of the season in 2012, the Sherman retrospective at the Museum of Modern Art (MoMA), and seeing Sherman's larger-than-life photographs of *Rich Women* (2008) staring disdainfully down from the walls, I was confronted with a mirror to our lives. Sherman is known for primarily using herself as her model, dressing up as the characters she wishes to play. Cleverly, her *Rich Women* were not all hung in a phalanx at MoMA but were scattered around the walls, so they came at you like dragon hostesses out of a drinks party. At the show's opening it must have been very difficult to distinguish between fiction and reality. These women wear their cosmetically sculpted faces in public and invariably have not known when to stop, so that the only things left alive in their portraits are their ferrety eyes, or rather the artist's eyes, peeping out from behind the façades of capitalism.

The cost of placing oneself at the centre of the world is written on the faces of Sherman's *Rich Women*. In the tradition of feminist art, she exploits her own body as her main material, but her bewitching skill is to sublimate her own character and reappear as someone else. This, of course, is just a more extreme version of the act millions of people across the world try to do in front of the mirror every morning. She has made more obvious feminist statements with basic sexual exploitation in the *Centrefolds* (1981) and *Sex Pictures* (1993) series, but her *Rich Women* do reveal the pressures on the matriarchal figure in contemporary society. There is an echo of Gabriel Orozco's question: where is the centre in our complex world? These 'successful' women play out 'central roles' in society, but is there anything at home?

Cindy Sherman
Untitled #465
from the series *Rich Women*
2008, chromogenic colour print,
163.8 x 147.3 cm (64½ x 58 in.)
with frame, edition of 6.

Sherman bites the hand that
feeds her yet empathizes with the
frightening state of people's lives.

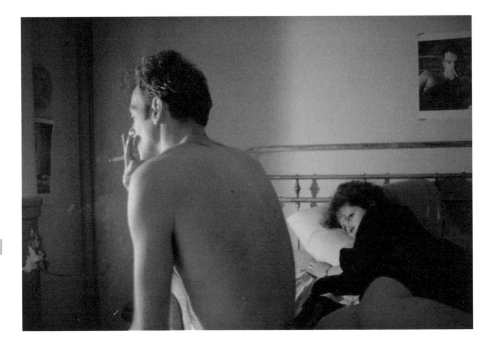

Nan Goldin
Nan and Brian in Bed, NYC
from *The Ballad of Sexual
Dependency*
1983, silver dye bleach print,
50.8 x 61 cm (20 x 24 in.).

Goldin lets us draw our own
conclusions about her post-
coital thoughts.

Bill Clinton damned Nan Goldin's vision of American society along with other attempts to glamorize 'heroin chic'. Gaunt, pale, near to death, her 'extended family' in the *demi-monde* are caught looking for ways to escape the pressures at the centre of civilization. Goldin's most critically acclaimed works are *The Ballad of Sexual Dependency* (1979–2001) and other slide shows, in which she harnesses an already dated technology to record a world of self-destruction stalked by the arrival of AIDS. Sex over, her boyfriend Brian smokes with his back turned obliquely. She looks at him forlornly from the bed. His fingers are curled aggressively around his smoke. This image can be interpreted in many ways. Some see it as the point of ultimate communication, others as the death of a decadent world. The relationship ended when Brian beat up Goldin badly. She did not put up with it, and she says: 'I used to think that I couldn't lose anyone if I photographed them enough. In fact, they [her pictures] show me how much I've lost.'[4]

Nan Goldin once focused her beady eye on me. She looked me up and down as though she was an undertaker and I was her next client. She was showing *The Ballad of Sexual Dependency* at a pop-up exhibition in London organized by my nephew Harry during Frieze week in 2007.[5] Harry introduced us, and Goldin scrutinized me again before whispering to my nephew and then repeating herself out loud. 'I know your uncle,' she said. She talked to someone else but kept on assessing me for my coffin as she rolled regally back towards me on Harry's arm. 'I know your uncle! I know your uncle!' she repeated, angry that she could not

Amy Cutler
Ironing
2003, gouache on paper,
41.6 x 56 cm (16⅜ x 22 in.).

Cutler dislikes the one-dimensional depiction of women so she revives their central storytelling role.

place me, but then her face lit up and she put her mouth up to Harry's ear. He roared with laughter. He told me later that she thought she knew where she and I had met. 'Has your uncle ever been in rehab, at The Priory ?'

Sherman and Goldin were gifted to me on a plate by a functioning art market, but I had to go off the beaten track to find another American feminist. It is only a short walk across the corner of Central Park from MoMA to the American Folk Art Museum, but a chasm divides them in public perception. It is possible to argue that American folk art is more part of the American psyche than contemporary art, but try telling that to New York's 'rich women', gallerists and other resident art dictators. I have to confess that, back in 2008, I only made the short walk because my friend Paula Rego (b. 1935, Portugal) was included in the Folk Art Museum's exhibition 'Dargerism: Contemporary Artists and Henry Darger'.[6]

Rego was represented by works from her breakthrough series *The Vivian Girls* (1984), depicting the writer and artist Henry Darger's pre-adolescent heroines insidiously wreaking havoc as only innocent children can. I instantly recalled her confessions to me in her squash court of a studio back in London. Rego suffers from agoraphobia so she blocks out the vistas, if not the light. When she arrived at the Slade, her London art school, straight from Portugal in 1952, she was the youngest student there. She was allowed to break the school's taboo against painting and drawing stories as all her tutors except L. S. Lowry ignored her 'as a silly young girl'. None of them realized how subversive her attack was on the big open spaces of male abstract and conceptual thought. She has always liked stories that insinuate their message indirectly, like the light in her studio.

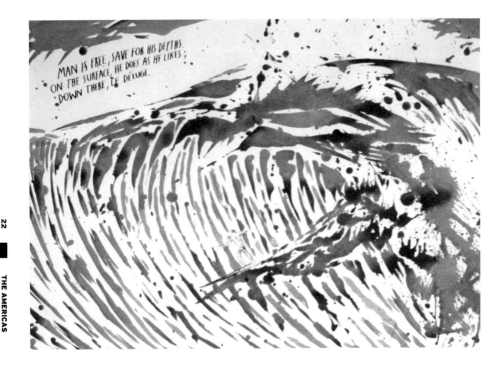

MAN IS FREE, SAVE FOR HIS DEPTHS;
ON THE SURFACE, HE DOES AS HE LIKES;
DOWN THERE, THE DELUGE.

As New York was the epicentre of the ban on stories in art, it was a surprise to find alongside Darger and Rego's work that of a young American storyteller-in-pictures, Amy Cutler (b. 1974, USA). Her paintings and drawings, which often depict female figures performing strange tasks, put women back at the centre of the story, as they invariably were in the past, and link the everyday with the magical. It is as though some of her women have taken on the whole weight of the founding fathers' aspirations and found them wanting. They look miserable, yet Cutler rescues them from their misery by offering us some mad uplifting detail. 'When I read the *New York Times*,' she says, 'I tend to latch on to random stories and the imagery. Recent scientific experiments, like the one where they grew a human ear off of a pig's back or genetically crafted hybrid mice, really inspire me. I am full of those stories. I could be the town freak with all her creepy tales, but instead I paint.'[7] In the past she might have been dismissed or, if taken seriously, persecuted as a witch. The stifling of stories and curiosity by male critics can be read as an anti-feminist act. Cutler's feminism, though, is turned on her own sex in *Ironing* (2003). This painting shows two women ironing a third until she is as flat as cartoon pancake. As the artist explains, the work refers to 'women's criticism of each other and their obsession with a super-thin, one-dimensional self-image'.[8]

While Cutler shifts the balance of the American Dream to include the women who made it happen, Raymond Pettibon

Raymond Pettibon
No Title (Man is free) (detail)
1999, pen and ink on paper,
56.5 x 76.2 cm (22¼ x 30 in.).

Pettibon's 'free man' has
his thrills, but also doubts
the momentum behind
his existence.

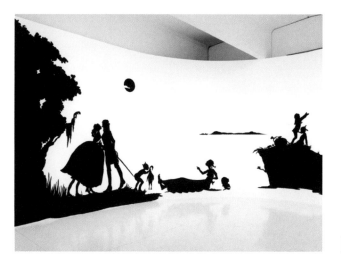

Kara Walker
Gone, An Historical Romance of a Civil War as it Occurred between the Dusky Thighs of One Young Negress and Her Heart (detail) 1994, cut paper on wall, 396.2 x 1524 cm (180 x 600 in.).

Walker, like many artists, is rewriting history. Her silhouetted stories spill round the room as sinister extensions of our nursery thoughts.

(b. 1957, USA) sends it the other way. He captures America's *Boy's Own* self-image and portrays it in an appropriate comic format. Unlike Roy Lichtenstein, who went for one-liner texts, the text bubbles in Pettibon's pictures are sometimes mini-essays on the American way of life. His heroes play baseball and surf. He lives in California, as far west as the American Dream took the pioneers, the land of the Gold Rush and home to Silicon Valley. 'Something like surfing describes a society,' he says, and seeing his little figures riding the bluest of waves in drawings such as *Man is Free* (1999), one wants to believe him, but the text in his pictures usually supplies an element of balance to this unbounded optimism. His most famous character is an amorphous blob called Vavoom, a version of the figure in Edvard Munch's *The Scream* (1893). There is angst deep within Pettibon's all-American soul.

The 'American story' is nothing more than a series of outsiders breaking and remaking the American mould. From looking at his drawings and reading the accompanying text I had assumed that Pettibon was made of apple pie and Coca-Cola, but while escorting the Estonian Minister of Culture around Frieze New York in 2012, I was informed that the Californian surfer was actually half-Estonian.

Wanderlust has become a defining part of our culture, and as the world becomes increasingly globalized, national identity becomes not necessarily weaker but more confusing. Many of the artists in this book live in the USA, so are included in this chapter, but they could and often will be referred to in other chapters too: Wangechi Mutu, Marcia Kure, Julie Mehretu, Aleksandra Mir, Eduardo Sarabia, Allan deSouza and Kamrooz Aram. Many of them address our fast-changing identity full-on,

with their art seeking to redress the balance of the past. Sometimes the roots are deep but the questions of identity still raw, as with Kara Walker (b. 1969, USA). 'I find that I am rewriting History, trying to make it resemble me, Kara (and me, Negress)…but there is a lot of (white, patriarchal) damage to undo,' Walker says.[9] Her black-and-white animated films and drawings show the slave trade as a physical act of rape. Yet she goes back to the era of slavery for the basic materials for her art, which is inspired by eighteenth- and nineteenth-century silhouette cut-outs. She makes much of this 'second-class' art form so frequently assigned to women. Like Amy Cutler, she sets out to revise the world viewpoint by showing us just how one-dimensional it is.

There is also a strong moral indignation in the work of Julie Mehretu (b. 1970, Ethiopia, but living mostly in the USA since 1978), but it is not quite as clear-cut as Walker's. Mehretu's work is in shades of grey. Ruin, and the innate potential for destruction in cities, drives her. She makes huge paintings that invite the viewer to behave as an archaeologist. We have to sift through the ambiguity of her cobweb drawing to find out how we live today. Her film-screen-size paintings can be seen one moment as architectural plans, the next as records of disintegrating rubble. It is as though we can see the positive and negative, both at the same time and separately. Is the world still being constructed, or is it disintegrating? The dependence of reality on faith is highlighted in *Believer's Palace* (2008–9), a title she takes from Saddam Hussein's underground fortress. The destruction of the World Trade Center and the architectural aspirations of one of the West's sworn enemies intertwine.

The path of Allan deSouza (b. 1958, Kenya) is even more convoluted than that of Walker and Mehretu. Before he found relative safety in America, his family had been chased around the world; their travelling definitely comes under the heading of enforced migration. Indeed, a racist attack in London and another mugging in Brooklyn actually physically changed the way he sees the world. The first assault damaged his eyesight. DeSouza has produced fuzzy photographs that work on the viewer like memories. We can't see everything clearly, so we fill in the details. As he recalls: 'I was too often in the wrong place,

top
Julie Mehretu
Believer's Palace
2008–9, ink and acrylic on
canvas, 305.4 x 419.1 x 5.1 cm
(120¼ x 165 x 2 in.).

The world is destroyed
and remade in Mehretu's
panoramic canvases.

bottom
Allan deSouza
Arbor
2004, C-print,
101.6 x 152.4 cm (40 x 60 in.).

DeSouza's vision is of a
world all too often distorted
by violence.

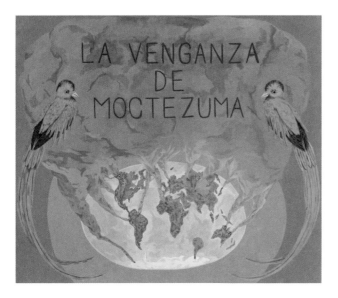

LA VENGANZA DE MOCTEZUMA

but if your family history and childhood experience are toured through three different colonies and their colonial powers – Goa under the Portuguese, India under the British and Kenya, again British – then being in the wrong place and at the wrong time too easily becomes habitual.'[10]

I was in the right place at the right time when I met Eduardo Sarabia (b. 1976, USA) at a dinner in his honour at the Regency Hotel in Miami. His white quarry-stone sculpture of two outsize drug dealer's boots stood across the road in the Art Basel Miami Beach sculpture park. It was a balmy late November evening and my British winter reserve melted on the Art Deco terrace under a kaleidoscope of palm trees, wine, Latin passion, tequila and fragments of conversation about Eduardo's escapades, which sounded more like those of an explorer than an artist. I was sitting a couple of places away from him so could not question him as directly as I needed, so through the host of the evening we arranged to reconvene for a pre-lunch drink on the same terrace later in the week.[11] Over drinks, Sarabia was soon telling me of his planned heist of the Aztec crown from the Museum of Ethnology in Vienna. *Moctezuma's Revenge* (2011) is his project to reclaim the headdress and end the curse that Moctezuma put on all foreigners after the conquistador Hernán Cortés stole the crown and sent it back to his king in Spain. Sarabia has made a bright blue watercolour that depicts the vengeance of the old Aztec emperor hanging like a cloud over the world. He told me how he'd had to go into the Mexican jungle to find a feather of the endangered quetzal bird, of which the crown is made. The quetzal has not sung its song since the Spanish invasion, but according to legend the bird will sing again when order is

Eduardo Sarabia
Moctezuma's Revenge
2011, acrylic on paper,
43 x 36 cm (16⅞ x 14⅛ in.).

Sarabia invokes the curse of the Aztec emperor in his bid to regain a pre-colonial paradise.

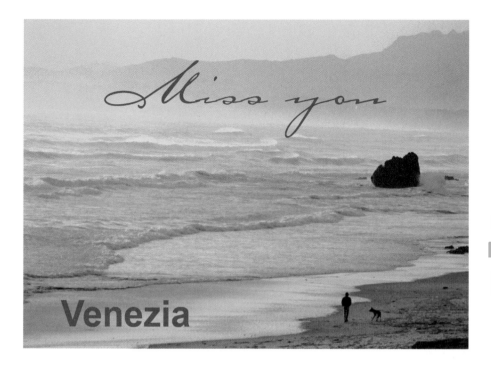

Miss you

Venezia

Aleksandra Mir
Venezia (all places contain all others) (detail)
2009, installation of postcards, 10.8 x 15.2 cm (4¼ x 6 in.) each.

By placing images of other places on postcards labelled 'Venice', Mir asks us where we really are.

restored to the world. Fact and fiction blend in Sarabia's work, much of which seems to be about the land of his parents. I asked him where he felt most at home. He replied solemnly, as if he had consulted the Delphic Oracle: 'I feel American in Mexico, in America I feel Mexican, but at home in Berlin.'[12]

Aleksandra Mir (b. 1967, Poland) is a citizen of the world. Her contribution to the 2009 Venice Biennale, *Venezia (all places contain all others)* (2009), mocks our lack of connection with place and location. The installation consisted of piles of postcards, which are trivial claims to a visited place, an echo of the explorer's flagpole planted in so-called virgin territory in the past. Most visitors to the Arsenale that year would have wandered along the front from St Mark's, or come by boat, but the day I visited I had walked from the other side of the island, along the main drag, down alleyways, past churches in piazzas and tucked-away *scuole* containing Titians, Bellinis and Carpaccios. During the Biennale the old warehouse in the Arsenale contains rows of mini-shows by some of the most exciting artists in the world. The artists compete to be seen, but Mir quietly stockpiled postcards, ostensibly of Venice. Yet they turned out to be pictures taken of everywhere *but* Venice. Emblazoned above scenes of snow, antelope and waterfalls was the legend and lie: 'Venice'.

That same year the Venice Biennale also supplied one of the most hard-hitting condemnations of the American way of life

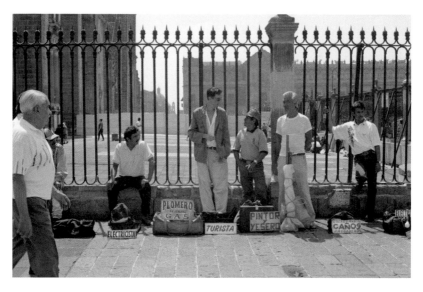

top
Teresa Margolles
Which other issue
we could talk about?
2009, performance.

A relative of one the victims
of drug-related deaths on the
streets of Mexico mops 'clean'
the Mexican Pavilion floor
with a diluted form of that
victim's blood.

bottom
Francis Alÿs
Turista
Mexico City, 1994,
photographic documentation
of an action.

Alÿs seems to be arguing
that being an artist is just
as natural and yet awkward
as other occupations.

when Teresa Margolles (b. 1963, Mexico) 'occupied' the Mexican Pavilion. I thought I had come to the wrong palace, which was irritating as it had taken me some time to negotiate the *calli* around the nearby Santa Maria Formosa. The tall galleries inside appeared to be little more than an extension of the miles of elegant, generous Venetian walkways. Many Italians are obsessive about cleaning, so I was not surprised to see someone mopping the floor. In retrospect, I was extremely fortunate to chance upon the event as I later learned it happened only once a day. Initially I could not fathom why there was a knot of people watching this very typical scene. As the man with the mop walked away, I saw a friend and he explained what was going on. The ritual wipe-over was done with the blood of victims of Mexico's drug battles. The man mopping was a relative of a victim. At the same time, the US Pavilion's bricked-up windows were further blocked with bloodstained fabric taken from corpses from the Mexico–US border.

Margolles has been more extreme than Gabriel Orozco, moving her studio into a morgue to make art out of the blood of the victims of two of America's biggest exports to Mexico: guns and death. After a while, however, she found the morgue constraining. 'Mexico has changed so violently that it's no longer possible to describe what's happening outside from within the morgue,' she laments. 'The pain, loss and emptiness are now found in the streets.'[13] She has moved her studio to the streets, which is where Orozco has long claimed his studio is. The heart of the more personal side of Orozco's debate about centre/off-centre revolves around where the artist operates – in the studio or out and about.

Francis Alÿs (b. 1959, Belgium) has perhaps done the most to take art out of the studio and onto the streets. An inveterate globetrotter, he works around the illusions that drive us on and on to find ever-greener lands. The shimmering allure of modernization is the subject of his film *A Story of Deception, Patagonia* (2003–6). 'They say that the Tehuelches hunted the ñandú bird by physically exhausting the animal,' he recalls. 'We, of our time, must chase mirages.'[14] The film shows a man walking across a barren landscape, with the camera constantly intent on the rising heat ahead. We are doomed to chase this illusion of progress for ever.

Artists can be as deluded about their role in society as every-
one else, as Alÿs demonstrates in his performance work *Turista*
(1994). He stands in the Zócalo human marketplace in Mexico
City alongside electricians, plumbers, painters and plasterers.
They are touting for business by the railings, advertising their
wares with small placards at their feet. The tall white man in
his cream trousers is too big for the space between his small
neighbours. He is an interloper. He has brought nothing to
compete with the tool bags of the other artisans but his awk-
wardness and his senses. The artist is making fun of his position,
showing himself to be like an overgrown cuckoo chick in some
poor tit's nest.

Turista demands a post-colonial reading: this joker gringo forcing
himself into an already squeezed local economy. Yet the others
in the line probably have more conquistador blood in them than
the Belgian.[15] Although the cultural mix of America continues
to prove fertile ground for artists, the anger of Alÿs's piece is
aimed not at the long-gone and assimilated Spanish invasion,
but rather at the here and now, the capitalist system so clearly
illustrated on the streets of Mexico.

The desire to move towards a perceived centre and a perceived
better world has driven many people. Jorge Satorre (b. 1979,
Mexico) has made a work out of the mass exodus of Mexicans
to the USA. Satorre believes in micro-history, which he records
through a multi-layered storyboard of drawings and commen-
taries. In *The Divine Truth (evidentiary Piaxtla)* (2008–10) his focal
point is the departure from Piaxtla of Maurilia Arriaga, the first
resident to leave the town in 1952. The small Mexican settle-
ment of Piaxtla is now extended by a comprehensive network
of former Piaxtecas working in New York. Satorre collected
legends and facts from this network, as well as through a series of
interviews in the town itself. He built up a body of 350 drawings
and a storyboard of 137 scenes for a film script. He then took this
material on the road with him and drove the route from Piaxtla
to New York. His investigation involved checking the same
facts from multiple angles, so he presented the assembled 'evi-
dence' to the novelist Elmer Mendoza to create a script and also
recounted the stories from memory to a group of illustrators. In
endeavouring to create the overall script, Satorre and Mendoza

Jorge Satorre
The Divine Truth
(evidentiary Piaxtla)
2008-10, multimedia installation,
dimensions variable.

By building up a multimedia
installation Satorre explores the
idea of the panoramic documentary.

were influenced by the car-race film *Two-Lane Blacktop* (1971), but when they discovered the plot was becoming too didactic, Satorre obscured the images compiled by the illustrators in a thick *sfumato*. There is enough to feed the eye, but also enough for the brain to realize it is not getting all the information. The audience is made to work and supply for itself the last layers of information about the endless battle between man and his borders.

The very pervasiveness of American culture that persuaded the Piaxtecas to get up and go to New York also supplied Daniel Guzmán (b. 1964, Mexico) with the basis of his art. He was brought up in Mexico City with the television on all day, imbibing Gabriel Orozco's North American teenager culture and the celebrity lifestyle perpetuated by Hollywood. Guzmán paints this world with the wild abandon of a rock drummer.

Cinema, music and television have been the great ambassadors of American culture so the arrival of video art in the 1970s brought with it instant claims of the death of painting. Here was a medium that would mean film and art could become interchangeable. We could all become film directors. YouTube, social networking and the ease with which films can now be made

Daniel Guzmán
P.P.P. Levitation
from the series ***The World
Doesn't Want Me Any More
and Doesn't Know It***
2006, acrylic on wood, 50 x
40 x 2.5 cm (19 ⅝ x 15 ¾ x 1 in.).

One can almost hear the television in the background and the radio blasting away.

Bill Viola
The Greeting (production still)
1995, video/sound installation,
colour video projection on a
large vertical screen mounted
on a wall in a darkened space
with amplified stereo sound.

The world's leading exponent
of video uses the medium as
an extension of painting.

have definitely added to artists' armouries, yet it is staggering how few artists have made their name primarily through video works. Bill Viola (b. 1951, USA) is an exception, but ironically his success has come by using the medium almost as an extension of painting. He thinks and feels like a painter, and lives and breathes the learning of older painters. 'I see painting as an art of time,' he says. 'It's about being in that one place, focusing on that one moment. The end result is directly related to the amount of time one spends with the object of consciousness. My favourite Cézanne quote is, "Right now there is a moment of time passing by, and we must become that moment."'[16] Notice he didn't say we must capture that moment: he said we must become it.

Viola is spiritual. It is possible that as a painter he might have become too aloof, too removed from everyday life, but his

medium has forced him to connect with everyday technology. He will risk pretension to convey important feelings and ideas, but he has the down-to-earth approach of the technician. 'When you come to America you have a VASTLY expanded idea of the mass culture,' he explains.

> Literally, people from all over the world have come to America. It's a land of opportunity. That sounds corny, but it's kind of real. It's brought people from all cultures to our shores, and that's very interesting. On the other hand, it makes it a little more difficult to come to any consensus about culture when you're living in this melting pot.[17]

He uses the power of the elements to carry away our emotions.

Viola is one of the few contemporary artists to get away with an art that makes sweeping, grandiose statements. We tend to prefer artists who can find us private spaces in between the crevices of our busy lives. Two of the most adept at helping their audience change their pace and rhythm are Elad Lassry (b. 1977, Israel, but brought up in the USA) and Marcel Dzama (b. 1974, Canada). Both artists have made films using ballet dancers. Their art is sure-footed, precise but difficult to place. They could be described as 'post-hasteists'.[18]

Lassry's photographs almost appear as a pastiche of art: they play with our expectations and then demand a continuous process of redefinition. They take a modernist stance, then twist it. Despite the vivid colours and contortions, one is still left comparing his still lifes with the calm of a Morandi or the systematic visual deconstruction of a Malevich. Lassry slips away from our categorization by declaring, 'Deconstruction has not

Elad Lassry
Untitled (film still)
2009, 16 mm film, silent,
11:40 minutes.

Lassry's colourful statements make his audience question their bold assumptions about art.

been satisfying to me, but it has been stimulating. It's like the misunderstanding of Postmodernism: it never arrived to demolish the modern notion; it's a chapter within Modernism.'[19] His isolation of objects is almost a reaction to Viola's point on the lack of consensus about culture. If you presented most people with his brightly coloured photographs and asked them, 'Is this art?' they would respond 'Yes', but then might be hard-pressed to describe why the images are more than just photographs. The artist plays on this:

> There are moments in my work, for instance in the black and white photographs that I frame in walnut, when the photograph's singularity almost takes over, when you think: 'Oh, this is – this should be – considered as a photograph.' But then you realize that it is part of a larger group of art works. The individual photograph becomes a disruption within the larger system I've created. With each strategy that I apply, at some point you'll find a failure in one aspect of it.[20]

Lassry, just like the European painters Luc Tuymans, Wilhelm Sasnal and Ivan Grubanov, whom we will meet in Chapter 4, is playing on our phobia of failure, our lopsided belief in a sugary idea of success.

I wish I had met Dzama when he lived in Winnipeg, before he moved to New York. He still carries those open spaces with him. You would recognize his type from films: the strong straight-backed silent one who goes out to the back yard to chop wood to release his anger. Yet he is much gentler than the Hitchcock stereotype. His art shows that he values company. As his films demonstrate, he is a team player, good at getting the best out of people. He was the leading member of an art collective in Canada, the Royal Art Lodge, and even since he became famous and left the country he has persisted in making occasional works with other artists in the group. 'I really love collaborating. With our drawings we used to throw back ideas to each other and lose our egos.'[21] He is a fluid, lyrical person, admitting that 'having one mission seems a bit limiting: from year to year I change a lot.'[22] With these changes come surprises. I was talking to him for about twenty minutes at Berlin's Art Forum about his anti-war films before he moved on effortlessly to discussing James

Joyce and a work he was planning relating to *Ulysses*. Then, in a moment of pure Hitchcock, he produced a card and drew a bat on it, which he explained acted as his signature. Suddenly his previous words made sense: 'I draw during the day, but the ideas come at night.'[23]

Dzama has made several films against war. They are not strident protests; they involve ballet dancers dressed as soldiers who flit between harsh reality and fantasy. My father would have had the soldiers in *The Infidels* (2009) in the guardhouse.[24] In the film, two armies are equipped with rifles and they stride with the exaggerated pomp of children across the wasteland that claims their lives. They die one by one in time with the music. There is a sense of unreality about the whole beautiful dream. Bullets seem to be going through bodies of straw, a head is severed yet it could be a scarecrow's head, but the total devastation is all too real: no one is left alive on a battlefield strewn with bodies. This casually futile violence is repeated in another dance film, *A Game of Chess* (2011). The references flow to the originators of strands of modernism, to Marcel Duchamp and his pursuit of chess or James Joyce and *Ulysses*, but Dzama's work is always on the move, like the armies on the chessboard and in the field. There is a continuous beat of the drum, revealed most clearly in a short video the artist made while his dancers were resting from shooting *A Game of Chess*. It shows the dancers repeating a basic move. Life is reduced to a single movement, a single beat: the human heartbeat.

The art form most influenced by the rise of film is the one that spawned it – photography. Two photographers, in particular, have adopted the techniques of filmmaking, with the first being Dzama's fellow Canadian Jeff Wall (b. 1946, Canada). Advertisements gave Wall his break in the mid-1970s. When he looked at large light-box commercials he 'thought immediately that the medium although it was used for advertising – in fact did not belong to advertising in any essential sense. It was a free medium, one inherent to photography and film.'[25] In 1977 he made his first back-lit Cibachrome. He used photography to adapt famous old paintings to contemporary scenes, but by the 1990s his productions had become like films, and this strategy is taken up by Gregory Crewdson (b. 1962, USA), whose photographs are shot just like films with a crew of around forty people.

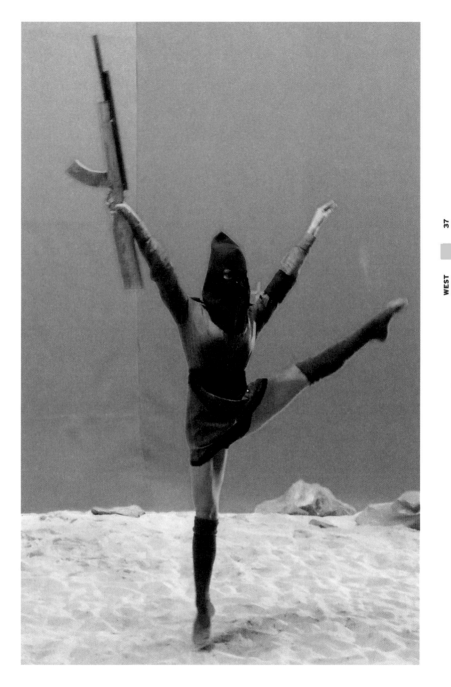

Marcel Dzama
The Infidels (film still)
2009, 35 mm film transferred to
DVD, black and white, 2:01 minutes,
sound video accompanied with box,
dimensions variable, edition of 15.

Dzama shows up the tragic futility
of war gently, eerily, lyrically.

bottom
Gregory Crewdson
Untitled (Beneath the Roses)
2003, digital chromogenic print,
144.8 x 223.6 cm (57 x 88 in.),
edition of 6.

Crewdson borrows the
production values of the film
crew to make his suburban
photographic scenes.

top
Jeff Wall
Boy falls from tree
2010, colour photograph,
305.3 x 226 cm (120¼ x 89 in.).

Wall was the first to apply the
lessons that photography has
learned from advertising.

Crewdson has declared that photography is like a picture window in almost a direct rebuke of Clement Greenberg's vision of pictorial flatness in modernist painting.[26] He has taken up where Edward Hopper left off in recording American suburbia. His pictures have that other-worldliness of twilight. He likes the time between day and night, and transports us from our world into his own. He emphasizes the construction process by making much of artificial lighting and all the tricks of filmmaking. The resultant photographs depict the suburbs of America with the visual vocabulary of old films. Crewdson talks about films as some others would talk of history: cinema is part of his history. '*Close Encounters of the Third Kind* [1977] was a film that almost in retrospect hugely affected my work...'[27]

So far in this chapter I have only talked about artists from the USA and its two neighbours, Canada and Mexico. Although the issue of New York's right to be at the centre of the world is a global one, it is obviously felt strongest within the Americas. The countries of the Americas, however politically aligned, find their cultures inevitably intertwined with the USA. The economic and cultural surge in Brazil has generated interest in Brazilian artists, but has not yet produced an art centre to rival New York. Apart from Mexico City, the only other city in the region that can claim to be a centre in opposition to New York is Havana.

Havana is a home to an ideological resistance to capitalism. It is also physically crumbling. *About these Untiring Atlantes That Sustain Our Present Day by Day* (1994–95), a diptych juxtaposing a photograph of a dilapidated Havana building and a drawing of the site by Carlos Garaicoa (b. 1967, Cuba), is a clash between utopian dreams and harsh ruins. The weight of the world is on our shoulders, but what are we doing about it? Garaicoa explains where the work comes from:

> Many artists in Cuba during the Eighties and Nineties approached...these spaces, these not strictly speaking 'artistic' structures, and of course I owe them something. After all, there is a wide theoretical tradition, starting with French structuralism, going in that direction. As a political and cultural project, Cuba is very close to the ideas of European

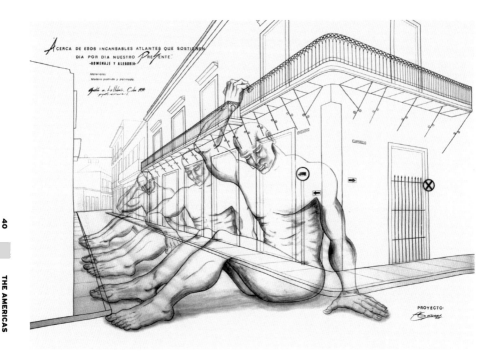

intellectuals in the 1960s; at the same time, the link with Russian thought of the Twenties or Thirties is also obvious: the idea of art linked to life, to areas of life not necessarily representative of 'bourgeois' traditions in art.[28]

Garaicoa has fed off Havana's mixture of clear dreams and collapsing structures, a microcosm of the world situation, yet in the end the city has not sustained him as a centre. But whom does home sustain completely? Not Cindy Sherman's *Rich Women*, certainly not Nan Goldin's 'extended family' or, of course, Gabriel Orozco. Just as Orozco spends as much time in New York as in Mexico, so Garaicoa has a studio in Madrid. He is not officially exiled from his homeland, but lives abroad due to circumstances not entirely controlled by himself. Nearly all of us exile ourselves in some sense, then try to compensate, find a new sense of balance. Garaicoa has recreated Havana, a little intellectual hub, in a run-down district just off one of the main streets in the Spanish capital.

The numbering on the way to Garaicoa's was not totally clear to me and I ended up walking right past his studio. In this part of town I didn't dare stop and ask the way, and so I was late for him. Garaicoa was staging a small exhibition of his friends' work. Although he is not normally particularly fast-moving, on that day he was like a human cannonball within the series of small rooms that make up his space. He was bouncing off the

above and opposite
Carlos Garaicoa
About these Untiring Atlantes that Sustain Our Present Day by Day
1994-95, diptych: ink drawing on vegetable fibre paper and colour photograph, drawing: 150 x 215 cm (59 x 84⅝ in.), photograph: 50 x 69 cm (19⅝ x 27⅛ in.).

Garaicoa examines the cost of keeping our dreams and buildings from crumbling.

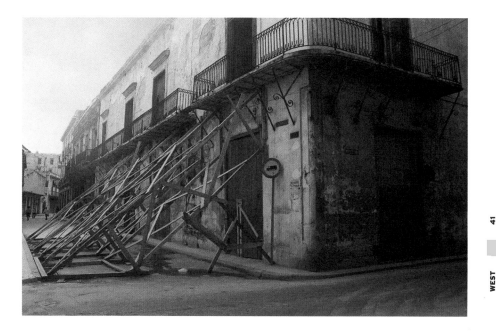

walls, helping one artist install a video piece while showing me a frighteningly wide range of his own work, before sitting me down in front of a screen that was linked to Cao Fei's *RMB City* (2007–11; see p. 118). I confessed I had never made myself an avatar in the Chinese artist's Second Life city so he let me use his – potentially a real fusion of identities.

Garaicoa was offering me a bolt-hole to slip through and change my world. This is the way his art operates, darting through holes in structures, most specifically Havana's ruins and the political systems of the world, yet he believes in the regenerative power of thought and art. Having suffered endlessly from the results of cynicism, he argues against it:

> Art is always fiction, invention, whatever its origin or the intentions it openly or secretly pursues. On this point there are no great disputes. Whether it is about dragons, angels, buildings in ruins or human beings killed in war, it would not occur to anyone to ask the artist for some sort of humiliating certificate of veracity or authenticity about the matter. It is enough to believe in his truths.[29]

This makes any art centre a clash of contradicting truths.

It is now possible for artists to carve an international career for themselves, away from the main centres, anywhere in the world. The arrival of the internet has been one of the major enabling factors. Sandra Gamarra (b. 1972, Peru) has used the Web to

great effect. Some artists can work in splendid isolation, but most need stimulation. Gamarra was so fed up that Peru did not have a museum of contemporary art that she created her own one, *LiMac – An Imaginary Lima Museum of Contemporary Art* (2002). Before the internet one of the main ways to experience art outside of museums and galleries was through publications. For her *Natural Selection* (2009) series Gamarra copied whole pages of the magazine *Art Now,* but she exercised her own selection of women artists. She gives the text equal prominence to the illustrations and thus achieves Boris Groys's aims for Conceptualism (see p. 163): the perfect balance between image and text. The writing, however, is practically illegible. Gamarra, with her sense of isolation, must work hard to learn about artists from all corners of the world, and this enriches her practice, but ultimately is her virtual art museum enough? Her own work tends to look towards the big art centres with adulation. For *Natural Selection* she copied paintings by the female artists who have conquered New York. She has not quite done an Orozco and gone to live in New York, but, like Garaicoa, she spends most of her time now in an even older imperial capital, Madrid. 'I play with truth,' she says, 'which is a hard game.'[30] Without the authoritative central voice of the past, the truth appears ever more elusive.

María Rosa Jijón (b. 1968, Ecuador) has made work about the border between Peru and her country of origin, Ecuador, but in her film *Paradoja Manta Manaos* (2009) she attacks the old Spanish colonial codification that still haunts her part of the continent. The camera in her film floats down the Amazon.

Sandra Gamarra
from the artist's book
Natural Selection
2009, oil on paper, 25.5 x
19.8 cm (10⅛ x 7¾ in.) each.

The text is intentionally unreadable in Gamarra's hero worship of female artists at the centre of the art world. Here, she copies an Elizabeth Peyton pastel, *The Age of Innocence* (2007).

María Rosa Jijón
Paradoja Manta Manaos
(film still)
2009.

As it floats down the Amazon
Jijón's camera is filtered by an
old map of the conquistadors.

Superimposed over the images of the great river and the lush, tauntingly untameable jungle is the very map that the conquistadors used to steal the country at the centre of the world. The name of Jijón's country is taken from its geographical location, the equator, the central line of all lines, but as she says, 'It is no longer about north and south. Some parts of society live in northern conditions, some in southern, wherever they live.'[31] Jijón has also walked along Ecuador's borders with young gangs, travelling with them along first the Peruvian and then the Colombian border to try and create 'images of the other side'. Yet again the irony is that an artist whose entire oeuvre is devoted to attacking the consequences of central thinking and control lives in a big city: Rome, the mother of all centres.

Jijón is not the only South American artist to incorporate maps into art. From an early age, Guillermo Kuitca (b. 1961, Argentina) used to stare through shop windows at maps until, as he admits, 'I got the idea that I was looking at the map to get lost not to get oriented.'[32] Maps were about an internal sense of balance, how he related to the outside world. This relationship turned another corner when he saw dance performances choreographed by Pina Bausch at a theatre in Buenos Aires in 1980. He suddenly realized the power of performance in art, the theatricality of art. Both Jijón and Kuitca seek to overcome the static qualities of maps and their attempt to impose an old order on us. After seeing the vitality and energy of Bausch's choreography, Kuitca identified theatres as places of constantly evolving, moving art; for him, even his 'maps' of theatre seat plans evoke the excitement of an art that is forever changing.

The relationship between dance and architecture would seem to be an Argentinian theme, as it also dominates the work of Pablo Bronstein (b. 1977, Argentina), but the fact that Bronstein's art looks so different from Kuitca's makes me think this is little more than chance. For a contemporary artist Bronstein travels very naturally between the past and the present. He draws with the bravura skill of the eighteenth-century artist Piranesi and is not embarrassed by his talent. He has the Latin ability to run with the young and the old, so his works take us on a helter-skelter architectural ride – we are never totally sure whether we are looking at a postmodernist building or a classical

top
Guillermo Kuitca
The Old Vic
2004, collage on paper,
149.2 x 148.9 cm (58 ¾ x 58 ⅝ in.).

Kuitca has been losing himself
in maps since childhood.

bottom
Pablo Bronstein
Tragic Stage
(performance documentaion)
2011, acrylic on canvas,
3.5 x 16 m (11 ft 6 in. x 53 ft).

Bronstein draws with the skill of
Piranesi and has his dancers exploit
sixteenth-century court concepts
in order to find a new relationship
between man and his environment.

top
Kamrooz Aram
Phosphorus Visions
2007, oil on canvas, 152.4
x 274.3 cm (60 x 108 in.).

Aram's paintings are a collision
of pattern and a modern
vision, of Persian carpets and
computer games.

bottom
Beatriz Milhazes
Brinquelandia
2008, mixed media collage
on paper, 115 x 143 cm
(45 ¼ x 56 ¼ in.).

Whereas Richter selects his
colours using a strict mathematical
system, Milhazes reaches for hers
naturally, but with similar results.

masterpiece, but most likely it is a seductive monster hybrid of the artist's creation. In embracing dance he also displays an uncanny ability to skip between time zones. In *Tragic Stage* (2011) there is an element of sixteenth-century *sprezzatura*, a courtly attempt to make the human body react in an equally mannered and man-made way as its architectural environment. Bronstein had ballet dancers performing in front of his massive painted backdrop of a Neoclassical façade. Yet he is not harking back, like Woody Allen's characters in *Midnight in Paris* (2011), to a golden age. He realizes the past had its problems, too. In his 2011 exhibition 'Sketches for Regency Living' he alluded to the *Architectural Magazine*'s 1834 attack on the 'incessant demand for novelty, which no designer, unless he possesses...an almost unlimited stock of ideas, can long supply without degenerating into absurdity'.[33] We live among such absurdities, and sometimes I enjoy nothing better than revelling in increasingly mannerist creations. Bronstein, however, precariously situated between the past and present, supplies us with an alternative route, a graceful but contorted dance between the towering edifices of our mind.

Bronstein is joined in his challenge against the Austrian architect Adolf Loos's declaration that 'all ornament is a crime' by Kamrooz Aram (b. 1978, Iran), who spends much of his time fighting this early twentieth-century Western aesthetic diktat. I visited Aram in the crushed corridors of New York's Parsons School of Design, where he teaches. He cuts an elegant, gentle figure and, like Bronstein, seems to hover between different time and geographical zones. He was in a comfortable camel-coloured suit with a red cravat to set off his dark curly hair. Twice, as we made our way through the labyrinth, students came up to him and fired questions that seemed to be part of a long extended dialogue. In answering their questions he was firm but sensitive to opposing views, just as he was in our discussion about the modernist dismissal of ornament. He admitted to being 'drawn to the geometry that modernists such as Adolf Loos claimed was the antidote to the "decorative"', but then went on to show his resolve to demonstrate the opposite in his own work: 'My aim is to show that the notion of the decorative is much more complex than Loos had claimed, and that today's false binaries of East vs. West are as problematic as Loos's concept of the sophisticated Modern Western Man

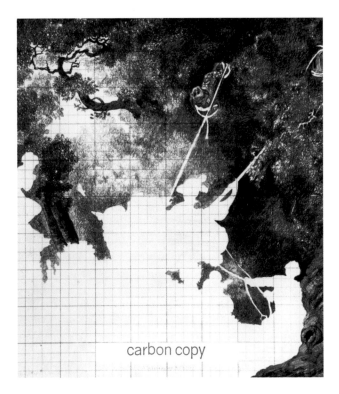

carbon copy

vs. the "less developed" Eastern cultures whose art is typically pattern-based.'[34] Aram's paintings are a collision of Persian miniatures, carpets and video games, but I sense in them the potential for something completely new.

Brazil has a tradition of the new, but the legacy of the Brazilian Conceptualists, whose reputation continues to rise, is difficult to define; perhaps the most important part of it is confidence. As Beatriz Milhazes (b. 1960, Brazil) says, 'Brazilian Modernism is based on the theory of "a culture eating a culture",' but, like Dzama and Lassry, her vision is totally uncompromising.[35] Her bright colourful paintings and architectural reliefs are almost the other side of the Gerhard Richter coin: whereas Richter systematically isolated colours in his colour chart paintings, Milhazes has reached for them naturally.

I was certainly excited when I came across the drawings/photographs of Marcelo Moscheta (b. 1976, Brazil) in the young section of Art Basel Miami Beach, and even more so when informed that Deutsche Bank's Americas committee had just bought some of his work. 'Art is not the world: it is how we see the world,' Moscheta maintains. 'For me landscape is like a mirror when you're alone.'[36] He makes 'carbon copies' of famous paintings and landscapes, highlighting the branches, the roots

Marcelo Moscheta
Carbon Copy-Fragonard
2010, carbon paper monotype and etching on paper,
40 x 35 cm (15 ¾ x 13 ¾ in.).

Moscheta's work seems to illustrate Orozco's description of the tree, growing from the centre, but it does not help if the tree is cut down.

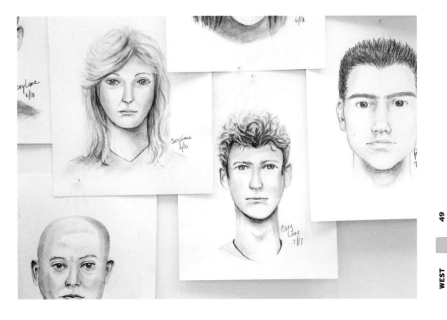

Rivane Neuenschwander
First Love
2005, pencil on paper, police
sketch artist, table and chairs,
drawings: 29 x 21 cm
(11⅜ x 8¼ in.) each.

These portraits were made not by
Neuenschwander, but by a forensic
artist hired to recreate the first
lovers of volunteers to the project.

and the lives of trees as though he were illustrating Gabriel Orozco's understanding of tree growth. As Orozco himself explains, 'I love the idea of how trees grow from a centre, how they also grow underground and on the ground from a centre and a horizon and they start to develop all the branches. A tree is a metaphor for me.'[37]

Rivane Neuenschwander (b. 1967, Brazil) is the Brazilian artist who most clearly expresses the global zeitgeist. Most of her work requires collaborators: she wants to involve people. She invoked Samuel Beckett's confessional short story *First Love* (1946) in a 2005 project of the same title in which she asked volunteers to reconstruct their first lovers, supplying them with a forensic artist to rebuild their memories. Why does the lover need to be redrawn by a draughtsman who normally deals with crimes? As with Beckett's story, there is a sinister element to the journey down memory lane. 'I am fundamentally interested in the permanent state of change the works are in,' Neuenschwander says, but, more than this, she actually encourages transformation. In *Carta Faminta (Starving Letters)* (2000) she fed snails on *carta*, which in Portuguese means both 'map' and 'letter', and let the little beasts create their very own map of slime.

There are moments when I realize the total insanity of attempting a global survey of art. As Gombrich warned, it is difficult enough to understand one artist, let alone the myriad connections between a galaxy of them. Francis Alÿs's short film *The Last Clown* (1995–2000) hit me hard. I am a dreamer, and from 1999 to 2011 could be seen happily in my own little world taking my West Highland terrier for a walk in London's Kensington Gardens and Hyde Park. So Alÿs's satire seemed a personal attack. The animated film, made from his own drawings, which are well known for their reduced colour and simplicity, shows a man and a dog out walking in what appears to be a park. It is a based on a real event. The man is Alÿs's close friend and collaborator Cuauhtémoc Medina, who in 2002 was appointed the first curator of the Latin American collections at Tate. As a curator and critic Medina is an achiever. He curated Teresa Margolles's installation at the Venice Biennale, which with its import of Mexican blood cannot have been easy to organize. He was also the coordinator of *When*

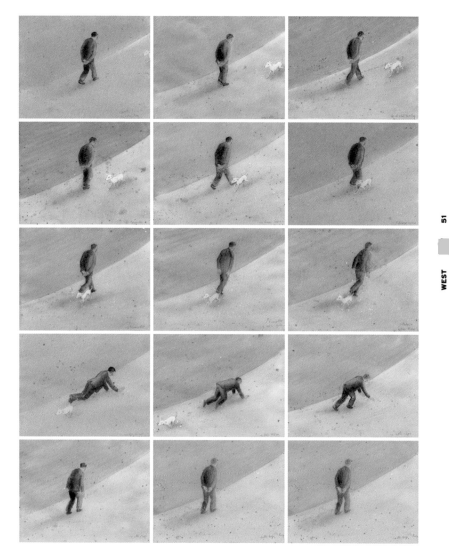

Francis Alÿs
The Last Clown
1995–2000, drawings for
animation, oil and pencil on
tracing paper, 29 x 38 cm
(11⅜ x 15 in.) each.

Alÿs's art-critic friend is not
looking where he's going so
he trips over the dog's tail.

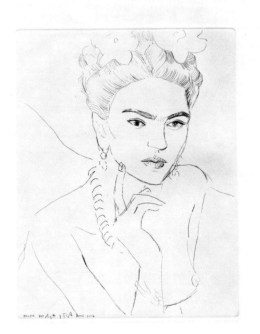

Faith Moves Mountains (2002), one of Alÿs's most monumental projects. He helped Alÿs round up 500 students, all dressed in white shirts and equipped with spades, to shovel sand and move a sand dune on the outskirts of Lima. They moved their 'mountain' mere inches, but the small physical change to the landscape was not the point. The event took place during an election that many feared was already fixed. It was a protest against the Peruvian government, which had declared, 'Everything is an illusion but power.' The recruitment of 500 people to move a mountain showed that the converse was also equally true: that 'illusion was power'. So Medina is hardly an idle dreamer, like me, yet in *The Last Clown* Alÿs shows his friend so engrossed in his theories, his head so much in the clouds, that he does not see the dog in front of him and trips over its tail.

I am certain that I fell over my dog a few times and for exactly the same reason: I was aiming for Utopia and my dog brought me down to grass, gravel and mud. I must have presented a funny sight as people are forever coming up to me wherever I am in the world and saying, 'You are that tall man with tartan trousers and a little white dog from London.' I can't deny it, but

Elizabeth Peyton
Frida Kahlo
2007, etching on Japanese surface Gampi paper, 25.4 x 20.3 cm (10 x 8 in.), edition of 20.

In this day and age Peyton's reduction of our vision of the celebrity world, both past and present, is almost unbelievable, but no less remarkable when it works.

all the time I thought I was having great thoughts about how to change the world.

I am going to conclude this chapter with the contradictory vision that drives so many and rewards relatively few: the American Dream, as supplied by Elizabeth Peyton (b. 1965, USA). Peyton's style of painting and drawing is a flat commonplace figuration with jackdaw moments of jewel-like splendour, and she uses it to display the fragmented celebrity global society. She rolls the aspirational, real and dead into one. Pictures of Napoleon rub shoulders with musicians like Jarvis Cocker, Kurt Cobain and Liam Gallagher, and repeated portraits of Frida Kahlo are produced alongside images of Peyton's contemporaries: Maurizio Cattelan (b. 1960, Italy), Jake Chapman (b. 1966, England) and her ex-husband, Rirkrit Tiravanija (b. 1961, Argentina). Tiravanija, who managed to get eleven thousand people to come and share soup with him at a single event, has undoubtedly produced more radical, socially inclusive work than his ex-wife, but the market persists in preferring Peyton.[38]

The London art world might have been very snooty about Peyton's incestuous, glamorous world if she had not cleverly presented her first London exhibition in an East End pub. Taken out of context, people looked at the work and started asking questions. The response of Gregor Muir, chronicler of the Young British Artists (YBAs) and now Director of the ICA, was typical. He demanded, 'Are these drawings for real?'[39] I recently met Peyton at the end of one of her openings and tried to continue this line of questioning. Her work is frighteningly slight, but so is the world she is depicting, the shimmering illusion of celebrity success. I want to know why she stops drawing and painting when she does. Is she consciously commenting on the inability to know when an art work is finished in our brave new multifaceted world, or is she blithely carrying on in the reductionist tradition of Andy Warhol and David Hockney? For an end of an evening she looked focused and serious. I saw a ghost of a response flicker across her bright and surprisingly stern face, but it was abruptly curtailed. Someone else came up to say goodbye to her. There are many times when I have to accept I am not going to get answers to my questions. That was it – that was my meeting with the famous Elizabeth Peyton.

SOUTH
● AFRICA AND THE MIDDLE EAST

'Just to think about the visual arts generally sends me into a panic.'[1] These words were uttered by the Palestinian-American academic and political activist Edward Said, who has had more influence than anyone else on the interpretation of contemporary visual arts in Africa and the Middle East. I have lumped these two regions together in this chapter as it is impossible to talk about the artists of any of them without reference to Said's ideas. I get an Orwellian feeling about much of Said's writing, as if I am caught in a trap that I cannot do anything about. The concept underpinning *The Global Art Compass* – that we try to activate our bearings to relate to 'the other' – opens me up to the accusation of being a 'latent Orientalist': Said's texts inform me that, as the offspring of imperialists, I cannot help but see Africa and the Middle East as sensual, spiritual and 'other'. Just as I don't feel anyone has given a satisfactory response to the criticisms of the way we live found in Orwell's *1984,* so I believe there has been no adequate development of the critique articulated in Said's *Orientalism* (1978).[2] Yet Said himself offered a way forward in his attempt to escape the political cul-de-sac: through music.

I originally envisaged this book as a quartet. I wanted to give four perspectives on contemporary art, with four different stories from east, west, north and south. My literary role models were the Alexandrian and Raj quartets of Lawrence Durrell and Paul Scott, but both of these were trying to revitalize an 'Oriental' tradition of storytelling that relied not on four voices but on many.[3] I realized that ideally I wished to let each artist tell his or her own story and supply some of my own links. The difficulty for this chapter comes from the fact that I have visited

remarkably few artists from Africa, Iran and the Middle East in their home and studio environments, and those I have were usually in exile. My conversations with Deutsche Bank's Nigerian art adviser Okwui Enwezor have invariably been at glamorous art meeting spots around the world, the most memorable sitting over a second breakfast on the Grand Canal in Venice. My very approach to learning about African art, locked away in the long room in the Victoria and Albert Museum that houses the British National Art Library, seems to conform to Said's worst fears of distant, second-hand knowledge. Hopefully the artists and Okwui have knocked most of my 'latent Orientalism' out of me.

Said's creation of the West–Eastern Divan Orchestra offers the inspiration that we are never as stuck as we might appear. In 1999, Said and the Israeli conductor and pianist Daniel Barenboim formed a youth orchestra of musicians from Palestine, Israel and the rest of the Middle East and Iran. Staggeringly, they named the orchestra after Goethe's last major cycle of poems, *West-Eastern Divan* (1819). Difficult enough for the Israelis to name anything after the great German Romantic, but I would have imagined the cultural imperialist Goethe would be the devil himself to Said.

I looked to Okwui to dispel some of my ignorance. Born in Nigeria, a country that supplies more than its fair share of creative people, he is now Director of the Haus der Kunst in Munich, but one is likely to find him anywhere around the world that new art is being discussed. Although to the general public Hans Ulrich Obrist (the 'Marathon Man' of the art world) is probably the best-known figure on the global art talk circuit, Okwui is the one most gossiped about by other speakers.[4] I once witnessed a lengthy chin-wag among other panellists in Dubai about the list of perks he allegedly demands before turning up. It was the super-king-size bed and the size of his hotel rooms that aroused most envy. Seeing him walk across the terrace at the Bauer Hotel in Venice, I doubted very much whether I would have guessed his occupation. He is a big man, but he moves more like a statesman than an athlete. He looks too well dressed to be an academic, although he was the Dean of Academic Affairs at San Francisco Art Institute from 2005 to 2009. He could be a politician, until his eyes light up, as they did over our cappuccinos when I questioned him about the relevance of Western

easel painting to contemporary art. He can talk for hours in a professorial language, the musical timbre of his voice supplying the only light relief, but he subscribes to the Socratic principle of teaching: he tries to make his interlocutors think for themselves. He looked sardonically at me when I tried to push him as to whether he thought the paintings of Picasso and Matisse were serving the same function for young artists from Africa as the traditions of African, Polynesian and pre-Columbian sculpture for the early modernists, that Picasso and Matisse were now a 'primitive', 'other' source to trigger a new modernity. We soon moved on to discuss migration, specifically Yto Barrada's work about the one-way borders between Africa and Europe. There is often a sense of watchful reserve in our conversations. Okwui is very happy to fire out names of artists at me, but as soon as we get to ideas there is understandably an element of the provocative tutorial in a subject where he has a pre-eminent position. He has written a great deal about the relationship between the centre and the periphery. I wanted to ask him about the constant movement in Africa, the nomadic travel resulting from the climate, economics and geography of the region. I didn't get round to it, as I failed to think of a way of articulating the other side of the love of movement, the love of dance. This seemed frivolous. I heard some words of his that I had read in the library ringing in my ears: 'Tourism and travel are the establishing shots of a troubled relationship between near and far, familiar and unfamiliar, native and tourist.' The same passage continues:

> In the eighteenth century, the Grand Tour (which bequeathed to us the word *tourism*) was an opportunity to broaden the traveller's horizon. Ultimately, it supported a habit of consumption: to seize and possess a slice of the world. Tourism gives the traveller the illusion of worldliness, the fleeting security of cosmopolitanism, but because the touristic imagination is famished and voracious, it feeds a habit, and often makes for the manufacture of fraudulent transactions.[5]

We are back to Said's dead end. Despite the spectacular conquest over apartheid in the south, Africa is all too easily defined by the problems on its peripheries: not only the seemingly insoluble dispute between Palestinians and Israelis, or between Iran and the USA, but also the uneasy relationship between North

Africa and the former European colonialists on the other side of the Strait of Gibraltar. Over a third of the artists in this chapter spend the majority of their time outside their country of origin. Displacement, combined with a concept of identity that is very different from that of their adopted countries, has added to the friction and tension in their art.

'Africa Remix: Contemporary Art of a Continent' was the first major show of African art I saw (in 2005, at London's Hayward Gallery).[6] The three artists in it who had the biggest impact on me all displayed an understanding of themselves far removed from the inflated full-frontal ego of mainstream Western thought. This was not necessarily clear at first. Indeed, unaware initially of the different role that the 'I' plays in African society, I thought the work of Wangechi Mutu (b. 1972, Kenya), Samuel Fosso (b. *c.* 1962, Cameroon) and Zwelethu Mthethwa (b. 1960, South Africa) was gloriously narcissistic.

I read Mthethwa's photographs as straight portraits. They are mostly of solitary figures and are invariably untitled. He explains the reason for this: 'I come from a culture where the collective is more significant than the individual. It is really about who people are connected to, where they are from, what work they engage in.'[7] Series such as *Interiors* (1995–2005) and *Sugar Cane* (2003) look different with a knowledge of Ubuntu, the belief that a person can only discover himself through other people.[8] In one of the images, strips of cloth hang off a sugarcane worker like the armour on a Samurai warrior. The man stands with the conscious swagger of the conquering warrior, one foot placed in front of the other, as if to claim the large expanse of cultivated land behind for himself, but he is staking this as a representative of his people and, more importantly, as someone who cannot be seen in isolation from his people and land. Okwui observes:

> His [Mthethwa's] take on landscape, portraiture, and social class is reminiscent of Thomas Gainsborough's famous eighteenth-century painting *Mr and Mrs Andrews* (1750)... it is important to make this distinction because Mthethwa's portrait of the cane workers inverts the moral codes (work ethic) and the process of identification (social stature) respectively associated with Dutch and English genre painting.

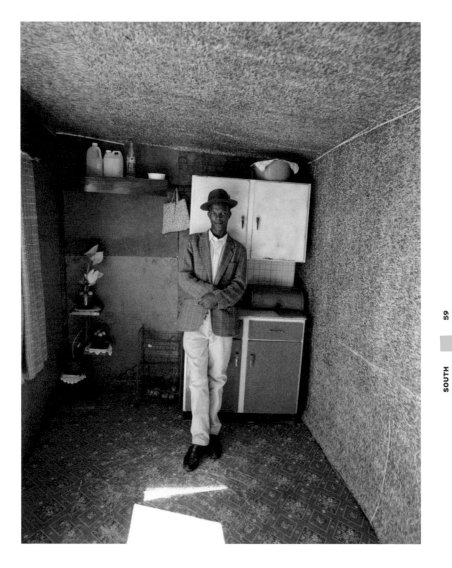

Zwelethu Mthethwa
Untitled
from the series ***Interiors***
1999, C-print mounted on Plexi,
129.5 x 96.5 cm (51 x 38 in.).

Mthethwa's subjects and their
surroundings seem to influence
each other: they have a relationship.

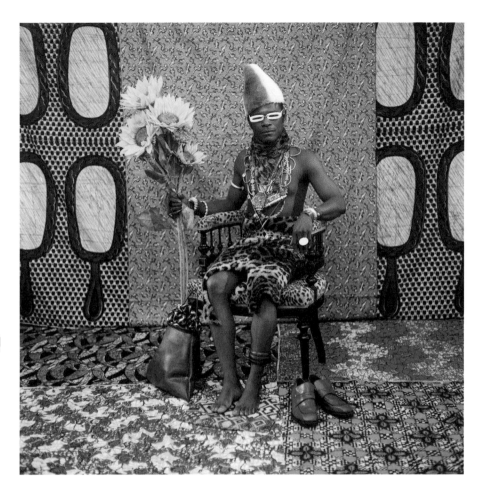

On the contrary, his is an interrogation of a political landscape and its supporting economic system: namely, the imbrication of global capitalism in the post-apartheid landscape.[9]

There is no formula at work, but it is almost as though Mthethwa is asking his sitters in the *Interiors* series to demonstrate that despite the horrors of colonialism, they have not lost their collective spirit. He asked them to pick their own clothes and choose their own settings and poses. Just as the sugarcane worker out in the open fields demonstrates the vast tracts of land to travel, so the man in *Untitled* (1999) has built himself a refuge from being constantly pushed around. The red walls and floor seem to be squeezing in on him. He too has one foot in front of the other, but, tentatively, his arms are crossed. The body language speaks of a man returning to the womb, but he smiles engagingly and his eyes insinuate that they know the ways of the world, the ways to dodge. There is a sense that rather than capturing types, as a documentary photographer might, Mthethwa is trying to let

Samuel Fosso
The Chief (who sold Africa to the Colonists)
from the series *Tati*
1997, C-print, 155 x 124.5 cm (61 x 49 in.), edition of 3.

Fosso is his own model and has an all-embracing vision of himself.

his sitters fit in, using photography to justify their existence. As he says, 'I wanted to give some dignity back to the sitters.'[10]

Mthethwa photographs other people. Samuel Fosso points the camera at himself. He has conjured up *African Spirits* (2009), psyching himself up like an actor to play Nelson Mandela, Martin Luther King and Muhammad Ali, but because of his belief in a collective self, it is more than acting. Fosso's commitment to the collective 'African spirit' made him realize that unlike an American or European artist he needed only himself as a model. As he explains, the series 'is in homage to the leaders who have tried to liberate us, to give us back our dignity as Africans and as blacks.'[11]

Economics, politics and a bloody war led to Fosso's first self-portrait photograph, taken around 1973. He is still not totally sure of his year of birth. He started taking pictures of himself when he was about thirteen or fourteen, to send back to his grandmother in Nigeria. His mother had been killed in the Nigerian–Biafran War and Fosso had moved to Bangui, in the Central African Republic, when he was around ten. He found himself a job in a photographic studio and used up the ends of the film rolls with self-portraits. He never gravitated to another model, partly as he did not have to pay himself; more importantly, having lost so much, he was also rebuilding his own identity: 'I felt, at that time, that I was handsome, young, well made and without stain. I wanted to have proof of this, to show my future children.'[12]

Fosso began taking self-portrait photographs before Cindy Sherman started her *Untitled Film Stills* (1977–80). Yet the image that propelled him to fame was *The Chief (who sold Africa to the Colonists)* (1997) more than twenty years later, by which time Sherman was at the top of the international photographic pile. Surrounded by a patchwork of colourful treasures, Fosso, the 'Chief', confronts the world from behind his narrow, white sunglasses. This picture would be more at home in an aspirational men's shopping magazine than on a gallery wall. Its title is a self-critical but vicious swipe at perceptions of Africa. Like Sherman, Fosso denies the egocentricity in the posing. 'I borrow an identity,' he claims. 'In order to succeed I immerse myself in the necessary physical and mental state. It's a way of freeing me from myself.'[13]

Ironically, it is not an African artist but the Iranian Shirin Neshat (b. 1957, Iran) whose work best demonstrates how self and society are joined at the hip. As an Iranian based in New York, her work has often been used to delineate the conflict between Iran and the West, with the debate revolving around Islam and the freedom of women, yet the subject that dominates many of her films is the integration of the individual into the group. Even if you interpret the single strong voices, the lovesick feelings, as fighting against the chains of the collective self, there is no release, no escape. From a Western perspective, *Turbulent* (1998), *Rapture* (1999) and *Fervor* (2000) seem to be demanding a redefinition of the self, but it is simplistic to see this trilogy of films as an updated Orwellian defence of the individual in the manner of *1984*.

When I first saw *Turbulent* in a small Wren church across the Thames from Tate Modern in London, I was struck by the strength of the singing voices and the confrontation of the piece. I looked from the male screen to the female screen. It was a competition. The male and female singers were locked in a vocal duel for my soul. The woman won, but she was not content with that. Her song was a battle-cry, a search for herself, for her place in life.

'As a young person, I was always drawn to religion – "Islam" and the idea of a "faith",' Neshat has confessed. She continues:

> In fact I prayed daily even if I didn't understand the meaning of those Arabic words that I recited every day. For us, religion functioned as a collective activity that offered emotional and psychological security and comfort. I remember as I arrived in the USA, and as my mild religious practice dissipated, came an overwhelming feeling of 'loss' and 'displacement', that I have never completely recovered from.[14]

Her films show people acting as a herd that has zero tolerance for the individual's desires and emotions. Groups of women act as one coherent being while groups of men act as another coherent being: the group is one being. The nomadic nature of man is highlighted in *Passage* (2001), where units of humans work together like columns of ants. A group of female figures

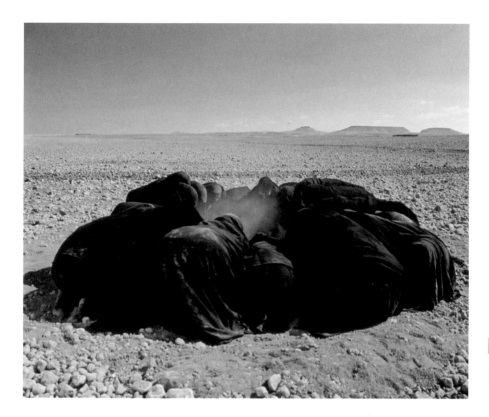

Shirin Neshat
Passage (production still)
2001, colour video and sound
installation, 11:30 minutes,
dimensions variable.

Groups of men and women
are united in the face of death.

acts like some very disturbed compass. It appears both inanimate and yet animal. It scours the surface of the earth. The film is about a Muslim funeral ceremony: the camera follows the ritual of death in a harsh and unforgiving landscape. Together as one, united against nature, these women are digging a grave by hand.

In contrast to Shirin Neshat, who has complained of having her work defined by one of the world's major conflicts – the clash between Iranian fundamentalism and American capitalism – the major shift in thinking by Wangechi Mutu (b. 1972, Kenya) and Marcia Kure (b. 1970, Nigeria) has been marginalized. Their work records the death of the concept as a single moment of genius in order to present thinking as a continuous, open-ended process in line with the ideas of the French poetical philosopher Jeanne Hyvrard, who has guarded her identity so that we do not know for sure whether she is black or white, or for that matter man or woman. By hiding the most obvious parts of her identity Hyvrard encourages the deeper self to rise to the surface. Despite the inherent feminism of her novels and poetry, the location of self is but a restatement of African philosophy: "'I" is not only one relationship but numerous relationships: "I" has a clan and a shrine.'[15] Rather than 'masculine' self-contained concepts, Hyvrard has invented more opened-ended 'encepts'.

Mutu's collages encapsulate Hyvrard's ideas on identity while challenging conventional standards of female beauty. *Me, Myself and Shy* (2010), for instance, shows the artist's many sides as a 'clan and a shrine'. The image is reminiscent of Picasso's distorted double-faced portraits, yet it is both sweeter and more sinister. Mutu uses Picasso as a starting-point, but as African art was for him, so Picasso is only a point of departure for her. Indeed, her 'encept' is a constant retort to his unbounded chauvinism. The main similarity between the two artists is their ambition to find an art that defies time. As Picasso said back in 1923, 'There is no past or future in art. If a work of art cannot always live in the present it must not be considered at all.'[16] Mutu has chosen to make her self-portrait, like most of her work, in collage, based on an ink drawing. She has taken South African artist Marlene Dumas's advice that drawing has more street cred than painting (see p. 178) to the next level, for she has mixed the drawing with materials that look like stockings and then placed it on polyester film. One painted eye looks down demurely, but the other, behind the mask, could come from a horror film, although I want to know its owner. This eye is all-seeing: it has witnessed wholesale destruction. The 'I' behind it has witnessed a world she will never leave behind. The subject may be shy, as the title indicates, but she is prepared to embrace a constantly evolving sense of self. As Mutu says:

I have never been afraid of extermination as such; I think being raised in a majority-black nation has a lot to do with that. But I have to admit that being transplanted changes your notions of self and survival. I'm sure the more extreme your migration story is, the more complicated issues of personal

Wangechi Mutu
Me, Myself and Shy
2010, mixed media: ink, paint, glitter, fake pearls and collage on Mylar, 128.9 x 131.4 x 2.2 cm (50¾ x 51¾ x ⅞ in.).

Not what you usually think of as your average shy member of the community.

Marcia Kure
Dressed Up #8
2010, archival digital print,
213.4 x 152.4 cm (84 x 60 in.),
edition of 3.

Despite the aspirational
connotations of its title,
Kure's fragmentary vision
is down to earth.

cultural survival become for you. Displacement anxiety and a
fractured identity are implied in my drawings; there are muti-
lations and awkward attachments in the collage work.[17]

Me, Myself and Shy shows a Medusa with many heads, yet there
is still a gentleness to the self-portrait. It is a picture about the
balance between the self and the societies in which the artist lives
and has lived. Okwui Enwezor sees Mutu as one of the artists
who show the 'living dynamic changing substance' of Africa.[18]
I have only met her once: at drinks at the Whitney Museum
before the dinner to launch Frieze New York in 2012. On this
occasion I was the one being shy. I would have loved to talk to
her about her relationship to the early modernists, but I am
not socially adept enough to throw Picasso's name at a serious
living artist during a drinks party. Picasso has led many more
artists astray than the occasional artist – such as Bacon, Dumas
or Mutu – who has found in him the inspiration for something
new. I did not get the chance to tell her this. Instead, I talked to
her charming Italian boyfriend.

I might have been on safer ground with Mutu if I had talked to
her about Michel Foucault, as she uses her body in her work
to revolt against the way we are controlled, a variation of the
way the French philosopher thought our minds and bodies are
manipulated by society. 'I use the body as a metaphor and as a
focal point,' she says. 'I took all those psychological issues and my
own personal stories and the stories of other women, and I man-
ifested them as body injuries or mutilations or malformations…
The only way to keep moving around this body that is society

is by mutating…That's where these chimeras, these creatures, these women warriors come from…they're not me, *per se*, they're human conditions.'[19] Marcia Kure takes up the theme: 'There is nothing coherent or unitary about the experience of modernity, during and after the age of colonization. At the organic level, we are nothing but a network of fragments of memories, fragments of experiences, fragments of tissue and body parts…My work can sometimes seem like a utopian project, born out of despair about the post-colonial and post-capitalist condition.'[20]

Artists have been as guilty as anyone of perpetuating the myth of the sacred nature of the idea. Conceptualism, the worship of pure thought, has been the dominant art form for the last half-century. Kure points out how we are all natural conceptualists in relying on contradiction. 'Contradiction gives critical and sensual charge/tension to a work. It is that thing that makes us ponder or pause; to ask why things are the way they are or are not. They make us uncomfortable, and it is at the moment of greatest discomfort that we are compelled to ask the most important questions about our lives, and our world!'[21] Her drawings and collages of hybrid bodies, which she appears to make out of her own and her family's surroundings, emerge out of the flow and eddies of her life. She is not trying to shock: the images, often made with basic domestic materials, just remind us of the lives we lead. She shows us her modern way of life.

The debris from the clash between the modern and the traditional litters Africa and the Middle East. El Anatsui (b. 1944, Ghana), one of the fathers of contemporary African art, uses as his main material the bottle tops, made by vast international companies, that lie in the dust and rubble of our everyday lives, sharp little irritants reminding us that the new and the old are not blending happily, that our husbandry of the world is not a success, and that we need to think again about how we interact with other people and our environment. El Anatsui flattens out the bottle tops so that they look like shiny military dog tags and then stitches them together to make a cross between a tapestry and a collapsed rainbow suit of chain mail. 'I believe that human life is not something which is cut and dried,' he says. 'It is something which is constantly in a state of change…Human relations are not fixed.'[22]

El Anatsui
Fresh and Fading Memories
2004, aluminium liquor bottle
caps and copper wire, 9.1 x 6 m
(29 ft 10 in. x 19 ft 8 in.).

This tapestry made of bottle caps
was thrown over the balcony of
Palazzo Fortuny in Venice during
the 2007 Biennale.

El Anatsui's work has the grandeur of Richard Serra's, but his is a very African approach. I find it difficult to accept these 'cloths' as anything other than craft, but this aspect is an essential part of them. Involving the community and representing the spirit of the community are a more important aim to an artist who has never aspired to the idea of solitary genius. 'There is an artist in each of us,' he says, sounding like Andy Warhol or Joseph Beuys. 'It is not only those of us who are called "artists" who have the creative juice. It's in everybody.'[23] El Anatsui carries a very different set of baggage from Warhol. This is not about self-empowerment. It is more Beuysian in its involvement with others, yet even less prescriptive. He was happy for the antique dealer, gallerist and decorator (and master tastemaker to the super rich) Axel Vervoordt to hang *Fresh and Fading Memories* (2004) over the balcony of Palazzo Fortuny at the 2007 Venice Biennale as the main thrust of the work is confidently egalitarian. His cloths are down to earth: the bottle tops have been described as strips of the earth's skin. Their flexibility, movement and composition from so many ignored individual elements talk of a similar soil and people to the works of William Kentridge or Shirin Neshat.

Empty dreams are equally a subject for art – and false motivational forces. The French-Algerian Kader Attia (b. 1970, France) warns against the idea that life will be better over the horizon. 'This myth,' he proclaims, 'the skyline, the dream of a successful life, a better life, is an empty myth.'[24] Attia's work can be seen as a continuous assault on the failure of the world community to come up with any convincing ideology, any formula for running the way we live. He sees little difference in the respective malfunctions of communism and capitalism:

> Capitalism and Communism are both wrong. Today, if we think about Capitalism, it is with exactly the same feeling that we had, when we were thinking about Communism at the end of the 1980s. At the end of the 1980s everyone knew that Communism was over. I remember I made a project in 1987. I was in art school in Paris. The project was a book cover: the 'collapse of Communism.'[25]

Twenty-five years later he is looking at capitalism in a similar way:

> Each person wants his or her success. 'I want this from me. I don't care who you are. I want this for me. It's all about me, myself and I.' This is one of the consequences of Capitalism – all self-satisfaction and selfishness. 'I exist if I consume.' As an artist, if you want to speak about this you have two different ways: through emptiness itself, or through its contrary, fullness.[26]

Attia combines the two in *Untitled (Skyline)* (2008), the work that induced his comment about the myth of the city skyline. He has created a sculpture out of refrigerators. Beautiful, if slightly the worse for wear, the fridges are covered with little mirror tiles so that when assembled they look like one of our big cities. It would make a very good companion piece to Francis Alÿs's *A Story of Deception Patagonia* (2003–6; see p. 29). Where is this place of our dreams? What is it made of? Too many of us keep our aspirations on ice, only to raid them like thieves. Attia is not only talking about the current cost of our way of living; he is also pointing out that we have nothing left in cold storage. We are running on empty. Le Corbusier's utopian twentieth-century vision has failed to supply homes for the twenty-first century.

top
Kader Attia
Untitled (Skyline)
2008, mixed media: 32 fridges, dimensions variable, edition of 3 + 1 AP.

Attia warns us about the emptiness of our aspirations.

bottom
Zineb Sedira
The Lovers
2008, C-print, 120 x 100 cm (47¼ x 39⅜ in.).

Abandoned in a water junk-yard off Mauritania, the ship on the left has a gaping hole that is hidden on the far side from its 'lover'.

If Attia concentrates on the hard, brutal suburbs to which our dreams of migration lead us, Zineb Sedira (b. 1963, France) shows a wall of a different nature: the inability to communicate with the ones we love best. In her film *Mother Tongue* (2003) the artist shows herself happily talking to her daughter in English, and to her mother in Arabic and French. The conclusion, however, is tough. The grandmother, who speaks Arabic, is unable to communicate with her granddaughter, who speaks English, after two migrations: the grandmother's move from Algeria to France and the artist's from France to England. Sedira explains: 'That's the way I feel about culture, how unfixable it is.'[27] Yet when she became a mother, she learned to overcome this so that she could pass on her culture. 'I had to make my own "history", a history removed from the official one of France or Algeria! Most of my work at the time was about spoken histories, stories passed on from one person to the next. My interest in listening and telling histories became stronger when I became a mother.'[28] Even in the bleakest of messages, she finds humanity: she transforms the dumped relics of our civilization into *The Lovers* (2008).

Yto Barrada (b. 1971, France) changed my opinion of her by reminding me of one of my favourite photographs of all time: Thomas Struth's *Louvre 2, Paris* (1989), which depicts a French teacher lifting up her pupils' eyes to the art around them on a museum trip. It is a vision of art's potential. It shows the power of art, but also the sheer energy that our curiosity can create when harnessed. I saw Barrada's real-life version of this image by luck. I was standing outside the entrance to Art Dubai and some fifty yards away, across a water feature, I saw a cluster of children. Right at the centre, with all the children's eyes on her, was Barrada. The setting was far removed from one of the great museum interiors of the world. The sun was out, the water between Barrada and me a deliciously artificial blue. She had built her temporary children's art centre under a basic pagoda structure with piles of colourful poufs and cushions. The theme of her project, and my reverie, was one of magical travel: 'Morocco to the Moon'. I was talking with my friend Omar Abu-Sharif, so I pointed out the scene to him. He immediately wanted to sign up his young son Bassam for the programme. There was no way that two grown men could interrupt that blissful scene, but we were lucky enough to catch Barrada on the way out of the fair a few hours later.

Yto Barrada
Hand-Me-Downs (film still)
2011, video, from 8 mm and
16 mm film, colour, sound,
30 minutes.

Barrada created a sixteen-part
video from found film clips. It
is her family's story made from
other people's family videos.

I begged for an entry ticket for my friend's son. She did not say yes at once; she set us an entrance examination. To enrol his son, Omar had to name the meteorite that had landed in Morocco earlier that year and was now in the country's Natural History Museum. Fortunately he knew the answer, so the young Buzz joined the charmed circle to train to be an art astronaut.

What remote relevance has this story? It illustrates Yto Barrada's role as an artist. Like Sedira and Attia, she was born in France, but her family is originally from North Africa – in her case, Morocco. She is now an internationally known artist, but much of her work has been about the relationship between Africa and Europe, about borders. She lives and works in Tangier. As an artist she mainly makes photographs, films and sculpture. Yet over and above this she sees part of her life's work as creating a centre for the arts in her home town of Tangier. She is the director and co-founder of the Cinémathèque de Tanger. This feeds her work; as she maintains, 'I come from a generation of artists from the Arab world for whom "home and away" matters – it's an exciting laboratory.' This is perhaps best expressed in *Hand-Me-Downs* (2011), a sixteen-part video that is ostensibly about sixteen family myths, stories that grew with her as she grew up. Barrada emphasizes the way we invent ourselves, within our own little family unit and within society as a whole, by making her work out of other people's family videos, which she picked up in flea markets. She has rebuilt her past with fragments from strangers' lives.

I see this as an all-embracing understanding of her role as an individual: if she is made up of dozens of other people's experiences, she becomes more than a single individual. 'I' becomes 'We'. It is a question of how the 'I' fits into the community: 'I' as part of the community or 'I' in opposition to it. Greek philosophy and its subsequent interpretations, such as the Cartesian *cogito* theories, have tended to be as narrow as possible in their search to define existence, but in Africa there is a history of a much more fluid understanding of the self.[29] Two more works by Barrada since her return to her roots in Tangier highlight this clash of interpretations, the individual as an island or part of a group.

As she was born in Paris, Barrada can come and go in Morocco as she pleases, but at times she has felt that the state of being in the country was defined by the border, that for many people the Moroccan way of life was dictated by being unable to travel to Europe. As she says, in explaining her photographic series about migration *A Life Full of Holes: The Strait Project* (1998–2004):

> The closing of Europe's common border to Moroccans coincided with the arrival of satellite dishes and DVDs in Tangier. So everybody was getting this rose-tinted vision of a European paradise that was forbidden to them. For some time, Tangier was a big existential waiting room. Thousands of people have died trying to cross the Strait. Now the city has other issues besides being a jumping-off place for immigration. There's a big push to develop the north, and real estate economics are driving everything in a kind of fast-forward transformation of the city.[30]

This is globalization at its worst, the imposition of a single vision on the whole world. The very nature of the one-way legal traffic in Tangier creates a bottleneck, physical and mental. Satellite images reinforce the idea of the 'free individual' indulging in a playground paradise. The idea of the Western self is being pumped up till the world is just one big inflated ego.

Barrada's *Tectonic Plate* (2010) puts Tangier's position in a different perspective. She has made a wooden map of the world. It has movable puzzle pieces, but the continents can only move along certain prescribed lines, those of the tectonic plates. The work

demonstrates that whatever border restrictions man imposes on man, the plates beneath are slowly moving and in 1.5 million years the Strait of Gibraltar will no longer exist. Africa and Europe will be one again.

I particularly enjoyed the sight of Barrada surrounded by children as it exemplified in concrete form what she does at the Cinémathèque de Tanger, but also illustrated her job at large. She is an ambassador for art. She is the embodiment of an art centre, but in Africa, where vast areas are virtually unserviced by the art market, this is not unique. Okwui Enwezor introduced me to Maha Maamoun (b. 1972, Egypt), who plays a similar role. There is a natural tendency around the world for young artists to wish to more be than, say, as in Maamoun's case, filmmakers and photographers. Maamoun is also a curator and founding creator of the Contemporary Image Collective (CiC) in Cairo. The main centres for contemporary art in the Egyptian capital, one of the biggest cities in the world, are artist-led initiatives such as CiC and the more famous Townhouse Gallery. The downside of the lack of art-market structure in Africa is that it is even more difficult for artists to make a living, but there is some compensation in that it produces artists like Yto Barrada and Maha Maamoun who have to find different ways to reach their audience.

Just after the toppling of the Egyptian president Hosni Mubarak in 2011, my family and I met Maamoun for tea at the Sheraton in Cairo. Although she had her cameras with her and had just been taking some photographs of bomb damage opposite the main museum in Tahrir Square, she was very calm. It is unfair to compare Maamoun to Barrada, as the circumstances of Tangier and Cairo are very different, but both artists have a sense of restraint and responsibility, a feeling that they must not make a false step as otherwise culture itself will suffer. This also places more pressure on their work.

Domestic Tourism (2005–6), Maamoun's two films and series of related photographs, expresses this pent-up energy behind the façade. There is one photograph that at first glance looks like a thousand postcards sent from Egypt. A felucca with a billowing white spinnaker sails gently down the Nile into the heart of Africa.

top
Maha Maamoun
Felucca
from the series ***Domestic Tourism***
2005-6, C-print, 24.6 x 74.9 cm
(9¾ x 29½ in.).

Africa is seen by some as one big postcard opportunity. Maamoun has Africa floating down the Nile.

bottom
Zohra Bensemra
Tunisian Woman, Hammamet
16 January 2011, digigraphie
on cardboard, 60.9 x 83.8 cm
(24 x 33 in.).

Two days after the deposition of Tunisia's President Zine al-Abidine Ben Ali, hundreds of people filed through the ransacked home of his nephew to show their contempt.

Yet the far shore of the river is obstructed by a floating city of thin, colourful walls and billboards: it is as though the whole of Africa has been transformed into a big funfair and is drifting down the Nile. In another image, a 'cliché' picture of *Cairo at Night* (2005), Maamoun 'intervened in the billboard images lighting up the skyline, so that all the billboards now displayed one image, that of a soft fatherly smile.' She describes the photo as 'an involved response to the authoritarianism, which is not solely or blatantly political, embedded in different forms of visual representation.'[31] As the camerawork is so measured, it took me some time to realize that Maamoun is not only community-minded; she also takes pictures that look like they have been put together by the community. The photographs remind one of postcards, as she shows us universal pictures. She might have more accurately filled all the billboards in *Cairo at Night* with a Big Brotherly eye, as though she had borrowed all our eyes to take her shots. We feel at home, and then she unleashes a disturbing element.

My route to the photographer Zohra Bensemra (b. 1968, Algeria) was perhaps more circuitous than most. I saw and read about her work in Okwui's 2006 exhibition 'Snap Judgments' in New York. He gave me her email address, but even though Deutsche Bank was interested in buying her work, I did not get any response, so a week or so later I sent her another email. She replied, explaining that she was travelling and I should deal with Ayperi Ecer, one of her bosses at Reuters. Practically my entire correspondence with Bensemra has been conducted through Ayperi and her team.

It is difficult enough to make a living as an artist anywhere in the world, but Algeria is certainly not the easiest place. In Bensemra's case, photojournalism has proved particularly risky, taking her into war zones such as Libya and Lebanon. Looking at her photograph of a woman standing in a bomb-shattered building, it is just as hard to say whether the image is art or reportage as it is to be certain what is window and what is bomb damage. Bensemra has travelled extensively in North Africa and the Middle East, but at the heart of it all is her own situation:

> To explain my relationship with my country, to talk about my Algeria, it was intended to show that it is difficult to remain neutral when it is one's very flesh that is being slashed.

The goal was also to say that Algeria, in the same way as a woman who is marginalized because she is different from others, is striving to find a solution to its problems, on its own.[32]

Since learning about Said and Barenboim's West–Eastern Divan Orchestra I have had a dream of an exhibition along similar lines. Despite the fierce antagonism between Israeli and Arab artists, there are several common threads between them, including the one that separates them – a lucid intellectual and political vigour. It would be good to see the prickly, literary work of Mona Hatoum (b. 1954, Lebanon) alongside the films of Yael Bartana (b. 1970, Israel) about the repatriation of Polish Jews to Poland (see p. 153). If I did not value my life, I would volunteer to put on such an exhibition, which would also contrast Hatoum's awkward structures with the magnetic drawings of Yehudit Sasportas (b. 1969, Israel), then set up the video *Evaders* (2009) by Ori Gersht (b. 1967, Israel) as a room of retreat. Given the panic the visual arts induced in him, Said was never likely to have been a candidate to curate this visual version of his and Barenboim's orchestra. He did, however, write a catalogue introduction about the woman who would have to be at the centre of any such visual bloodbath: the Palestinian artist Mona Hatoum.

It was the installation *Present Tense* (1996) that first attracted Said to the work of Hatoum, a Palestinian living in London and Berlin. Bars of soap make up the work's base, into which glass beads have been pushed to make an outline of a new world. It is a map made of soap. The choice of material is confrontational. Hatoum's soap is Jerusalem, a traditional Palestinian product made from olives. A neutral observer might want to interpret this is as an olive branch, but Said's words ring more true:

Ori Gersht
Evaders
2009, pigment inkjet print on aluminium, linked to film of the same title, 20.5 x 29.5 cm (8⅛ x 11⅝ in.).

A man retraces the path taken by the Jewish writer Walter Benjamin during his escape from Nazi-occupied France.

Hatoum's art is hard to bear (like the refugee's world, which is full of grotesque structures that bespeak excess as well as paucity), yet very necessary to see as an art that travesties the idea of single homeland. Better disparity and dislocation than reconciliation under duress of subject and object: better a lucid exile than sloppy, sentimental homecomings; better the logic of disassociation than an assembly of compliant dunces. A belligerent intelligence is always to be preferred over what conformity offers, no matter how unfriendly the circumstance and unfavourable the outcome.[33]

Said is not seeking conciliation here; he is not advocating peace.

The Light at the End (1989) illustrates Hatoum's dangerous, uncompromising stance. A grid of light greets the viewer at the far end of a darkened corridor. When I saw it, I thought it looked like a prison cell, containing, in my mind, political prisoners, so I did not go to take a closer look. Those who did could have been in for a physical shock, as the electric heating bars were totally unguarded. Hatoum had people like me worked out, for as she said, 'I come from a culture where there isn't that tremendous split between body and mind. When I first went to England, it became immediately apparent to me that people were quite divorced from their bodies and very caught up in their heads, like disembodied intellectuals.'[34] She gave me a good lesson on how I had neglected my own art compass for much of my life.

Other works like *Corps étranger* (1994) and *Deep Throat* (1996) show Hatoum's commitment to using her own body as a map: she is most famous for her desire to remap the world. She has made maps without borders, which of course is a delicious contradiction in terms. Some of her sculptures are composed of constantly shifting sand. She is questioning our foundations. Hatoum has described *Map* (1999), which is made up of almost 1,500 kilos (3,300 lb.) of glass marbles, as 'so unstable that even the geographical delineation of the continents cannot be fixed, since the simple movement of those walking across the floor will shift parts of it and threaten to destroy it'.[35]

While remapping the world is fruitful ground for Hatoum and others, such as her fellow Palestinian Oraib Toukan and Emirati

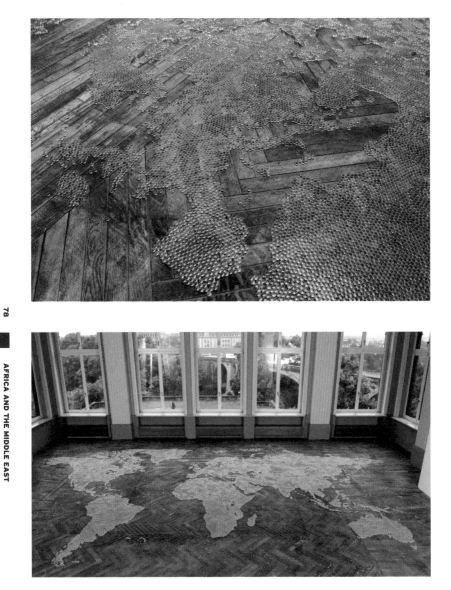

Mona Hatoum
Map
1999, 14 mm glass marbles,
dimensions variable.

Walking on Hatoum's map of
marbles, one soon realizes the
rockiness of our foundations.

artist Ebtisam Abdulaziz, understandably – as the very existence of their country depends on the defence of its borders – Israeli artists tend not to make new maps. Yet they are intensely involved in locating themselves in the world. Many of the large spidery drawings of landscape and architecture by Yehudit Sasportas were created by magnetic forces, as though the artist was trying to use a compass to locate herself. Walking into her exhibition in the Israeli Pavilion at the 2009 Venice Biennale, although it was very black and white, and although the sculptural and architectural elements were bold and chunky, I still did not really know where I was. 'I always lived in two worlds,' Sasportas recalls,

> the modern, mediated life of the western world, and the immediacy of experience in the world at home. My parents came to Israel from Morocco in 1967. We used to live in a modern habitation unit built in the '60s. From the outside it looked very anonymous; at that time, Israeli architecture sought to convey a uniform society. Our neighbours came from all over the world; outside was desert. I can still remember coming home from school and entering these anonymous projects, which inside resembled a crazy theatre: on the first floor there were people from India, on the second from Morocco, then people from Russia, from Georgia, and the only thing that connected them was the fact of being Jewish. This was like a 3-D simulation of a postmodernist structure. The more people feel disconnected, the more they need to compensate, to emphasize the culture they come from. Carpets on the wall, but far too many of them. It was always a bit exaggerated. The more they felt disconnected, the more there was.[36]

Sasportas may not be making maps, but her ambivalent relationship to codes and systems is close to Hatoum's. 'Structure is very important to my work, and at the same time it is an illusion. The minute one imposes a structure it immediately dissolves,' she says.[37] She may not have us literally walking on marbles, but her world is constantly changing, for, as she admits, 'one is as an artist constantly dissatisfied with what one realises. So one tries to fix and give a form to it, but of course the moment you fix something you have already lost it and you are on to the next place.'[38]

My ironic place of rest in this imaginary exhibition of Israeli/ Arab art is effectively given over to the ever-on-the-move master of the fragmentary, Walter Benjamin. The Jewish writer's attempt to escape the Nazis is the inspiration behind the dual-screen video *Evaders* (2009) by Ori Gersht. The video tells the story of man trying to cross a border. As the artist says, 'although it was filmed in the Pyrenees, I wanted to make an association to German Romanticism. [The landscape sings of Caspar David Friedrich.] In doing this there is an element of displacement and it suggests the cultural force that the figure in the film is trying to struggle against and that those forces keep on pulling him in.'[39] Gersht empha- sizes, however, that it is not a re-enactment of a historical event:

> The connection to Benjamin is that we were mapping and filming the same route. But the figure in my film is not pre- tending to be Benjamin. He is just trying to survive and walk through this journey in these extreme circumstances. There is one significant difference which for me epitomises the film. When Benjamin made the journey, he reached the border and could not cross and this border decided between life and death. In 2009, there was no border as such. All the checkpoints were deserted. So our journey was an absurdity because there was nothing to cross.[40]

For Benjamin there was no escape, as the Nazis controlled the border. Today there is no such barrier. The structure has melted away. Will the same happen in Israel? Benjamin killed himself in anticipation of his repatriation by the Nazis. In Gersht's film, on one screen the figure keeps disappearing in the mist and snow. A great mind is being snuffed out. On the other screen the man's heavy breathing speaks of crisis after crisis. How might Benjamin have chronicled his own death?

Perhaps the most disarmingly accurate new artist's map, politi- cally speaking, is *The New(er) Middle East* (2007) made by Oraib Toukan (b. 1977, USA). Although Toukan was born in America her family is originally Palestinian, and she has lived much of her life in Jordan. I saw her map at an event for Deutsche Bank staff in London arranged at a foundation that exhibits the work of artists from around the world, the Institute of International Visual Arts (INIVA).[41] The map consists of white foam magnets

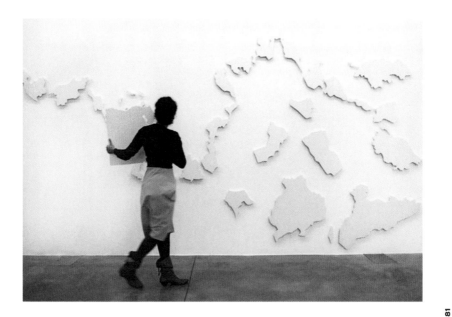

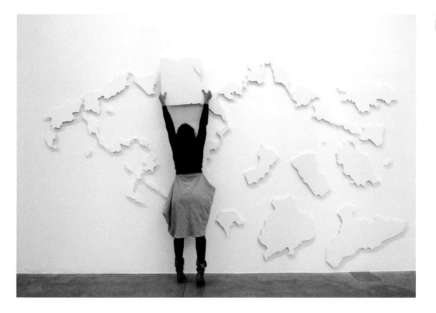

Oraib Toukan
The New(er) Middle East
2007, magnetic puzzle:
magnet and plastic, total area:
5 x 4 m (16 ft 5 in. x 13 ft 1 in.).

Toukan sets viewers the
challenge of rearranging
a map of the Middle East.

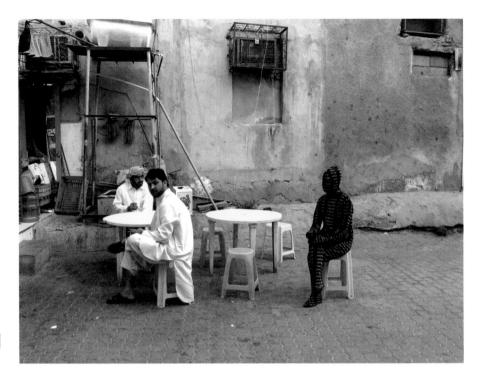

cut into the shapes of the seventeen countries of the Middle East. Visitors to the foundation were invited to fit the pieces together into one united form. When I walked in the door, two friends from the Bank were competing against each other to solve the puzzle. Half an hour later I lamented to the show's curator that I had not had a chance 'to play', so to cheer me up she whispered that the puzzle was insoluble.

The maps of Ebtisam Abdulaziz (b. 1975, Sharjah) are more posi-tive. There were no suitable art schools in the UAE for her, so she did a degree in maths. I met her for coffee at Third Line, her gallery in Dubai. Contrary to popular perception, it is as difficult to be as honest in art as it is in life, but Abdulaziz is a very straight artist. 'I hate lies,' she declares.[42] She acknowledges a debt to Lawrence Alloway's theory of Systemics, which describes an orderly way of making abstract art, but she has a freedom with theories that Alloway and the other theoreticians of the 1950s and '60s could never have had. Like the British artist Keith Tyson (see p. 188), she is making her art between the prescribed patterns of our way of life. She is suggesting new ways of thinking within the gaps in our conventional ways of thinking. Tyson maintains that maths is just a means of seeing patterns in the world, but that does not mean that either he or Abdulaziz are locked into each individual theory or formula. For her performance piece *Autobiography* (2003–7) Abdulaziz dressed herself in a body suit,

Ebtisam Abdulaziz
Autobiography, part 2
(production still)
2003-7, video, 5:54 minutes.

Abdulaziz discards the traditional chador for a body suit covered in bank statements.

as far removed as possible from the traditional Muslim chador, her normal attire. She was totally covered, but her identity was revealed, if you had the key, through a mass of numbers printed on the suit that were taken from her bank statements. As with Timo Toots's *Memopol* (see p. 164), there is an Orwellian shudder here. How are we defined by modern society? Merely as amalgams of data, as material consumption machines? Do we have any freedom to resist this? Abdulaziz wandered through the souks in her suit and she lay down and relaxed in public gardens. She is not happy to be judged by how much money she earns and spends. One reading is not enough. She makes this point most emphatically in her work that remaps the world.

Abdulaziz has transformed the letters of the Middle Eastern countries into numbers and grid references, turning geographical entities into geometric shapes. This simple transference of the countries, with all their historical baggage, onto graph paper gives them a new life in a pure mathematical world that is untainted by their colonial past and legacy. It is a big leap from the Conceptualism of the 1960s. 'I always hated geography,' the artist recalls, 'but I have now reduced it to numbers and mathematical shapes. I read and see enough about wars and the economic crisis, so I want to remap the world in a different way.'[43] She began her career in the arts as head of the Art Centre at the Sharjah Ladies Club. As with Yto Barrada, part of her practice involves being a human art centre.

Two years after visiting Abdulaziz, I returned to the few rows of large warehouses that make up the Al Quoz gallery district in Dubai to talk to the brothers Ramin (b. 1975, Iran) and Rokni Haerizadeh (b. 1978, Iran). There was more than a touch of pathos and voyeurism about the situation. A group of friends had been invited to listen to a conversation between the artists and myself at Gallery Isabelle van den Eynde. I am used to being a voyeur, but I felt like an intruder, so what must the other guests have felt? In the gallery, the brothers had recreated their home and studio in Dubai, which in turn had been created in the spirit of their original home and studio in Tehran. This really was a home from home, carried lovingly on their mental shoulders from Iran. Every inch of available space was covered in wallpaper paintings, framed paintings, sculptures, and *objets*

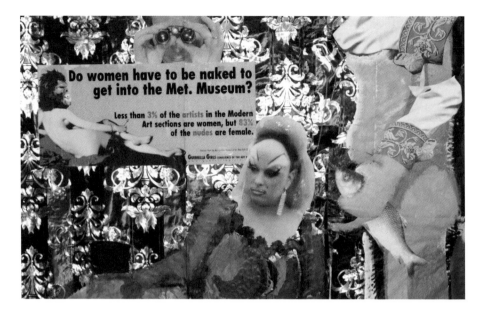

Do women have to be naked to get into the Met. Museum?

Less than 3% of the artists in the Modern Art sections are women, but 83% of the nudes are female.

GUERRILLA GIRLS CONSCIENCE OF THE ART Y

d'art and not so *d'art*. They brought everything with them. The gallery was their second home, or perhaps even their third or fourth home. Their home was in exile.

In Tehran, the Haerizadehs were forced to live behind walls. 'People have to hide their true characters to go around and do their business, so everything is done in privacy behind closed doors,' explains the elder brother, Ramin.[44] The brothers made art together, and with their friend Hesam Rahmanian (b. 1980, USA), when they were children during the Iraq–Iran War. 'There was no television, no other form of entertainment, so we drew,' says Ramin.[45] Rokni went to art school and then set up a studio. His brother came and worked in the studio with Hesam, and others dropped in to join them. 'It was like a factory,' Hesam claims, but it was a lot less dictatorial than Andy Warhol's Factory.[46] After their art began to receive international attention they moved to Dubai and set about transforming their new home into one large collage, not only covering the floors and walls around paintings and photographs, both by themselves and other artists, and making sculptures to set beside found objects, but also making a video of the interaction. 'We have two lives traditionally – the Qur'an speaks of the spiritual and moral aspects, and "1001 Nights" of daily life – but when it came to art, just one side emerged,' Rokni comments, explaining why the oppressive regime in Iran today forced him and his brother to leave their own country.[47] For Ramin, art is likewise a way to break through the 'layer of holiness' that he claims covers every act of daily life. He expresses himself in the third person, like Ming Wong (see p. 126) or Yto Barrada in *Hand-Me-Downs*.

Ramin and Rokni Haerizadeh, and Hesam Rahmanian
Untitled Banner (13)
2012, mixed media, plastic sheets and found objects, approx. 185 x 135 cm (72⅛ x 53⅛ in.).

The Haerizadeh brothers and friends have used every inch of their home/studio to create a world in which art becomes synonymous with everyday life.

The starting-point of his collages is the work of Shirin Neshat crossed with Qajar theatre and Taaziyeh religious passion plays, in which women were prohibited from performing. 'To reveal myself,' admits Ramin, 'I have to play all the characters that society asks us to conceal.'[48]

The Haerizadehs and Rahmanian are influenced by film as much as by any other medium. Images stolen from cinema stare back from their walls. Hesam explains that their daily routine involves sitting down after a meal at the end of the day and watching a film. In their work they plunder the vocabulary of such well-known directors as David Lynch, Lars von Trier and Krzysztof Kieslowski, but they also benefit from Iranian filmmakers' rich integrity and a sense of time that is a million miles from Hollywood. 'Iran has traditionally been a country that values craftsmanship,' explains Ramin. 'Cinema became a universal language for Iran when directors such as Abbas Kiarostami displayed the craftsmanship of the medium. We too freeze time, and if I was to choose what time to freeze, it would be the future.'[49]

It was the Iranian Revolution of 1979 that forced Shirin Neshat's family to flee, but the Haerizadeh brothers had to leave Iran because of their art. Although Tehran is the most significant cultural centre in the region, Ramin's parodies of Neshat's work touched a homophobic nerve in the Iranian regime. His rough *Men of Allah* (2008) series echoes her *Women of Allah* (1993–97), except his collages depict men in drag. His *Sweet Shirin* (2009) has hardly departed from Neshat's photographs of women toying with weapons against walls of calligraphy, except that it is his own hairy face that stares back at us.

There is a timelessness to the work of Neshat and the Haerizadehs that appears to be a common thread in Iranian art. Similarly, time and changing values provide the subject matter for Shadi Ghadirian (b. 1974, Iran). Rather than leaving Iran, Ghadirian found her source of inspiration deep in the vaults of Tehran's Golestan Palace, where she worked with the museum's collection of photography. (The collection is one of the finest in the world, as the rulers of Iran embraced photography when it was invented back in the mid-nineteenth century. Nasser el-din Shah, the Qajar king between 1848 and 1896, had twenty thousand

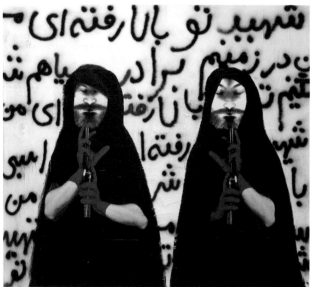

photograph albums.) Ghadirian used this collection as a start-
ing- point for her *Qajar* (1998–2001) portrait series. She dressed
up her friends like ladies of the nineteenth-century Qajar court
and asked them to re-enact the poses in the old photographs, but
then added to each scene a single item from the modern world,
such as a ghetto blaster, a vacuum cleaner or a guitar. My first
take on the photographs when I saw them at the Saatchi Gallery
in London was that they were a screeching cry for women's
rights. They are still screeching, but I have come to realize
that there is more to the images. 'My pictures became a mirror
reflecting how I felt: we are stuck between tradition and moder-
nity,' Ghadirian says.[50] She is committed to changing the world:

> I am trying to say that we have been given the benefits of
> modern technology, now we want the benefits of modern
> values...As a woman and as an Iranian, I find that we are
> changing – we are not timeless. We too are part of a con-
> sumer culture – we drink Pepsi and use vacuum cleaners...
> I am also looking for an Iranian filter of modernity. Change
> is an inevitable process.[51]

In the *Qajar* series, most of each picture is devoted to a tradi-
tional view of womanhood. There is only a single modern item
disturbing each image, along with the determined expression of
its subject. *West by East* (2005), a series in which Ghadirian acts as
a censor by using a black marker pen to obliterate the 'offending'
parts of 'immoral' Western women, is an attack not specifically
on traditions but rather on the artificial barriers put up to defend
traditions – not just by the censors but by most of us.

Ramin Haerizadeh
Sweet Shirin
2009, mixed media on
canvas, 200 x 220 cm
(78¾ x 86⅝ in.).

Gender roles are reversed
and confused in Haerizadeh's
take on Shirin Neshat's
famous photographs.

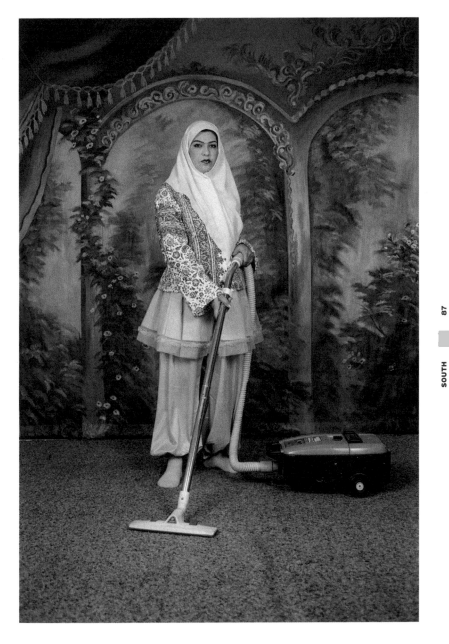

Shadi Ghadirian
Untitled
from the series *Qajar*
1998, C-print, 213 x 152 cm
(83⅞ x 59⅞ in.).

Ghadirian bases her work on old
photographs from Tehran's Golestan
Palace in order to comment on
the complex relationship between
tradition and modernity.

I was stopped in my tracks at Art Dubai in 2012 when I saw a film of a canary trying to escape suffocation in a glass cage. *Flight* (2008) by Morteza Ahmadvand (b. 1981, Iran) shows how easy it is to snuff out the desire to make a new world. It is a warning that can be taken in many ways. Is the artist demonstrating what might happen to informers who 'sing like a canary', or is the film a reference to the canaries that used to be taken down mines to detect poisonous gases? The miners were safe as long as the canary was singing. This canary is definitely dead by the end.

Ebtisam Abdulaziz helps me to justify why I have included so many Iranian artists in this book. Her sculpture *Re-Mapping* (2010), which was placed outside the entrance of Art Dubai in 2010, outlines the cultural importance of Iran. Once she had reduced the seventeen countries of the Middle East into geometric shapes by mutating the letters in the countries' names into grid references, Abdulaziz represented the countries in three-dimensional form, with their height in proportion to the wealth of art within their borders. In this financial valuation Iran towered above the rest. This explains why Iran is seen as the flag-bearer of the region in fighting the once all-pervasive invasion of Western, and particularly American, culture. After all, there are very few cultures that can be seen in such blatant opposition.

Morteza Ahmadvand
Flight (video still)
2008, video, 2:48 minutes,
edition of 5.

The life of Ahmadvand's canary is snuffed out in its attempt at flight.

Despite her irritation at being defined so tritely, it is this tension between her adopted and native countries that helps make Shirin Neshat such a powerful artist. Similarly it has made the Iranian-American painter Kamrooz Aram (b. 1978, Iran; see p. 47) explore ideas in painting that have been neglected by others. One can clearly see two threads in his work: the pleasure in ornament and the greater pattern of life competing against individual angst. At the moment it is rare to see both in a single canvas or drawing. As he produces new paintings, I wonder whether he has fused the two ideas. I have even started asking whether it is possible any longer to contain these clashing spirits in one work, whether his work should not be seen as a continuum, but deep down I expect one day to be presented by him with a work of art that does everything. 'I have never thought about trying to achieve everything in one canvas,' he claims.[52] I am still thinking of a series of his paintings. When he first showed them to me on his mobile phone at Art Dubai, my senses were seduced, but I believed the series to be too limited to one thread. They are large paintings, over 2 metres (6 ft 6 in.) square. The one that remains in my head, *International System II* (2012), has a violet background, although there is not much background as a huge green-to-yellow flower fills the canvas. But it is not a real flower. When I first saw the painting I flirted with the idea that this flower might be origami, but it is made of more solid, stalagmite strips. Its colour indicates jade or some soapstone, but it is more synthetic. Staring at this seductive pattern, I wondered what on earth had made such a serious man as Aram spend hours painting it petal by petal, or icy stalactite by stalagmite (there is no way of knowing which way up they are). The initial elation at the seduction turns to ennui. I am bored of this disease that makes us find patterns everywhere, this love of binary systems, everything reduced to yes and no – yes to the ghetto blaster, no to the time-honoured aesthetics of Qajar, yes to flight, no to the singing canary. This tick-in-the-box way of life, which is reinforced by the basic mentality of the computer, aggravates my perverse nature. No system satisfies. Why can't I just throw up my hands and give in to the red hole in the middle of the flower? It could be reduced to Freud, but it is more than that. Aram's painting takes me on a journey that mirrors life.

I devote the conclusion of this chapter to South African artists. Thematically they do not particularly fit together, except in that

Kamrooz Aram
*Backdrop for
an Anxious Interior*
2012, oil on canvas,
152 x 137 cm (60 x 54 in.).

The gentleness of Aram's
picture disguises its
repressed ambition to
incorporate decoration
into mainstream painting.

they set my art compass moving sporadically in the way that
the very ground moves in William Kentridge's animated films.
Kentridge (b. 1955, South Africa) is one of the world's most pow-
erful artists, but he is only following in family tradition: his father
was an anti-apartheid lawyer. His films remind me of the paint-
ings of Anselm Kiefer (b. 1945, Germany): the scorched earth, the
power instilled in the environment, the grand crumbling archi-
tecture. Both artists are archaeologists, sifting through mounds
of mud to find meaning. They never jump to speedy conclusions;
indeed, the land always wins, reclaiming its own timeless dignity
from the horrors of history. Kentridge draws then erases, draws
then erases. His is a constantly flickering world. One can see the
undergrowth growing. He has the earth's surface heaving with
unrest before, rather like the editor of a photojournalist, marking
in red the unseen war graves. He treats people with no more and
no less respect than the ground on which they walk. His figures
have a rock-like character, as in some early cartoons such as
Captain Pugwash, yet he counters this with the cloth, constantly
wiping away not only his hard-won yet vulnerable charcoal
images, but also our preconceptions of identity.[53]

Kentridge manages to keep on giving us very specific messages
(his early work was emphatically against the apartheid regime in
which he was brought up), yet he is a master of constant change
and ambiguity. This is summed up when the words 'That which
is not drawn' flicker up in the animation *Other Faces* (2011). His
technique of rubbing out makes us more aware than usual of
what has been and what has been destroyed, of what is there but
cannot be clearly stated. The title of the film reflects the fluidity

William Kentridge
Sighs and Traces
2012, charcoal, chalk, coloured
pencil and Indian ink on book
pages from Workshop Receipts
pinned to Velin d'Arches,
400 gsm, 122.5 x 102 cm
(48¼ x 40⅛ in.).

The identity of both Kentridge's
characters and Africa changes
before our eyes.

between the people depicted. They appear and disappear like sand. Kentridge wallows in contrasts, so, for instance, in *Felix in Exile* (1994) the white man in his cell-like bedsit in Paris is erased and replaced by his black female alter ego, complete with a sextant, reorientating Africa. The sextant keeps on changing hands, as does the artist's great camera, which has a life of its own.

Themes blur into each other in Kentridge's work before recurring again in the same work, and yet again in another film or drawing. Men and women look at each other through opposite ends of the telescope. Black and white study each other and then mutate. In a reference to the massive study of African bodies by nineteenth-century German colonialists, the attempt to understand 'European supremacy', the artist depicts men analysing skulls, drawing them and redrawing them until they turn into globes.

Kentridge is still not as well known as he should be, but that is partly due to the vagaries of the art market. Jo Ractliffe (b. 1961, South Africa), while critically accepted, is one of the art world's secrets. Again this is partly because of her choice of medium. Though haunting, her black-and-white photographs of Angola in the series *Terreno Ocupado* (2007) give more away through their omissions than their content. As Okwui Enwezor writes, 'A remarkable aspect of Jo Ractliffe's work is the idea, pursued with relentless asperity, that photography, above all else, is a way of seeing; that it is much more than it depicts.'[54] In the series, Ractliffe depicts an abandoned world. It is as though she has consciously dislocated herself in case she upsets the tortuous line between the colonial past and herself. 'What I'm trying to do is not speak about an experience or history I'm not sure I can claim as mine, but about my desire to recover my own experience and space/place – albeit seemingly petty, ordinary or small – within that history.'[55] In Angola she photographed reminders of the past: a crumbling map of Africa in an abandoned school, for example, or tile murals depicting Portuguese explorations in an equally ruined fortress. The ceramic rendering of the guilty pleasures of colonial plunder is damaged, but the mural image of a bare-bosomed woman amid the undergrowth is still as potent as ever.[56] Ractliffe darts and weaves between our thoughts. Her photographs operate like those left-behind wall tiles. They remind us of the forgotten places in our convenient memories.

Hasan and Husain Essop
Suguud, Closest to God
2007, lightjet C-print on Fuji
Crystal archival paper, 84 x 118
cm (33⅛ x 46½ in.), edition of 5.

Some will take this ironically,
others as a vision of a self-
effacing community.

In talking about the South African artist Zwelethu Mthethwa earlier I mentioned Ubuntu, a concept that recurs in many African cultures in slightly different forms. The origin of the exploration of the self by the twins Hasan and Husain Essop (b. 1985, South Africa) is more connected to the Muslim faith and its juxtaposition with Western traits, but the pair could almost be defining Ubuntu when they say, 'As twin brothers we have set out to find ourselves in each other.'[57] I first saw their work up several staircases in central Cairo in the apartment-cum-gallery space that is CiC in the spring of 2011, and since then I have noticed them at practically every art fair.[58] From their first series of works, made while they were studying at the University of Cape Town, they have played with multiple images of themselves.[59] 'Our work is quite surreal,' they admit, 'in the sense that in some photographs it is impossible for it to be reality. It's fake – there are five of us.'[60] There seem to be many more of them – there is a legion of similar bodies lined up in *Suguud, Closest to God* (2007) – but we, the audience, gain from their genuine desire to find themselves in each other.

In the photograph *Cape Town, South Africa* (2009; see p. 204) the twins stand on one of the southernmost walls of Africa, staring south. In the right-hand twin's pose there is an echo of the defiant confrontation with nature depicted in Caspar David Friedrich's painting *The Wanderer above the Sea of Fog* (1818).[61] This twin has put down his bag to embrace nature. On the left his brother looks down nervously, his hand grasping his hold-all, as though doomed to a life of drudgery, of not being able to experience his environment, of always being on the treadmill, unless he jumps and ends it all. But, as the twins maintain, our individuality is not based on a straight polarity: there are more than two options.

EAST
● ASIA

China invoked its old faith in numbers to proclaim its domi-nance over modern times. At eight in the evening on the eighth day of the eighth month of the eighth year of this millennium, Cai Guo-Qiang (b. 1957, China) orchestrated the fireworks for the opening ceremony of the Beijing Olympics. Cai has built his career around pyrotechnics, with gunpowder and fireworks playing a similarly revelatory role to that of African masks and sculpture for Picasso. Both artists use an earlier 'primitive' art to reinvigorate their work.

As the black powder delivered its patterns of light into the dark virgin sky, the debate about globalization and post-colonialism was probably far from the minds of the over one billion viewers watching on television. The display was called *Footprints of History* (2008): the fireworks erupted from twenty-nine spots along the Olympian path to symbolize the previous host cities. This can be read as basic linear history, but it has its roots in Cai's gun-powder drawing *Bigfoot's Footprints: Projects for Extraterrestrials No. 6* (1991). Big-foot yeti and humans look remarkably similar from outer space!

The choice of time to launch Cai's fireworks at the Olympics must have been made in consultation with countless others. The eighth hour of the eighth month of 2008 appears to be an aus-picious point at which to begin the Asian chapter, but this is a chronologically confusing story, not helped by the fact that I met Cai only recently, in 2012. When we did finally talk, despite the sense of anticipation and drama, I felt I already knew him. He has been working closely with Deutsche Bank and my colleague

Friedhelm Hütte over the last ten years. In one sense this is a back-to-front relationship, but in another it is very natural, as the main way most artists reveal themselves is through their work.

While installing a small show of Cai's work in the Deutsche Bank Lounge at Art Hong Kong, I had a burning question I wanted to ask the artist about one of his earliest gunpowder drawings *Self-Portrait: A Subjugated Soul* (1989), yet the process of asking this question involved more than a week of meetings and communications.[1] Museum shows take days and even weeks to hang, but, like most other art fairs, Art Hong Kong is located in a purpose-built trade-fair hall, so there is very little time to do anything special. The Hong Kong Convention and Exhibition Centre is better positioned than most such buildings, with good views of the harbour from the large windows on its outer corridors. I arrived on a Sunday when the space was nothing more than a shell with hundreds of staff scurrying around to build a couple of thousand walls. A charming man flew in from Japan to supervise the hanging.[2] *Vortex* (2006), Cai's 9-metre-long (29 ft 6 in.) gunpowder drawing on paper, was unwrapped and laid out flat overnight. A system of barriers was created to protect it and an extra security guard came for the night. Within thirty-six hours the Japanese supervisor had the show up and ready. At 8.30 p.m. I was just about to go to a big rooftop dinner for a host of Hauser & Wirth's star artists, including Zhang Enli, Subodh Gupta and Bharti Kher, when I was informed that the man himself had arrived at our booth.[3] We had made the lighting a little melodramatic to give our guests shelter from the super-bright light

Cai Guo-Qiang
Footprints of History: Fireworks project for the Opening Ceremony of the 2008 Beijing Olympic Games
Beijing, 8 August 2008, fireworks.

Cai used fireworks, one of China's oldest art forms, to make new art.

of the rest of the fair, so I arrived to find Cai's bald head catching the light: he was centre stage among a small entourage.

Although Cai has spent much of his time since 1986 living outside China, first in Japan and then in the USA, he is accompanied constantly by a translator. The message is clear: he is a Chinese artist. It enhances his aura of a statesman. As I walked across the darkened space towards him, his smile told me he was a man of the people. We said hello in English. He was friendly, and his translator, Chinyan Wong, took me aside and informed me how pleased Cai was with the installation, that he had been planning on coming in first thing the next morning to make the final adjustments, but as he was happy there was no need. Chinyan's involvement in the exhibition had been signalled from her first email, signed 'Project Manager', but her fuller significance only emerged with each meeting. We had several three-way conversations, but while both she and Cai seemed to listen with interest to my theory that Cai was pioneering a new Chinese modernism, they refused to be drawn. I felt like a little boy throwing a stone into a pond. The splash of my words was too loud, too one-way; I sensed at once that I would have to wait for the ripples. There was not the usual instant gritty resistance of an artist defending his borders, until I raised the issue formally at the end of a presentation Cai made to fifty members of Deutsche Bank's staff. He showed films of his works, which he explained in Mandarin, with Chinyan translating into English. They managed to get a succession of laughs in both languages. The early self-portrait I wanted to talk about came up. 'As a young man I was rebellious,' Cai said. 'I was rebelling against my overly cautious and conservative self-image, so I blew myself up.'[4] This brought up the question I had been trying to formulate all week: was it the Western idea of self, or the Eastern idea, that Cai was wanting to blow up in *Self-Portrait: A Subjugated Soul?*

In the 1980s Cai did not seem a particularly Chinese artist, but with the benefit of hindsight he could be seen to be in the process of reinventing himself with *Self-Portrait*. 'The act of exploding my self-portrait was an act of rebellion in my adolescence, and it was an act of resistance towards the repressive social climate at the time,' he admitted at the presentation. 'But my concept was rooted in the idea of construction through destruction, and

to create new life from thence.'[5] In 1998 he produced a series of miniature bomb explosions, lasting a minute in total, to initiate the renovation of the Taiwan Museum of Art. He called it *No Destruction, No Construction*, which stated the equation bluntly: without clearing away the past, the new cannot be built. He was blowing up the obstacles to the future. Yet the event came with baggage: in its title, Cai was paraphrasing Mao Zedong. There is a dramatic change of emphasis between *Self-Portrait* and *No Destruction, No Construction*, made ten years apart. Cai is not only confronting the changes in his own country; he is also identifying himself firmly with them. Being Chinese is being at the heart of change.

It is possible to interpret *Self-Portrait* as a straightforward protest against the subjugation of the individual and his rights. Yet I am convinced it is more complicated. The blowing-up of the self in Cai's work is similar to the attack on the self in the mirrors of Lee Yongbaek (b. 1966, Korea; see p. 123). Traditionally in the East there is a respect for the idea of constantly remaking oneself. Back in the 1980s Cai was doing this by looking at prehistory as a true modernist. This need to look back was heightened by the removal of a chunk of his country's history in the form of the Cultural Revolution (1966–76). Yet Cai, as ever, expressed it far more diplomatically: 'You are absolutely correct in saying that the forms in my early paintings are closely related to those in prehistoric drawings. During the '80s, I often visited sites with cave carvings to make rubbings. I was trying to find a primordial spirit and soul in my own drawings, so the resemblance between my early work and prehistoric drawings is not a mere coincidence.'[6] After my conversations and communications with Cai, through Chinyan, I do very much feel I have been talking to more than one person. There are many press offices for large organizations that could learn from the way the Cai studio handles requests: they give considered responses to individual questions rather than didactic statements. Cai is not a solitary artist isolated in his studio. Not only does he collaborate with countless other people to prepare his work, but he also makes us feel that we are all vital to the work.

Cai's choice of prehistoric drawing goes beyond a modernist tendency. The Chinese Cultural Revolution stopped history dead.

Yan Pei-Ming
Execution after Goya
2008, oil on canvas, 280 x 400.7
x 6.7 cm (110¼ x 157¾ x 2⅝ in.).

Yan has an alarmingly direct
approach to easel painting.

Everything outside the present was prehistoric. Cai felt like any Western rebellious youth might, but the gap in his own history continued to work on him until, as he says, 'I returned to China [from living abroad] to find my own history was like an alien culture to me.'[7]

This sense of dislocation has been used by several other Chinese artists. Yan Pei-Ming (b. 1960, China) left China even earlier than Cai, aged nineteen, to live in France. His brand of modernism feeds off Western art history, so apart from visits back to his homeland, he has remained in his Dijon studio. There is an element of reverse modernism: just as Manet once exploited Japanese woodcuts, the artist from the East now makes use of Western easel painting in a similar way. When Yan was given an exhibition at the Louvre in Paris in 2009, he made a portrait of his father and placed it next to the *Mona Lisa*, as if to acknowledge his painterly ancestry. His thick encrusted paintings are bichromatic, with the majority being black and white, but with the occasional foray into red for such 'dangerous' colonial clashes as his *Execution after Goya* (2008).

Although made in France, Yan's large canvases are slightly out of sync if perceived in a purely European context. He emphasizes this dislocation in talking about his landscapes: 'This is an international landscape and thus we don't know where we're located.'[8] One would naturally associate his direct figurative style with

the zeitgeist of the 1980s, but that would misrepresent it. His teacher and still close friend is that most stringent of Conceptual artists Daniel Buren (b. 1938, France). Yan's work is far removed from Buren's, though, except in its simplicity. The reduction of colour is a clue to his aims, and it gives his paintings a news-like quality, as though they are delivering short, sharp messages. 'At home I only ever had black and white televisions,' Yan says. 'Today, colour is everywhere. Only black and white allows me to go back to my world. I am interested in the picture, writing and expression, the subject itself, the painting. Colour for me is a sort of ephemeral firework.'[9] What is his world? It is a world that started from scratch, as his most famous series reveals. He began making large portraits of Mao in 1987 and the paintings were exhibited under the title 'My Story Began with His History'.

For a country obsessed with the new, the word 'history' crops up rather frequently in contemporary Chinese art: in the title of Yan's exhibition, in Cai's *Footprints of History* and in *The History of Monuments* (2009–10) by Wang Qingsong (b. 1966, China). Wang confronts his fellow Chinese with the once invisible wall of history. The format of the work could not be more traditional: it is a 42-metre-long (almost 138 ft) frieze that could happily be wrapped round a Classical temple. Yet all of these references to history are sidelong, rather than confrontational like Cai's *Head On* (2006), which can be interpreted as an indictment of super-stition or the exact opposite, modernity crashing. Cai made ninety-nine beautifully furry replica wolves and suspended them mid-charge through the air. It is a magnificent, magical sight until one gets to the front where the leader of the pack, bigger and more magnificent than the rest, lies sprawling on the floor under half a dozen of his immediate followers. The wolves all continue to crash into the glass wall that their leader did not see. 'I wanted to depict the universal human tragedy which

Wang Qingsong
The History of Monuments
(detail)
2009-10, C-print, 1.25 x 42 m
(4 ft 1 in. x 137 ft 10 in.).

Like a Classical frieze, Wang's massive photograph seems to be talking of an ancient past – that is until one examines the mud-clad figures more closely.

results from storming ahead blindly, the uncompromising way we try to achieve our aims,' Cai says. 'In Zen there is the notion of "tragic beauty", which is based on the fact that most of these actions are completely senseless.' The wall in *Head On* is a glass one; throughout his practice Cai emphasizes that the most difficult boundaries for us to overcome are the unseen ones, the ones we create in our minds.

The collision of cultures has many results, from minor misunderstandings to catastrophic wars. I had some sympathy with the Chinese government when *Art Review* put Ai Weiwei (b. 1957, China) top of its 'Power 100' list of 2011. The government statement declared, 'China has many artists who have sufficient ability. We feel that a selection that is based purely on a political bias and perspective has violated the objectives of the magazine.'[10] The state had given Ai, alongside Herzog & de Meuron, the prestigious commission of designing the Bird's Nest stadium for the 2008 Olympics, but the truth is that it has been politics, not art, that has brought him success. The irony is that there are many more radical artists who are seriously challenging the way we live our lives. On the merits of his art alone Ai would not have been mentioned in this book.

So far this chapter has concentrated on China, and yet Asia is the most diverse and fast-changing continent in the world. I am now going to let you get lost with me in the backstreets and byways of Delhi looking for the studio of the Raqs Media Collective, a group of three artists: Monica Narula (b. 1969, India), Jeebesh Bagchi (b. 1965, India) and Shuddhabrata Sengupta (b. 1968, India). I took a half-hour taxi ride through the broad twentieth-century boulevards of the Lutyens-designed colonial centre of the empire to an older vision of India. The streets narrowed as I approached the urban village of Shahpur Jat, which has partially escaped the city's zoning regulations and as a result has become popular with artists. The taxi driver could not find Peacock Lane, my destination. I felt like we were in a scene from a thriller – life was closing in. The houses may have been smaller, but the walls were starting to lean in on us, seeming to grow taller with the history of the area. We were on the site of the fourteenth-century citadel Siri, which was built by the Turko-Afghan king Alauddin Khilji. My driver

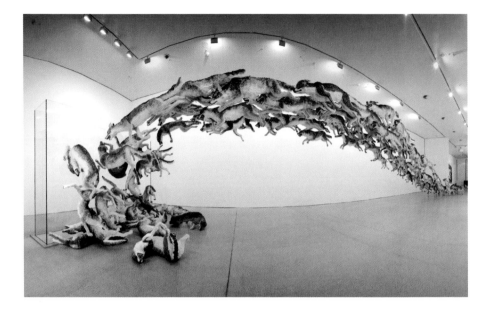

was getting more anxious as the walls threatened to scrape his paint. I was cross with myself for forgetting the stories of massacre, love and sacrifice linked with Khilji. Although bicycles, scooters and people were coming at us from all directions, it was as though the round red bubble of the car was in a one-way stream that led nowhere. The driver put on the brakes when the street widened to let another alleyway lead off diagonally backwards. I telephoned the studio and Monica said that Jeebesh would come and look for me, but once the car had made its escape, as I am tall, I felt remarkably static and alone in the crowd, like I was a dead stone sculpture in a whirling pool of life. I did not know whether I was in the old India or the new one. I took a few conspicuous steps in search of a street name. I was in neither the fourteenth century nor the twenty-first. Was that Jeebesh coming out of an ordinary blue door? I had met the group briefly after a panel discussion at Art Dubai two years earlier,[11] but on that occasion I had only talked to Shuddha and Monica, so I was not sure I would recognize Jeebesh in this sea of faces.[12] Even though he is striking, my doubts were proven correct: the figure in the doorway was not him. I strode purposefully down another street, trying to tell myself that I was as alive as everyone around me. I looked up to search for the nonexistent street sign and bumped into someone. I looked down into a smiling face and was about to say hello to Shuddha, but then realized it wasn't him.

I am normally relaxed about interviews, as I hope my interviewee soon realizes that I genuinely want them to explain themselves, but I am not used to interviewing groups of people, and certainly

Cai Guo-Qiang
Head On
2006, 99 life-sized replicas of wolves and glass wall, wolves: gauze, resin and painted hide, dimensions variable.

The worst boundaries are the hidden ones.

not three such intellects. My interviews are usually casual one-to-one conversations. Raqs's panel discussion in Dubai had a smooth impenetrability, rather like a late-night culture programme that had already been recorded but speeded up in the making, as the protagonists knew each others' positions so well that they were desperate to reel off every cog in the argument in order to find a morsel of uncovered ground. Was I going to be able to keep up? I would not be able to scribble down my usual notes and have a four-way conversation at the same time. In this nervous state I was jumping to conclusions too quickly, seeing Jeebesh and Shuddha at every colourful corner. I did not expect to see Monica yet, so did not conjure her up out of the milling crowd.

Then suddenly Jeebesh was shaking my hand – the real Jeebesh. I followed him off the street and up a couple of flights of wooden stairs into a room that could have belonged to a graphic design company. Monica greeted me and offered me coffee. It wasn't a studio, but it wasn't a home or office either. The spaces were not clearly defined and I did not know whether I was in a living or working environment. The kettle boiled. Jeebesh sat on the sofa by one wall and Shuddha sat closer, on an upright chair on the other side of me. Although I was sitting opposite Monica, she occupied the table between us as though it were a desk, a large partner's desk.

Small talk does not stay small for long with Raqs: it suddenly offers different avenues. I idly commented on the strange hexagram pattern on which the centre of Delhi is laid out and Shuddha informed me it was a Masonic symbol. This sent a shiver through me. A half-remembered conversation came back to me from my childhood: I was sitting listening to my imperialist grandmother talking about colonial Delhi. She had no patience with Freemasons so would have poured scorn on Shuddha's theory, but sitting in Delhi with three free minds, the thought of this antiquated, constipated network of thinking being imposed on India barely a hundred years ago scared me.[13]

Luckily, escaping from the oppressive system of time is one of Raqs's main themes, and we were soon talking about their series of works that includes the installation of twenty-seven clocks *Escapement* (2009).[14] There is an element of those rows of clocks

on airport walls relating international time. Indeed, Raqs's clock hands do refer to different time zones, but there are no numerals on the faces. The 'hour' numerals have been replaced by words for feelings such as 'guilt', 'panic', 'duty' and 'ecstasy'. As the artists declare collectively, 'Each word takes you to a different place, to a different emotional station.'[15] *Escapement* has been installed in different versions, but there is always one clock that does not function like the others. In one variation it goes backwards at a wild World's End speed.[16] The structures on which we rely are not always reliable. Raqs find holes in the systems that rule our lives, not just for negative critical reasons but in order to address our limitations. As they say, '"Escapement" is a very special word…We like its connotation with escape. "Escapement" is about escaping as well as being bound up in time.'[17]

The very name Peacock Lane seems to conform to Edward Said's idea, expounded in *Orientalism*, that Westerners are incapable of seeing the East in anything other than a condescending way because of their imperialistic conditioning. Working on a book called *The Global Art Compass*, which is constantly feeding off a sense of balance and imbalance, proximity and distance, I am in obvious danger of perpetuating the myth of the exotic East, yet as I sat in the comfortable no man's land of their space, Raqs came back at me quickly when I broached the subject of post-colonialism. 'Edward Said produced a set of questions that made Westerners examine their own self-assumptions, but we don't think these movements were ever only in one direction. There have been plenty of times when Westerners have been considered exotic savages.'[18]

Raqs certainly attack the legacy of colonialism, but the artists are even-handed in their assault on the sanctity of philosophies and the myriad thought structures that try to contain us. Before attempting to describe their way of thinking, I will leave those anxious early moments of our interview on the second floor of Peacock Lane to try to give an understanding of some of the artists working within the post-colonial debate out of which Raqs emerged.

The award for the most wittily aggressive anti-colonial work goes to Wong Hoy Cheong (b. 1960, Malaysia). Wong certainly

Wong Hoy Cheong
Jeannie
from the series *Maid in Malaysia*
2008, Duratran lightbox,
150 x 300 cm (59 x 118⅛ in.).

During the 6th Taipei Biennial
Wong's *Jeannie* lit up Zhongxiao
Xinsheng MRT Station. Thousands
of underpaid maids send home
their hard-earned cash, but
dream of a different world.

dwells on Western savagery in his assault on the colonial legacy, its trail of economic, cultural and actual slavery. He made a series of photographs, *Maid in Malaysia* (2008), that depict exploited Indonesian and Filipina maids as different female cultural icons: from the Virgin Mary and Florence Nightingale to Mary Poppins and Lara Croft. Although maids send home over US$10 billion a year, Wong sees them as 'enslaved and abused'. He is an example of an artist taking full advantage of the break with the classical linear understanding of art history. Finally we have the embodiment of Baudelaire's sense of freedom, the enjoyment of breaking with the establishment view of the past and present. Although Wong does not believe 'in the modernist notion of singularity…in progressive linear development', he is not a postmodernist; he merely refuses to conform to a single theory.[19] He engages with the welter of structures that dominate modern life and cavorts in the cracks between them. He rejects the narrow confines of Clement Greenberg's modernism but admits to an admiration for the Abstract Expressionist painter Hans Hofmann's 'push-pull' ideas of the same era – not specifically the way different colours have different impacts in space, some pushing, some pulling, but more the interaction between apparently unrelated forces.

Wong has also created one of the hardest-hitting but funniest works of the century. To make *The Colonies Bite Back* (2001) he took a pile of British school textbooks with condescending old imperialist titles, such as *Great Men of the East*, and fed them to

termites. He then used the pulp and shredded books in a series of intricate collages. Although colonial ideas have provided him with one of his best targets, he is the first to admit that 'traditional notions of the post-colonial and colonial legacy are fast crumbling'.[20]

Wong's hard humour feeds on smouldering embers, which do not appear to exist in an earlier pile of pulp, made by Huang Yong Ping (b. 1954, China), with the title *The History of Chinese Painting and the History of Modern Western Art Washed in the Washing Machine for Two Minutes* (1987/93). The work emphatically underlines the impossibility of washing one's intellectual laundry, but also highlights our inability to stop trying. Huang was a founding member of the Xiamen Dada, a group of artists who burned all their paintings after a 1986 exhibition in another clear attempt to draw a line under the past. He has lived much of his life in exile in France. 'I live in the West even though I am Asian,' he says, 'and I used my culture as a source of creation. But I do not live in the present context.'[21] There are still many walking wounded from the acts of the Cultural Revolution.

Literature, and indeed education as a whole, tends to play a larger role in the visual arts in Asia than in the rest of the world, and nowhere more so than in India. I am constantly surprised when I visit artists, even relatively impoverished ones, by the size of their libraries, but it is also the extent of their reading that is impressive. There is much more cross-fertilization between the arts, and indeed every form of life. In the case of Raqs this seems to extend into every crevice and corner of life – from neurosurgery to films and all forms of new technological communication, to politics and philosophy – but sitting up on the second floor of Peacock Lane, Shuddha, Jeebesh and Monica talked to me about the German writer W. G. Sebald. When I met more artists in India, such as Dayanita Singh and Sarnath Banerjee, they also mentioned Sebald.

Wong Hoy Cheong
The Colonies Bite Back
2001, books (partially eaten by termites), 18.3 x 26.2 cm (7¼ x 10⅜ in.) each.

Wong fed old elementary school books about the East to termites. The results were made into collage works with grand titles like *The Colonies Bite Back* and *The Colonies Turn on Themselves*.

Huang Yong Ping
The History of Chinese Painting and the History of Modern Western Art Washed in the Washing Machine for Two Minutes
1987/93, installation: Chinese tea box, paper pulp and glass, 76.8 x 48.3 x 69.9 cm (30¼ x 19 x 27½ in.).

Art history has been pulped. Can we start afresh?

The way the former professor of German at the University of East Anglia described taking a walk through the lanes and byways of the English countryside in *The Rings of Saturn* (1995), but in the process also took us on a march through mainstream intellectual thought and its divergent tributaries, is a model for many of today's artists. Sebald's novel treads the line between fiction and everyday life; it derives painstaking joy from every step taken in man's understanding of himself, and yet by its very nature – describing a 'casual' walk in Suffolk – it underlines the fact that there are many options and paths through life.

I had to hunt down Dayanita Singh (b. 1961, India) at her own party in her house in the leafy suburbs of Delhi to get the promised interview. She is a diva of a hostess and everyone wants her attention. 'Photography cannot just be satisfied by place,' she declared, forced ungallantly by me into her kitchen corner. 'It is more about the places in our head. Without that, photography would be at a dead end. My best advice to young artists is to give them a copy of Sebald's *Austerlitz* [2001] and say, "Read, read, read!"'[22] Sebald used photos in his novels, and photography and text are bound together in Singh's *House of Love* (2011), which is presented in the form of a typical novel and takes as its starting-point the way the German novelist laces his highly manicured writing in *Austerlitz* with rough, old snapshots to demonstrate that the reader is getting only one perspective. 'I want you to feel you are looking at a novel and then be surprised, page after page, story after story,' Singh has said.[23] To emphasize the fluidity between art forms, she then turned *House of Love* into a sculpture, making a cabinet of twenty-four books, each with a different cover.

Dayanita Singh
File Museum
2012, installation: 1 large and 3 small structures, 140 archival pigment prints, large structure: 188 x 110 x 47.5 cm (74 x 43¼ x 18¾ in.), small structures: 33.5 x 33.5 x 10.5 cm (13¼ x 13¼ x 4⅛ in.) each, prints: 31 x 31 cm (12¼ x 12¼ in.) each with frame, edition of 3.

By building mini-libaries of photographs, Singh shows us just how much information is hidden at any one time.

Sarnath Banerjee
'A loss of Fantasy' from the
graphic novel *The Harappa Files*
2011, published by Harper Collins.

Banerjee is a master of
functional fantasy.

Sarnath Banerjee (b. 1972, India) has managed to irritate both the art world and the literary world by blending them in his graphic novels. They used to be called comics, but his fellow comic writers distrust him as he does not believe in superheroes. The format appealed to Banerjee's restless, mocking and fun approach to life. In *The Harappa Files* (2011) there is an image of a frightening group of 'ordinary' people standing on a pedestal emblazoned with the legend 'Teamwork Communication'. Out of their speech bubbles comes the ultimate committee art talk: they declare that 'To tell new stories one needs new languages.'[24] This is the type of nonsense committees speak. Although the book does have a sense of fluidity, an element of escape from one moment of time, I sense while I talk to Banerjee, as he calls by my local café in London's Gloucester Road, that the graphic novel format won't contain him for long – it is too formulaic. He admits that he has always been attracted to 'novels that misbehave, like those of Sebald', but he is quick not to wave the flag of any one artist or writer.[25] This is reflected in another project, set in Berlin, called *Enchanted Geography* (2013), in which he learns from famous writers' relationships with their real or imaginary locations: Fernando Pessoa in Lisbon, Charles Baudelaire in Paris, Khalifa Harun al-Rashid in ancient Baghdad and Raymond Roussel in his head. The Berlin connection is provided by Walter Benjamin, who wrote in *Berlin Childhood around 1900* (1950), 'Not to find one's way around the city does not mean much. But to lose one's way in a city, as one loses one's way in a forest, requires some schooling.'[26] For me, this is a reminder that it is not just we the audience who lose our way and benefit from it by finding a new way; the artists themselves are constantly

battling with a sense of dislocation. In large countries such as India and China it is possible to be an international artist and not known domestically, just as it is also possible to be famous inside these countries but almost unknown outside. There are pressures that make artists choose to conform to the international or domestic norms. Of course, artists such as Singh, Raqs and Banerjee refuse to be forced to take such a limiting decision.

'Location has ceased to be of paramount importance but locatedness hasn't,' declare Raqs, before admitting 'We may hesitate to use the term "Indian" to describe our work.'[27] They talk of Delhi and feed off the specifics of the Indian capital; steering interesting paths between globalism and localism is becoming an Asian strength. The collapse of the idea of a central authority in mainstream art could not have happened at a more appropriate time for many artists in the region, since, with their economic and cultural ascendancy, they are as well placed as anyone to take advantage of the new freedom. In previous centuries artists had to either conform to the rules of a relatively small, global avant-garde or steal the position for themselves. There are still huge pressures, however, many of them fostered by the fault lines created by the colonial legacy.

Millions of people were displaced amid horrendous bloodshed by the partition of India in 1947. A two-headed microphone swings back and forth as we alternately hear the pro-independence speeches of Muhammad Ali Jinnah and Jawaharlal Nehru in the sculpture *In Our Times* (2008) by Shilpa Gupta (b. 1976, India).[28] The message of this piece may sound very obvious and didactic, but coming across the swinging microphone in a half-empty gallery at the 'Indian Highway' exhibition at the Serpentine in London, my first thought was that it was just an abandoned mic from the show's opening night.[29] I am so used to seeing discarded props for propaganda that I did not take it very seriously. Its lugubrious movement reminded me of a see-saw. I realized pretty quickly that it must be an art work, yet it did not seem to deserve much attention in a show stuffed with great work. As a sculpture, it was not that visually arresting. Then I heard the voices of the long-dead politicians and rivers of blood and history flowed over me. The effects of that 1947 division are still being felt. And yes, my grandmother was ashamed of 'that stupid man Mountbatten',

Shilpa Gupta
100 Hand drawn Maps of India
2007–8, video, 3:40 minutes,
40 x 52 cm (15¾ x 20½ in.).

What can maps tell us when
everyone has a different vision
of the world?

Bose Krishnamachari
Ghost/Transmemoir
2006–8, installation:
108 used tiffins, LCD monitors,
amplifiers, DVD player,
headphones, cables, scaffolding
and wood, dimensions variable.

The story of post-colonial Mumbai
bursts out of Krishnamachari's tin
tiffin carriers.

the last British Viceroy of India, and his handling of the situation. Most of Gupta's work dwells on the difficulties of finding or refinding a sense of belonging. 'I am interested in how we create structures around ourselves and how hard we have to try to contain them,' she says. 'We create borders, knowing well, like birds, who fly from one hemisphere to another when resources become less, individuals will too finally take flight, across age, sex and religion, across all limitations.'[30] In the video work *100 Hand drawn Maps of India* (2008) she asked a hundred people to draw India from memory. Every single map was different. As the video jumps jerkily from one vision of the country to the next, one begins to realize the impossibility of any accumulated coherence.

No two people inhabit the same world. If a hundred Indians map their own country differently, what does it say about how much we understand each other? What are we sharing? Buried under an avalanche of modern communication tools and information, it is perfectly possible to become increasingly isolated and alienated. This is one of the reasons why artists are trying to avoid grandiose theories and slick solutions. It is why the South African artist William Kentridge's art still works powerfully on me when the political struggle against apartheid has been won. Kentridge's rough animations work a little on the Gupta principle: with his rough vision, we are not entirely certain of what we are seeing. The very ground he draws is unstable. Bose Krishnamachari (b. 1963, India) uses the same crudeness to engage us in his masterpiece installation *Ghost/ Transmemoir* (2006–8), which again I saw for the first time at the 'Indian Highway' exhibition. It is as though Krishnamachari has taken a can opener to 108 disused tiffin boxes to fit them with LCD monitors, out of which comes a 'selected cacophony', his way of describing the 108 talking-head videos of the people of Mumbai.[31] The racks of tiffins, complete with an ugly bristling hedge of wires, are reminiscent of a sacrilegious cow-milking machine, but they are actually part of an old and extensive food-supply system. The transportation of lunch boxes from across the country through the long arteries of Mumbai reveals some of the city's complicated character. This is further fed by the video images and the voices we hear via headphones, which, as the artist explains, come from 'a range of Mumbai residents, from street vendors to socialites, industrialists and

intellectuals' in order to 'give a kaleidoscopic view of the city'.[32] There is a post-colonial twist in that the food-supply system was initiated by British colonialists who were not prepared to eat the local cuisine. The system is labour-intensive, with its dabbawallahs, but it takes advantage of most forms of transport. Krishnamachari's structure looks a little like an early mammoth computer, or indeed the human brain. It is a metaphor for the way we think and remember; the artist is milking our memory. This is a vivid image: hundreds, thousands, millions of us walking the streets of Mumbai, a mass of memory banks crossing each others' paths and criss-crossing them again.

Walking my dog in Kensington Gardens I met Nikhil Chopra (b. 1974, India) dressed up as a gentleman of the end of the Raj. He was camping out during 'Indian Highway' as part of his performance *Yog Raj Chitrakar: Memory Drawing V* (2008). In a later variation, *Yog Raj Chitrakar: Memory Drawing X, Part 2* (2010), he made himself up like Queen Victoria and stood in the middle of the former Victoria and Albert Museum in Mumbai (now the Bhau Daji Lad Museum) confronting the marble sculpture of Prince Albert, the flesh-and-blood, cross-dressing Chopra working out his relationship with the memory of a dead husband. His performances have been described as 'a cinema of slowness'.[33] He indulges in role play as one of two deliciously dandified figures of the Raj, either Sir Raja or Yog Raj Chitrakar. Drawings are made as a vital part of the performances, which inevitably end with the artist running out of life and standing as still as a statue. The storytelling in the performances seems to be matched by an equal desire to kill the story.

It is time to return to my place across the table from Monica on Peacock Lane. The subject of my conversation with Raqs evolved away from post-colonialism. We talked about how the three artists had met at film school. 'We are radical orphans,' said Jeebesh. 'We are radical orphans,' repeated Shuddha, but added, 'We don't have an art background, and we don't come out of Conceptualism, although we are conceptually driven.'[34] The passing of an idea between them seemed totally natural. Shuddha repeated Jeebesh's point about their artistic parent-age, but then emphasized one side of this – the break with the belief in pure, undiluted, sacrosanct ideas. The discussion

Nikhil Chopra
Yog Raj Chitrakar:
Memory Drawing X, Part 2
2010, digital photograph on
archival paper of performance
at the Bhau Daji Lad Museum,
Mumbai, 110.5 x 73.7 cm (43½
x 29 in.), edition of 7 + 2 AP.

Chopra's role play sees modern
living India confront its dead past.

went on about the friction needed between minds to transmit information. Communication can never be totally seamless; otherwise it is not happening. I suddenly realized I could see and hear the process happening in front of me. It was as though the Raqs members were the cogs of a brain bigger than that of one individual: they were the cogs of the Raqs brain, and they were including me in the process of thinking. 'The name Raqs implies constant movement,' part of the brain told me. 'Raqs is the state that dervishes enter into when they whirl,' another part explained. 'We would call it a kinetic form of contemplation,' they continued, and I now forget which one was speaking. 'There is nothing in the world that is still. Indeed, one has to move to observe the world moving.'[35] This excitement in the moment, this need to constantly redefine the moment, is allied with an acceptance that they and everything they observe is constantly spinning. The art compass locates them not as a single star, nor as a fully blown constellation. There is a special word for them: an asterism, a formation of three stars.

When is a Raqs art work finished? The dialogue between Monica, Shuddha and Jeebesh never ends. It continues not just between them but with everyone around them, physically and through their wide range of networking systems. As soon as one accepts that art does not have to be the product of solitary genius it becomes more flexible than time. The development of Raqs's main timepiece demonstrates this. The first prototype for *Escapement* was shown in 2003. Ten years later the idea is still evolving. In the video work *Whenever the Heart Skips a Beat* (2012) the emotions that stand in for the numbers on the clock face are no longer fixed to a static dial but are in motion too. The world 'Hold' flashes up on the hour hand. 'Thresh' comes up with the minutes. We have reached the threshold. It is wordplay: Live – Wire! Flood – Gate! Market – Forces! The words fit together, but they don't satisfy the full demands of time, of the system of the clock, which becomes more and more demented. Time itself seems to have emotions. One hand reads 'tight', the other 'rope', and then suddenly both hands sag and are brought to 6.30 by the forces of gravity. This could be an allegory for the three artists themselves, for none of them obeys the laws of time. They go one way, then the other. Sometimes the second hand is charging round; next it is static while the others circulate together or in opposite directions. The artists

change directions frequently. And, of course, the three members of the group are not typecast: they are free to vary their parts.

Raqs explain that

> the changes in our work over the last ten years reflect a lessening of interest in systems and an increase in the use of the word 'life'. In our new 'clock' work – titled *Whenever the Heart Skips a Beat* – the words are no longer fixed. They keep on reconfiguring their content and position. In between *Escapement* and *Whenever the Heart Skips a Beat* we became interested also in developments in neuroscience, leading us in the direction of investigating different temporal registers, different biorhythms, different senses of time. For instance, the pineal gland, deep within the brain, registers a sense of time and light. The pineal gland affects our sense of time – it makes us think about whether or not we are with time.[36]

Their words, in the form of their explanations or the words flashing up on their clock faces, are never enough. It was only half an hour earlier that I had been lost in the streets of India, overcome by the sheer number of people, before Jeebesh had rescued me. *Whenever the Heart Skips a Beat* plays on this balance between the tiny individual and the excitement of each new emotion, each new thought arrayed against the vastness of unforgiving time. Raqs are not artists in the traditional sense of the word: much of their work is about breaking down the barriers between art and everyday life. They were co-founders of the Sarai study and research programme, which tries to make intellectual hubs, both in the real and virtual worlds. The internet would seem to be a natural area of growth for artists, seeing as most of us now flit between reality and cyberspace. The networks the Web has enabled naturally undermine the idea of a central authority, yet they have also created a thirst for more truth, a greater belief that there are answers out there. 'The last ten years have seen a new attitude to the function of power,' explain Raqs. 'There is no longer such belief in hidden power. The whole of society has become a dangerous place...There is a great need for acts of imagination.'[37] Raqs place this onus on all of us, but they also expect that artists should take responsibility for leadership in the field of the imagination.

So far, there have been remarkably few great works of art made using the internet. Cao Fei (b. 1978, China) uses it most effectively, yet ironically she lives and works in China, one of the few places where the internet is partially censored. She has built *RMB City* (2007–11), a virtual world populated by avatars. Cao shows us that the real boundaries are mental, not geographical. She encourages contributors to *RMB City* in making their avatars not only to build up their spiritual side, but also to break down their internal mental barriers. Although I had spent a little time in *RMB City* when I visited Carlos Garaicoa in his Madrid studio (see p. 41), I learned a lot more about it when I flew into Beijing in May 2010 to talk to Cao Fei.

It was a fleeting visit. I did not even spend a night in the Chinese capital, as I was on my way from London to Art Hong Kong. For the amount of the real Beijing I saw I could have been within Cao's computer graphics. I was picked up from the airport and driven through streets that could have been designed by the artist, except that they lacked her easy sense of colour and love of unusual curves. My path seemed straight, the traffic heavy, the city merely an extension of the sky, which was a very dull, pale grey. I was delivered to Vitamin Creative Space, one of the many off-white blocks, and greeted by the gallery's founder, Zhang Wei. She could see I was disappointed at the building's normality. I could have been in a hotel lobby anywhere in the world and the space had none of the energy and dynamism of Wei and her artists. She was quick to explain it was a temporary 'creative' space. Cao arrived, bringing colour with her: she was dressed in yellows and reds. Her videos were playing on screens around the rooms.

The three-way interview between Cao Fei, Zhang Wei and me was a far cry from the quick wordplay of Raqs in Delhi's Peacock Lane. Wei was acting as interpreter. The main topic of conversation was Cao's understanding of the individual in relation to the real and virtual worlds, a restatement, in her view, of old philosophy. 'We are all performers,' she said, 'but sometimes our mind has to come out of the performance. It is a question of moving in and out between the inner and outer selves, in and out between the world of ideas and the practical world.'[38] She acknowledges a debt to old Cantonese

Chrysanthemum

Who Else?

Raqs Media Collective
Whenever the Heart
Skips a Beat
2012, single channel
video (loop), edition of 5.

The numerals on Raqs's clock
faces are replaced by words and
phrases, by constantly changing
emotions and wordplay.

thinking in her desire to balance the inner and outer selves, but it is a distant influence compared to the more drastic recent break in thought, the Chinese Cultural Revolution, which in its attempt to destroy all the traditional thought structures in its path can be seen as the most brutal form of modernism.

In *RMB City*, Cao is rebuilding the world. 'We live in the new Great Leap Forward,' she maintains. 'We have demolished everything and are building anew. There is an aura of construction everywhere.'[39] In her world everything is possible: it is possible to build one's own world. The project has a universal appeal – man or woman in relation to the rest of the world through the keypad. Cao's alter ego, her avatar China Tracy, explains, 'It is perhaps no longer important to draw the line between the virtual and the real, as the border between these two has become blurred. In virtual reality we are not what we were originally, and yet we remain unchanged.'[40]

My inability to speak Mandarin became less of problem as Wei, Cao and I continued our talk over lunch in a restaurant with the kind of smart Chinese decor that has been replicated in hotels around the world. Our love of food became a common language, and as we ate, I enjoyed the refreshingly equal relationship between artist and gallerist. They are united in explaining how the younger generation in China feels. Cao evokes this in her

video *COSPLAYERS* (2004), which follows a group of young people dressed up as characters from computer games. 'All the COSPLAYERS are extremely young,' she says,

> their heads full of dreams, for an early age spending all their waking hours in the virtual realities, playing video games. So that when eventually they grow up, they find that they are living a lifestyle that is frowned upon and rejected by society and family alike. With no available channels of expression for their feelings and aspirations, they resort to escapism, allowing themselves to become alienated. However, in the very instant that they are turned into genies, chivalrous knights, fairy princesses or geeks, the pleasures and pains of escapism are fulfilled, fleetingly, even if the reality they live in has not changed in the slightest.[41]

In contrast, the individual seems to play very little part in the work of Yang Yongliang (b. 1980, China), another artist to exploit the latest technology. Instead, we are presented with the results of mankind's lack of restraint, which has devastated the old world. Yang uses photography and video to mock the dreams of the past and present. His digital landscapes, which have come out of the aesthetic of traditional Chinese scroll painting, are full of oil rigs, factories and roller-coasters. The old idyll has been transformed, and so has the mode of representation. Instead of relying only on pen and ink, the artist is happy to take advantage of new techniques and software. While there is no escaping the dire ecological warnings of his reworked scrolls, there is a certain ambiguity. There is dynamism, a sense of the funfair, riding roughshod over long-gone history. 'When I was a child I lived in small town, Jiading, which was full of culture and there were lots of historical sites and a very humanistic environment', Yang writes.

> Now instead of canals and the old streets it has high rise apartments, instead of the waterfront and the gravel roads it has cement highways…What happened to a small town in China is part of the process of urbanization in China to catch up with the rapid pace of Western developed countries, but the price paid is very heavy. Culture and the arts are experiencing a new round of 'baptism'.[42]

Yang Yongliang
A Bowl of Taipei
2013, scroll photograph,
100 x 100 cm (39 ⅜ x 39 ⅜ in.).

We are seduced by the dynamism of Yang's updated idyllic bowl of soup only to be horrified by the ecological devastation it contains.

Cao Fei tries to alleviate our sense of alienation in the modern world. During her time as artist-in-residence at the Siemens OSRAM lighting factory in China's Pearl River Delta region in 2006, she created the video *Whose Utopia?* (2006), which transformed the factory's motto 'from a production-centric one (TPM, Total Productive Management) into one of humanism and solidarity (TPM, Team, People, Motivation)'.[43] Cao asked individual staff members to act out their dreams as though they were just another task at the factory. So, for example, one lady in the video dances down the factory aisle in a peacock dress.

Cao actively tries to involve people in her art. Tabaimo (b. 1975, Japan) wraps the world around us. The effects of the earthquake and tsunami of March 2011 gave her installation *teleco-soup* (2011) at the Japanese Pavilion in Venice a few months later an awkward poignancy as she surrounded her audience with the power of water to explore her country's identity as an island state.

She is one of the few artists really to have adapted film to her own artistic designs: she has created rooms from walls of film so that film becomes our architecture, our surroundings. She makes us look harder, as the walls appear to be alive. At twenty-four, while still at college, Tabaimo made the video *Japanese Kitchen* (1999), which she describes as 'my first piece that explores every-day Japanese life. Like many other young Japanese, I feel there's so much going on in Japan today that I don't understand.'[44] In her videos she builds 'commonplace' settings such as kitchens, train interiors and, more disturbingly, in a work called *public ConVENience* (2006), a ladies' lavatory that inverts the shock factor of Marcel Duchamp's urinal as male viewers suddenly find themselves in a forbidden place watching things that shouldn't happen: a woman shattering her mirror reflection with a hammer, or a baby being born out of a woman's nose and then being flushed down the pan with a turtle.

Tabaimo's world is hand drawn in a style steeped in the old woodcuts of Hiroshige and Hokusai, but she believes that there is a gulf between their work and hers:

> My generation's approach to traditional Japanese culture is not that different to how foreigners approach it. Sadly, we

Cao Fei
Whose Utopia? –
My Future is Not a Dream
2006, photograph, linked to the video *Whose Utopia*, 120 x 150 cm (47¼ x 59 in.).

The very material of Cao's film and internet work is our dreams, our aspirations, our motivations.

don't have the same immediate link to our tradition that previous generations had. The Second World War runs like a thick dividing line between generations in Japan with regard to a lot of things, including art. The Post-War generations are simultaneously drawn to tradition and feel alien to it.[45]

The historical scars are markedly different in China and Japan, but the two nations and other Asian countries like South Korea are united by rapid technological change, however alienating.

I met Lee Yongbaek (b. 1966, Korea) in 2011 at the Hakgojae Gallery, which is just over the road from the edge of Samcheong-dong, a district of Seoul that has the atmosphere of an extended town market but also contains most of the city's commercial galleries. Sophisticated Korean galleries and their clients played a key role in creating the Asian art market and introducing audiences to contemporary Chinese art. Although the galleries in and around Samcheong-dong are mainly modern, they are designed to fit in with the traditional low-rise buildings. Sitting opposite Lee Yongbaek at a low table in the basement of Hakgojae with three members of gallery staff acting as translators, I felt I could be anywhere. I seemed to be moving from one isolated bubble to the next. But my experience of Lee's installation *Broken Mirror* (2011) earlier that year at the Venice Biennale made me think that the walls might be less solid.

In the only photograph I had seen of the artist, his face was fragmented, and I hoped I was not peering at him too rudely the day I met him, when his face was broken only by his glasses. The memory of the installation brought back the sensation of entering a peaceful room of mirrors in the Korean Pavilion on a hot June day – it was next door to Tabaimo in the Japanese Pavilion. I am not particularly narcissistic, but I looked at myself in the mirrors. I could not stop thinking about the use of mirrors in recent art: Gerhard Richter's mirror paintings, which appear intermittently throughout his oeuvre; Gavin Turk's do-it-yourself self-portrait *Your Authorised Reflection* (2009); Michelangelo Pistoletto's broken mirrors…then crack! All the mirrors in the room shattered at once. I have obviously watched too many films because I thought I was under sniper attack and almost threw myself to the ground. Later on, when I looked in

Tabaimo
public ConVENience (video stills)
2006, video installation, dimensions
variable, 6:05 minutes (loop).

In Tabaimo's immersive video
installation a women's lavatory
becomes the stage for some
strange taboo-breaking antics.

the catalogue at Lee's mirrors, I relived the experience and was disturbed to see the artist's own figure fragmented by the illusion of broken glass. Back in Seoul, it felt like a confession, sitting in front of the artist and telling him that he had made me feel insecure. He was keen to point out that in Korea it is lucky to break one's own image as it means a fresh start, a reinvention of oneself.

Despite his more positive spin on his broken self-image, Lee's work undoubtedly explores the weight of society on the individual. He was brought up in a dictatorship. 'When I went through school – sixteen years from Elementary to High School – I lived under a military regime. As many people went off to the war or simply died, I was advised by parents and friends not to sit in the front row, not to bring attention to myself. I learned to filter information and censor myself.'[46] Since then he has looked for a path that is not determined by such binary thinking. He loves literally holding up a mirror to our polarized vision of the world. As we peer at the glass of the video work *Inbetween Buddha and Jesus Christ* (2002) the head of a god suddenly appears but, buzzing like an angry trapped insect, it cannot make up its mind whether to be Buddha or Christ. As the mysterious image fizzes away in front of us, we gawp at man's attempts to justify his own existence.

Not only does Lee use the latest technology to make his work; it also provides him with his subject matter. 'The credit card, mobile phone and internet have appeared and dominated from around 2000 – my main focus is how these things are changing our lives. As we depend more and more on mobiles, iPhones and social networks, ironically we feel much more lonely, more alienated.'[47] He plays on our restless spirit by remaking his art works in several different formats: for instance, *Angel Soldier* (2005) has appeared as a performance installation, a straightforward photograph and a video. He further rounds out his practice with meticulous paintings of fish lures. In marketing parlance he looks as though he is simply taking advantage of horizontal integration, so that he hooks as large an audience as possible. He acknowledges his changing ambition: 'When I made *Angel Soldier* I was a local Korean artist, now I am more interested in the Asian situation.'[48] This new pan-Asian viewpoint has led him to examine the rapid changes within

his continent: 'Sometimes I get a bigger culture shock travelling within Asia than in Europe.'[49]

Artists are no longer pilgrims to one shrine. In the eighteenth century European artists and collectors travelled to Rome to drink deep at the source of classical culture, the root of all Western art. Even as this was challenged, Paris and New York continued to trade on this tradition of one-way travel to culture. Now, however hard the siren voices of gallerists in the big art centres of the world may try to convince you otherwise, there is no such thing as one-way culture. Lee Yongbaek's work repeats this message: there is no central authority.

Ming Wong (b. 1971, Singapore) explores the dangerous results of seeing life from only one perspective. I met him at Zhang Wei and writer and curator Hu Fang's wedding banquet at the Hong Kong art foundation Para Site in 2011. It was not a totally straight wedding, although the banquet relied on the basic wedding format as an allegory of the art world. I rushed to get there from Art Hong Kong and was one of the last of the 300 guests to make my way up to a fourth-floor, old-fashioned, low-ceilinged restaurant by a rather tinpot lift. I was ushered to one of many round tables, where I was seated next to the art curator and writer Karen Smith. I was pleased to talk to her as I had just read one of her articles on the painter Jia Aili (b. 1979, China).

Many artists, including Ming Wong, had showered their works on the newly married couple and some of the videos played

Lee Yongbaek
Broken Mirror
2011, video installation: 42 in. monitors, mirror and stereo speakers, 250 x 183.5 x 8.5 cm (98 ⅜ x 72 ¼ x 3 ⅜ in.).

Visitors to Lee's exhibition thought they were under attack as the mirrors suddenly shattered.

over dinner. The emphasis on the wedding gifts can be read as a commercialization of a spiritual act, or the cementing of a business partnership between families. Yet in China the giving of money to the couple carries little sense of irony; this was saved for the main theme of Ming's contribution – identity.[50] It was a Conceptual wedding and Ming's photographs had been prepared before. They were displayed in an album at the doorway to the restaurant. At first, they appeared to be conventional photographs of the wedding participants in full traditional costume. There was only one difference from thousands of other wedding pictures. Flicking through the album pages, I saw a changing cast. On the first page Ming was dressed in the same gorgeous turquoise cheongsam he was wearing that night and he was the maid of honour to Wei and Fang. On the next page Ming was the bride and Wei had been demoted to maid of honour. On the following page he took Fang's place and played the part of the bridegroom. Ming Wong played all the roles.

This theme of changing identity was further explored by Ming at Art Hong Kong, where his *Four Malay Stories* (2005) was playing on banks of old-fashioned television screens, as if to exaggerate the dysfunctional side of film, the friction in our role play. Much of the artist's video work is based on the golden age of independent cinema in Singapore in the 1950s and '60s, when films were usually made by Indian directors with Chinese money, yet the language was Malay, with Mandarin and British subtitles. In *Four Malay Stories* Ming reworks four of these classic films, playing sixteen of the main characters himself in Malay, a foreign language for him. In another work, *Life of Imitation* (2009), he inverts the title of Douglas Sirk's Hollywood melodrama *Imitation of Life* (1959) and although he does not physically cast himself in a role, he has male actors from the main ethnic groups in Singapore (Chinese, Malaysian and Indian) take turns to play the characters of a black mother and her mixed-raced daughter, Sarah Jane, who breaks down in front of her mother and a mirror. Nothing will shake from her mantra: 'I'm white. White!'

Film smoothly transports millions of viewers into other worlds and roles; it has become a prescribed experience. We sit in the dark and gaze at a big screen, and then we walk away at the end. The great film directors make you walk away a changed person.

Artists, using film, build on this process, making the experience more personal, more intense. Ming Wong jolts our assumptions about our sexuality and race. I was delightfully jolted. I asked him to dance at Wei and Fang's wedding and I am glad I did, as our dance was the closest I got to an interview. Within twenty-four hours of our solitary waltz Ming was stripping off the very same blue Madam Butterfly dress in front of nearly a thousand people. He was making a valid point at the annual Intelligence Squared debate to try and prove that 'Art must be beautiful.'[51]

Even intellectuals have feelings! The plight of *The First Intellectual* (1999–2000) in the photograph by Yang Fudong (b. 1971, China) could be a comment on the rebirth of intellectual life after the Cultural Revolution. The lone figure is like a child: it is as though he is unaware of where his thoughts and emotions come from, wanting to blame anything, or anyone, that comes along. 'One wants to accomplish big things,' says Yang,

> but in the end it doesn't happen. Every educated Chinese person is very ambitious, and obviously there are obstacles – obstacles coming from society or from inside oneself. The first intellectual has been wounded: he has blood running down his face and he wants to respond and react, but he doesn't know at whom he should throw his brick. He does not know if the problem stems from himself or society.[52]

It is Hamlet after the death of his father.

'Many young people – I'm referring above all to the generation subsequent to mine – don't take the past into consideration at all,' Yang says. 'They don't even need to forget it, since they didn't know it in the first place.'[53] For artists working in the wake of the Cultural Revolution, history is virgin territory. Yang's five-part film *Seven Intellectuals in a Bamboo Forest* (2003–7) is a staggeringly

I'm white. White!

EAST

Ming Wong
Life of Imitation
2009, two channel video
projection installation, shot
in HD, 16:9, colour with audio,
26 minutes (loop). Inspired by
Imitation of Life directed by
Douglas Sirk, 1958.

Film can transport people
into different worlds, but
in its imitation of life it is
alarmingly random.

straight re-evocation of The Seven Sages of the Bamboo Grove, an old story that refers back to the mid-third century, a time of political unrest in China. Shot in black and white, the film is a stylistic reminder of the existentialist French films of the 1950s and '60s, as well as recalling the culled Chinese intellectuals of the same period. The Seven Sages of the Bamboo Grove is an oral myth. It was not written down, which makes the intellectuals' search to lose themselves in pure thought and discussion seem all the more fresh and modern.

The husband-and-wife team that is Shao Yinong and Mu Chen (b. 1961 and 1970, China) were also at Art Hong Kong in 2011. Sitting in a VIP lounge surrounded by other groups chattering away easily around low chairs and tables, the two artists took their time to say anything about *Assembly Hall* (2002–4), their series of twenty-four large-scale photographs that gives a unique glimpse into recent Chinese history. They did not seem to believe my questions, but it was a delicate conversation about such a calm yet brutal survey. The couple visited all twenty-four provinces of China to photograph the old town halls in which the denouncements of the Cultural Revolution took place. 'The first meeting hall we came across was covered in dirt,' they said, 'it was like looking through a doorway at a specific period in time.'[54] Given their significance in the history of photography, it is difficult not to see the influence of another couple, Bernd and Hilla Becher (b. 1931 and 1934, Germany), in the objective, single-perspective approach that the Chinese pair have taken in recording the town halls.[55] The spaces are reduced to haunting specimens from a far-off world. The Cultural Revolution can be read as an extreme and, luckily, a failed attempt to achieve objectivity at the expense of subjectivity.

Nandan Ghiya (b. 1980, India) has been contemplating both his own and his country's history for almost his entire life as his father is an antiques dealer. I saw him standing by his installation

The First Intellectual

Yang Fudong
The First Intellectual
1999-2000, colour photograph,
193 x 127 cm (76 x 50 in.).

No wonder Yang's intellectual
is angry: he has been
dumped unceremoniously
in an alien environment.

EAST

Shao Yinong and Mu Chen
Shanghang
2002–4, C-print mounted
on aluminium, 122 x 168 cm
(48 x 66⅛ in.).

The young Chinese couple
emulate another artist duo,
Bernd and Hilla Becher, in their
objective view of history. It is
up to the viewer to decide how
much the camera reveals.

at the 2012 India Art Fair in Delhi. He had that displaced air that comes so naturally to some intellectuals: his tastefully colourful clothes talked of an earlier era. So did his pictures, made up of found images and other objects, and framed like the vintage paintings and photographs on which they are based. The frames are linked together like fungi: indeed, they creep around corners. There is something insidious, almost cancerous, about the images and the way they spread, and as one looks closer, one sees that the old pictures have been subjected to modern-day viruses. In the process of digitization their visual information has suffered an earthquake. The images are skewered by our magpie understanding of the past. Ghiya's knowledge of the past not only leads him to know where to find interesting antique frames, but also to appropriate pictures made at the time of British rule. He then subjects these pictures to the vagaries of modern communication and they seem afresh, but with their pixilation askew. The distorted images of our memory get another life of their own as they seem to grow into each other. The artist does not emphasize the British occupation of India. There is hardly any evidence of the British left over in his work, but at the end of the *deFacebook v.1.2-* exhibition catalogue he laments, ostensibly referring to his personal computer, that 'some day hopefully the system will recover.'[56] Even if we are more sceptical than ever before, even if we know that there is no one system to cure all, the person sitting at the computer lives in hope that the answers will come down the line, that their life has some order.

Nandan Ghiya is the same age as Cao Fei, who talks of the dividing line between generations. 'People of my generation, born in the late 1970s, are immigrants to the net,' she says. 'Those younger than us are native born. This is obvious in Second Life [the virtual world in which *RMB City* is set]. People my age often

compare and contrast the real world with the virtual, looking for points of friction. But the generation below us, they were born into the internet, and they are fully immersed in the digital world.'[57] One of the dangers, though, of sitting in a cocooned box, whether virtual or real, is lack of friction, which creates most deep communication. The danger of isolation was scarily revealed in the first performance work by Miwa Yanagi (b. 1967, Japan).

A uniformed lady sits in a glass box. She is turned out immaculately, like a Pan Am air hostess during the airline's glory days. Yanagi's first work in her *Elevator Girls* (1994–99) series, like Cai Guo-Qiang's ninety-nine wolves running into the glass wall in *Head On*, is a dire warning against the wholesale acceptance of Western ideas. Much like Lee Yongbaek, Yanagi wanted to reach a wider audience, so she turned from performance to large-scale photography. The nightmares caused by a woman being reduced to a 'human label', the consequences of global consumerism clashing with local social pressures, come flooding out in the 18-metre-long (59 ft) photograph *Midnight Awakening Dream* (1999). In one of the central panels luxury goods float like debris in the wake of a disaster and a series of identikit, uniformed girls are silhouetted against the reflection of the water, with all its Freudian implications. 'I began *Elevator Girls* when

Nandan Ghiya
Single and Available
2011, manipulated vintage photographs and wooden frames, 132.1 x 175.3 cm (52 x 69 in.).

The relationship between the old and the new has a viral quality in Ghiya's work.

Miwa Yanagi
Elevator Girl House 1F (detail)
1997, directprint, 2 parts,
240 x 200 cm (94½ x 78¾ in.).

This series began as a performance
piece about a young girl working
in a glass box. To spread her
message, Yanagi turned to hard-
hitting photographs.

I was a teacher. I often rode on a "box" (the train) to another box (the classroom) and performed daily in front of people, and on the way back, I'd shop at a "box" (department store) and go home,' Yanagi explains, before providing a verdict on the girls' fate: 'The girls cannot get out. There is no exit.'[58] There is an echo of Francis Bacon's popes, screaming in their transparent cubes.[59] Like Bacon's paintings, Yanagi's photographs touch on everyday matters, yet are terrifyingly isolating.

The conceit of this book is that we can discover art around the world by using our own internal art compass in relation to international artists – our stars. This system has flaws, like any other, and one of the biggest stumbling blocks is Australia. There are four points of the compass, but five continents producing art, so I lump Australasia in with Asia. To add to the complication, although art in Australia is changing as fast as anywhere, in general Australian artists do not conform to the trends that we have been talking about.

The photographs of teenagers by Bill Henson (b. 1955, Australia) caused a controversy when they were shown at the Roslyn Oxley9 Gallery in Sydney in 2008. The pictures are disturbing, but not as an old rehash of the Lolita argument; they seem to lay bare the Australian soul and Australian soul-searching. Although there are references to the early fifteenth-century Italian painter Masaccio's depiction of lost innocence, Henson has the teenage bodies emerge out of darkness, cutting them off from too many connections to the past. His sitters often look away from the camera, but when they look up there is an uncompromising engagement. It is as though Gabriel Orozco had made the mistake of extending his remark that American culture was based on the teenager to include Australia. Henson is acutely aware of Australia's isolation and proud independence, which he sees as being based on vulnerability. He explains:

> There is so much beauty in all of the B-grade anxiety about being 'important' or 'international', or whatever in Australia, and this insecurity lends the physical landscape a tenuousness because things are constantly being torn down or destroyed in the desperate drive for 'improvement'. The landscapes

Bill Henson
Untitled #63
1999/2000, type C photograph,
127 x 180 cm (50 x 70⅞ in.),
edition of 5 + 2 AP.

There is a mocking innocence
to Henson's work.

of our childhood are being ripped away from our everyday experience with such rapidity that it always strikes me as incredibly violent. And in the end, with little remaining trace of the landscape in which one grew up, the city itself becomes a sort of 'lost domain' where no one actually feels 'at home' any more.[60]

When I first looked at Henson's photographs, my eyes seemed to skim over the surface of his works too easily as I did not know where he was coming from. It took time for the emotional and intellectual message to catch up with the very seductive vision, but I suspect this is simply a form of artistic jet lag. Henson explains his 'locatedness' in Melbourne eloquently:

When I used to wander around the run-down paddocks as a kid in outer Melbourne suburbia and these blended in my imagination with the marshy landscapes that I was studying in books of Rembrandt's etchings, it seemed entirely natural. The sunlight hitting the little stone bridge in a stormy landscape 400 years ago has always seemed as real to me as the light that might have fallen across Melbourne on an autumn evening in the 1960s. The indescribably beautiful breathing closeness I encountered when I stood for the first time in front of Rembrandt's last painting of his son Titus in the Kunsthistoriches Museum in Vienna felt just like falling in love with one's first girlfriend at high school and finding yourself in this extraordinary proximity – examining her beauty whilst under some kind of spell.[61]

Henson's 'fashion and expediency' are sadly not limited to Australia: they are the rule for the international art market. Luckily there are gaps. There still has never been a global art zeitgeist; there are always some areas of resistance, or the timing is out. To European eyes, the work of Tim McGuire (b. 1958, England, but an Australian from the age of one) is in tune with the Neo-Expressionist paintings shown in the infamous 'Zeitgeist' exhibition at the Martin-Gropius-Bau in Berlin in 1982.[62] The fact that McGuire trained at the Düsseldorf Academy, where many of the slightly older 'Zeitgeist' painters studied, reinforces this link, but it is not as simple as that. McGuire's outrageously straight images of lush flowers seem to be functioning more in line with Yan Pei-Ming's need of direct imagery, rather than with Neo-Expressionist explosions of paint.

Australian artists are big travellers. I went bar-hopping with McGuire in Hong Kong. It is a pretty good rule of thumb: follow the Australians for a good party. And nowhere is too far. While at home in London, I was talking on the phone to Sally Smart (b. 1960, Australia). I assumed that she was safely tucked up on the other side of the world in Australia. Thirty-six hours later we were having breakfast in Manhattan as she decided on the spur of the moment to fly over for a party and to attend Frieze New York. Most of Smart's work illustrates the wisdom of Marlene Dumas's remark about drawings (see p. 178): her collages and 'femmages' are certainly 'streetwise'. The word 'femmage' was coined by the American feminist Miriam Shapiro in 1976 to describe the kind of craft assigned to women. Smart's works come out of this repressed background and play. She frightens us with *Flaubert's Puppets (femmage)* (2011), which alludes to Gustave Flaubert's novel *Madame Bovary* (1856), the ultimate male depiction of a woman trying in vain to shake off her man-made cage. In her series on female pirates, *The Exquisite Pirate* (2004–7), Smart takes us back to nursery school yet again, but the tables are turned. She uses scissors and paper once more, but this time to make a world where women enjoy the best roles. Her assemblages, made up of accumulated fragments of other people's visions, question what women really think of themselves and what men think of women. 'What are little girls made of? Sugar and Spice and all things nice!' This is not just an un-cosy return to our childhood. There is

a strong echo of Russian Constructivism, but Smart always ultimately breaks with the grids and geometries to escape to the open seas. Nor is she prepared to limit herself to two-dimensional images of women. The rough-hewn feminine touches to her *Die Dada Puppen* (1999) question the unsullied purity of Conceptual art, a masculine conceit.

Far away at the Western tip of Asia, Nilbar Güreş (b. 1977, Turkey) has similar ambitions to Sally Smart: she also uses collage and drawing to sever the patriarchal shackles. Like Smart, she attaches textiles – a 'woman-prescribed' medium – to paper, but most of her work is a result of performance. Films, photographs and collages are the residue left behind after her occupations of male preserves or bizarre parodies of beautification sessions.

Both Smart and Güreş, international artists exploring global themes, enjoy local specifics and use them to make their universal points. Smart plays on the Australian male psyche's vision of himself as a bit of a pirate, while Güreş's performances are made with groups of victimized Turkish women. Yet their use of specifics is nothing compared with the Yangjiang Group, whose major work is increasingly firmly located in the Chinese city from which they take their name.

On the Monday morning after Art Hong Kong in 2012 a minicab came to pick me up from the Conrad Hotel. The car was already full, and by the fifth hour of driving I was feeling guilty at getting the best seat simply because of my long legs. I felt sorry for my fellow British traveller, the gallerist David Juda, who had a two-day trip ahead of him. He had come along for the ride on the first day of his journey to see Duan Jianyu (b. 1970, China) as he had been told it was a short detour. Still, the Yangjiang Group's gallerist, Zhang Wei, and her partner, Hu Fang, kept talking from the back seat, ensuring our time was not wasted.

I love the idea of travelling to see a work of art. We were on our way to visit the home and studio of Zheng Guogu (b. 1970, China), the leader of the Yangjiang Group, and the architectural project *Age of Empires* (2000–), which I had heard so much about but could not envisage. The anticipation grew, even though, just as we crossed the border into mainland China,

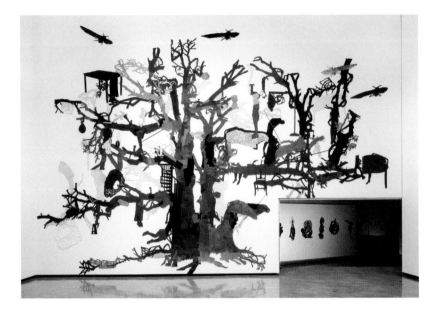

top
Sally Smart
*Family Tree House
(Shadows and Symptoms)*
1999-2002, synthetic polymer
paint on felt and fabric with
collage elements, 10 x 12 m
(32 ft 10 in. x 39 ft 4 in.).

There are elements of a family
tree and hints of a tree house
as Smart builds up her web
of connections.

bottom
Nilbar Güreş
Kaza / Accident
2011, mixed media on paper,
152 x 230 cm (59⅞ x 90½ in.).

Güreş's drawings are often
records of performances in
which women rebel against
the situations they find
themselves in.

Wei informed us that Zheng was not at home: he had decided to go to Beijing for a few days. Although there were some mountains beside the road, it was a flat, straight motorway. When we arrived at Yangjiang, there was uncertainty. We just seemed to be on an extension of the motorway, although the road was now lined with basic shops that looked like open garages. There was endless discussion, but finally we spilled out of the car and into the grey-white building that is home to Zheng's living and working space. The staircase inside had no rounded edges, yet it reminded me of a lighthouse – up and up to the seventh floor. The door was opened by two women, one of whom was Zheng's sister. We found ourselves immediately in a kitchen and dining area with a round table groaning with food. I looked out the window to see the Chinese equivalent of Lucian Freud's back-garden view from his Holland Park studio. I was suspicious of the normality of the place. Apart from two pictures over 2 metres (6 ft 6 in.) square, there was little indication that we were in an artist's house. Certainly the missing owner was interested in interiors and space without being fussy. Function mixed with the decorative in a very easy way, the old with the new.

After we had eaten, Wei and Fang led us on a tour. It was more of a jigsaw than a house. That square communal staircase had been very misleading, as inside there were few sharp edges. Some of the walls were completely covered in colourful religious Tibetan paintings based on the wheel of life. Walking through the different rooms was a real journey. Even the doors were different shapes, with some of them rounded like wheels. There were echoes of Dante's spiralling map of the underworld, except we were going the other way – upwards. The room in which Zheng paints was not marked out in any special way, except that there was an unfinished 2-metre-square (6 ft 6 in.) painting on the wall. The patterns within it were closely based on the older Tibetan paintings next door. Two weeks later I was to see the same painting in its finished form at Art Basel.

I am afraid I am one of those idiots who tiptoes around a studio even when the artist is not there. I never get over the feeling that I am intruding. I had met Zheng before, at one of his food calligraphy performances, so although our single meeting had not prepared me for his home surroundings, I felt his presence.[63]

Indeed, I started to over-project his character. Each room was different, playing on the line between the old and the new. As well as being a painter Zheng is a sculptor, and he makes Ming Dynasty-style chairs that he describes as being 'impacted by a meteorite storm'. They look a little like Diego Giacometti's furniture, but with an extra thousand years of wear and tear, as though they have been fossilized. And as he exhibits them alongside actual Ming chairs, which look much newer next to Zheng's creations, there is a conscious confusion of time.[64]

A shadow passed over me and I ducked slightly – I thought I felt the artist above me. I went up another floor and discovered that the shadow was not the artist but a champion carp. On this extra extended floor, wending its way among the terraces and follies, was a fishpond-cum-stream with the largest carp I had ever seen. Wei informed me that the artist's fish had won competitions for the province. They were fat. Even if I had been quick enough, I would not have been able to put my large hands around their glistening gold, red and white scales. I had seen the shadow as the stream had a glass base, so from above I could see past the fish onto the floor below. I looked up on the way back down and saw the overblown goldfish perform their balletic turns. For generations the masters of brush and ink have paid homage to the dexterity of such fish by emulating their movements with their hands. Zheng Guogu has a private shadow performance while he works.

Our next stop was the Yangjiang Group's new studio. The minicab took us to a small section of the city tucked in between the mid-rise buildings. It wasn't the sort of suburb that I am familiar with. I could practically see the grid lines for the allocation of space for the houses, but they were all highly individual buildings, although often too restrained by their space. It reminded me of New York, or New York as seen in *The Sopranos*. It was as though the directors of the American television series had taken all the buildings they had seen on their drive through the Bronx, Brooklyn and Long Island, shaken them up and squeezed them out onto an enlarged chessboard. The Yangjiang Group's studio, made of bright, white stone, wants to burst out of its prescribed space. There are no big, clear surfaces: it is a concertina of pyramids. Its interior is wilder, somehow a cross between the work

Yangjiang Group
The Morning After:
Masterpieces Written While
Drunk, No.1: 'I Need a New
Kidney to Kill Bin Laden' (detail)
2010, calligraphy (paint on canvas),
498 x 210 cm (196 x 82⅝ in.).

The Chinese collective drink
and draw, and their calligraphy
collapses, demonstrating that
you cannot build a new world
on old traditions.

of Barcelona's architect Gaudí, the impossible fantasy designs
of the Dutch artist M. C. Escher and a playing-card house, but
made in stone. The building work had not been completed when
I visited, but there were still 6-metre-long (20 ft) canvases on
the walls, paintings of calligraphy falling to pieces. A black iron
and stone staircase wrapped its way up the walls, clinging to the
sides for dear life. The floors were not yet finished, so halfway up
the stairs we saw an elderly woman carrying buckets of build-
ing materials up a ladder. She passed a welder sitting on a beam
some two floors up, with nothing beneath him but air and the
sparks from his machine.

I was getting nervous about the time by now as I had a plane
to catch that night from Hong Kong airport. Yet the Yangjiang
Group's environment was proving to me that there are no divid-
ing lines between art and reality. Their work evolves as fast as
China itself. Zheng talks openly about economics:

> When consumerism still hadn't emerged in the large cities in
> China, we had accepted consumer culture from Hong Kong
> media in Yangjiang. Comparing with the planned economy of
> our childhood it is easy to see that the supermarket is definitely
> a great improvement for us. Before, we had to carry a bag of

rice to exchange it for rice noodles in the early morning. The commodity exchange was so hard and we had to stand in long queues all the time. Suddenly you are free to consume and the supermarket turned out to be heaven. You can buy whatever you want. So in the piece, *AD2000, Rust Another 2000 Years, 1*, I cast the commodities that we found on the shelves in the supermarkets in iron. This is my response to heavy memories of the commodity exchange of my childhood.[65]

Zheng Guogu
*AD2000, Rust
Another 2000 Years*
2007, brass,
dimensions variable.

Commodities are in danger
of rusting before we find a
perfect economic and/or
political system.

In one sense Zheng's sculptures are an interesting take on Andy Warhol. For instance, he casts Coca-Cola cans, but all you see is a rusted brown canister, which is very heavy if you try to pick it up. This may be a condemnation of the old commodity exchange, but it also highlights the malfunctioning of capitalist markets. It is as though the whole timing of exchange has gone awry.

Finally we drove into the countryside in pursuit of *Age of Empires* (2000–), a vast complex of exhibition spaces and garden areas that draws its inspiration from the video game of the same name. We rounded a corner in a lane and were presented with two large ponds protecting a building site. In a gangster television series we would have arrived to discover the dumped bodies, but alarmingly 'superior' minds were the creative directors of this location. The ponds were made with massive boulders of carefully selected shapes, boulders with the shapeliness of a Hans Arp sculpture or a scholar's rock from a classical Chinese garden. Traditionally, rocks were seen to carry spiritual meaning. They were like temple guardians. It made me think of how the stones used to build Stonehenge were dragged for miles.

There is a gloriously maverick element to *Age of Empires*. It is a form of muscular anarchy. Mind and matter are moulded together. Some might think that it shows up Zheng Guogu as a pastiche of a Yangjiang warlord; but while parodying the very real planning crisis in China, and indeed the rest of the world, the construction project is no mere folly. The work's incomplete state is important. While we were there, a man was polishing a parquet floor of an octagonal room with an unfinished roof.

The complex is art compass dream territory. It heightened my sense of being lost. This was glorious isolation. Travelling from room to room, I thought I might discover absolutely anything, and in one of the central rooms I did get a surprise. I was on my own several rooms away from the nearest visitor or worker in this contemporary ruin, contemplating the connection with the eighteenth-century British vision of personal empire-building; *Age of Empires* is based on the older Chinese tradition, but the clash of an encrusted classical past and the forces of nature was similar. I was standing in a half-built room, not thinking what I was looking at. The belly laugh welled up inside me and burst out, even before I fully realized that I was not back at the art fair, for there in front of me in this apparently abandoned space was a 3-metre-long (10 ft) painting by Zheng. It was from *Basel* (2007–8), one of his series of paintings of art fairs around the world. This particular painting, tucked away in its half-idyllic sanctuary, was the ultimate in art globalization, even though it only depicted three people in the small Swiss city. It was based on a highly posed publicity shot for the most famous art fair in the world: it was a picture of the three people who replaced Sam Keller as directors of Art Basel – Annette Schönholzer, Marc Spiegler and Cay Sophie Rabinowitz – and they were alone with the Art Basel logo emblazoned above them.[66] One cannot escape the power of the market.

Painting is just part of the Yangjiang Group's armoury. There is a disparate group of Chinese and Korean artists, however, who are painters through and through, and feel painting is the best way to express the push-pull of the self: Duan Jianyu, Jia Aili, Lee Eunsil and Lee Youngbin. Perhaps the best known among them is Duan (b. 1970, China), whom David Juda was on his way to see in Guangzhou, although Jia (b. 1979, China) has had a

meteoric rise. In 2011 at Art Hong Kong he was relatively unknown, but the next installation of his that I saw had a price tag of hundreds of thousands of dollars.

Jia's paintings often highlight the loneliness of figures in a desert-like landscape. He has admitted to being 'too innocent to nurture the navigational skills required to ride out the storm of change'.[67] His installation *Hallelujah* (2012), which I saw in a disused residential block half an hour from Art Hong Kong, certainly appeared as uncommercial as possible. It consisted of two life-size figures of Karl Marx, one dressed in a space suit, surrounded by piles of paintings. The canvases are stacked high so that you do not know what they depict, you just know the images are there. They are meticulously finished paintings, which the artist has spent months working on. There is a tradition in painting of hiding much of the work beneath the surface. From the dozens of layers of gold laid on the early altarpieces to add value, to Titian's intricate combination of glazes, washes and paint, to Frank Auerbach's insistence on scraping off each day's work so he could start afresh the following day, it has long been acknowledged that much of the art of painting is unseen. The more I look at paintings, the more I treat them as an archaeologist treats earth that might reveal ancient secrets. In *Hallelujah*, Jia is playing on this idea of buried history. The long table in front of the dual figure of the father of communism could almost be a coffin. One Marx looks forward as an astronaut; the other looks back like an antiquarian bookseller. The whole charade is smothered in the dust of stalemate. 'Hallelujah' should be an instantaneous expression of joy, but this work talks to me of suppressed emotion, of buried life. It needs a Nietzschean frame of mind – a mind that embraces chaos over order – to call this dust-covered pile *Hallelujah*.

The blatant sexuality in the pictures of Lee Eunsil (b. 1983, Korea) challenges the closed nature of Korean society. My visit to her studio was appropriately furtive. Her gallerist, Emma Son, drove me through the Seoul traffic to a block of anonymous studios, indistinguishable from those in New York or London. Lee's large canvases were resting in the corridor outside. She had given birth only days before, but had kindly insisted on keeping our appointment. I later learned that her husband had moved all

Jia Aili
Hallelujah
2012, installation of painting
and sculpture, dimensions
variable.

Our appreciation of Jia's
paintings has to change when
they are stacked up like this.

top
Lee Eunsil
Confrontation
2008, ink on Korean paper
stretched on canvas, 130 x
180 cm (51⅝ x 70⅞ in.).

The confusion of the sexes
encapsulates the complexity
of the confrontation between
old and new.

bottom
Lee Youngbin
Bath
2011, Korean ink and
watercolour on paper,
127 x 159 cm (50 x 62⅝ in.).

Lee Youngbin explores a slow
contemplative understanding
of the self.

the paintings and then made himself scarce. Sitting in her studio as if it were her living room, she spoke with the same combination of ambiguity and directness that is found in her paintings.

'Korean interior spaces can appear to be wide open,' Lee Eunsil said, 'but are in fact often closed off.'[68] She uses Korean buildings both as a stage and symbolically. Despite the two erect penises at right angles to each other in *Confrontation* (2008), there is a blurring of the sexes. 'I want to explore the interior map of my body, to go inside it,' she declared, explaining her attachment to the use of paint by describing another picture: 'The title, *Take Off*, is about the paint. There is a lot of escaping from the paint, from the problems – the mess. He is taking off the skin of his body and all that is left is this rather weak ego that might drift off in a puff of wind. There are two skins in the painting, the male one and the female neatly folded away under the chair.' She paints thinly on paper laid down on canvas, which makes her surfaces very tactile. It makes one want to touch the obviously delicate skins of her paintings.

I am glad I met Lee Youngbin (b. 1980, South Korea) on neutral ground in her gallery as she is reclusive. It was as though my questions to her, relayed by the gallery team, were hand grenades. To enter her personal space, which is very much the subject of her work, on first acquaintance would have been an outright invasion. I asked about the symbolism of a stepladder in one of her pictures. Minutes later she responded, 'Change is like falling off a ladder.'[69] I could feel the bump of her landing. (Apparently this had happened to her as a child.) Her world revolves round her house and old-style baths, which she describes as 'my space'. In her series *Bath* (2011) she often pairs together gardens and baths so that they are placed beside each other, with one leading to the other, symbolizing the inside and outside, her interior and exterior. The colours and style conjure up Ambrogio Lorenzetti's frescoes of *Good and Bad Government* (1338–39) in Siena, and one senses in her work the same strictness of thinking, yet if one looks at the grids of tiles in *Bath*, the order of the images, there is little attempt at straightness. In the pictures, the order in her world is challenged. 'I want to share the fact that we are not in control. There is a co-existence of orders.'[70] There is a spirituality to Lee Youngbin that speaks of another time and place but,

much like Cao Fei, the purpose of her work is to show that there is little division between worlds. She reflected for a long time on our meeting and months later sent me a message: 'The spiritual world is not a faraway star that cannot be one's world.'[71]

I cursed the fact that I did not allow another day after Art Hong Kong to go on from Yangjiang to Duan Jianyu's studio in Guangzhou, but two weeks later I got an opportunity to study her work at a private retrospective on the top floor of Rita and Uli Sigg's castle in Switzerland. Uli, a former Swiss ambassador to China and North Korea, has the best collection of contemporary Chinese art outside China, much of which he is donating to M+, the Kowloon museum due to open in 2017.[72] He arranged for a bus to bring artists, curators and friends from Art Basel to his home. It was a beautiful setting in which to see Duan's work. I was desperate to see a cross-section of her oeuvre, as I had disliked the first painting I saw by her. Some of her paintings, such as those from the *Artistic Chicken* (2003–6) series, are funny but difficult, not always yielding their power quickly, let alone instantly.[73] Much of their content is left unsaid. They rely on seduction. In its basic composition, *Goodgood Morning No. 10* (2007) would work as a postcard or an old idyllic image, yet most people would saunter past it. We are drowning in images: we are bombarded by advertisers and the efforts of the camera in all its formats. Equally, when someone says 'Good morning' to us, we don't usually question the asser-tion. 'Goodgood Morning' is more likely to get our attention. The writing in the pictures supplies a similar grit. At times Duan's version of Baudelaire's idea that some ugly blemish is needed to complete beauty is too much for me, as when, in one of the *Artistic Chicken* paintings, a roasted chicken replaces a live one but is still treated as the main subject. This is one drawback to Duan's real achievement of giving her paintings a life of their own. Her paintings demand a relationship.

Zhang Wei sees Duan as opening up 'a crack in the real world that lets us briefly slip the bonds of social conditioning...her paintings open up a door for us'.[74] The doors she opens are only slightly ajar, or sometimes, as I experienced at the beginning, completely closed. I was given two chances in Schloss Sigg to remedy this. The first was climbing up the ladder into the castle's

Duan Jianyu
You are welcome No.2
2009, oil on canvas, 181 x
434 cm (71¼ x 170⅞ in.).

There is an innocence to
Duan's painting that is never
the full story.

capacious loft to see the display of paintings. I stood in front of
them and tried to work out why I liked them. I didn't do very
well. The chicken still worried me. But my eye trotted around
enjoying itself. A couple of hours later, when it was time to leave,
I was standing with the thirty other guests by the bus to go back
to Basel, talking happily to the Siggs, Hu Fang and another
friend, Pirkko Ackermann, who had introduced me to the Siggs
at Frieze London in 2007. I was about to make a rather obvious
comment about the circles we make in life, as it was also on that
occasion that I first met Wei, when I noticed she was missing.
Her partner confirmed that the bus was waiting only for her.

At that moment a little figure popped out of the castle. Wei
could have been a character in one of Duan's paintings. It was
a fairy-tale image. I was looking back over a bridge across the
lake. The rich evening sun caught the painted woodwork of the
hilltop castle. Down the path tripped a tiny figure. I went to
greet her on the bridge and discovered she was carrying doggy
bags of food. She had obviously charmed the cook in the same
way as she charms everyone else with her curiosity about all
that is important in life. Wei would be a perfect Duan Jianyu
heroine, as she blends everyday canniness with fairy-tale magic.
Not everyone walks into a castle and comes away with a supply
of delicious food. Not everyone looks at Duan's paintings and
is fed by them. Wei teaches us to pass lightly between worlds.

Isolated genius is the exception. Most of us work in groups,
like Yangjiang, Raqs or even the Cai studio. The art market, of
course, still clings to the notion of solitary artistic genius, but
it will change to reflect the times. Raqs talk of working through
'dissensus' rather than accepting a more passive consensus. As
they say, working together 'sometimes means three people in
turbulent disagreement, but there are other moments, as in jazz,
when one is "playing in praise" of the others'.[75] The role of the
artist is evolving fastest in Asia.

NORTH
 EUROPE

We are scared of getting lost, but I was quite glad to be hope-
lessly adrift on my first and second trips to the magnificent
Moscow Metro. I apologize to the charming woman from Art
Moscow who had to come to extract me from the system![1] I
was fully armed with a Metro map, but I can't read the Cyrillic
alphabet and so could not work out the names of the stations. To
get off or not to get off, that was the question. Two weeks later
Laure Prouvost (b. 1978, France) summed up my predicament
as I saw her fix to a door between the tents in Regent's Park a big
sign that read, 'You are going in the wrong direction'. This was
part of Frieze Projects at Frieze London in 2011. Prouvost was
playing on the same sense of insecurity I'd had in the Moscow
Metro, reminding us control freaks of a basic truth: 'You make
mistakes, you learn from mistakes.'[2] That is how we learn to
orientate ourselves.

Europeans are not at the centre of the universe. Millions of us
need serious reorientation, not only in relation to the rest of the
world, but also internally. Europe has changed dramatically since
the collapse of the Berlin Wall in 1989. Altuf'evo, Clignancourt
and Cockfosters are the ends of lines in the Moscow, Paris
and London undergrounds, and it is end-stations like these that
become our signposts. We learn as much from the periphery as
from the centre. Equally, in trying to define European contem-
porary art, we must look to the border cities between Europe
and Asia, such as Moscow and Istanbul, and the friction between
Africa and Europe. There was a dramatic example of this at the
Venice Biennale in 2011 when the Poles devoted their exhibition
space to the Israeli artist Yael Bartana (b. 1970, Israel). As part

top
Laure Prouvost
You are going in the
wrong direction
2011, oil, varnish and collage
on wooden panel, 25 x 29 cm
(9 ⅞ x 11 ⅜ in.).

Prouvost's humorous hand-painted
sign informed visitors to Frieze in
London that they were going in the
wrong direction.

bottom
Yael Bartana
Mary Koszmary
2007, one channel super 16 mm
film transferred to video.

Bartana turns the tables with her
Neo Nazi-style campaign rallies in
support of the repatriation of three
million Israelis to Poland.

of her installation *...and Europe will be stunned* (2007–11), which consists primarily of a video trilogy, the entire Polish Pavilion was turned into what originally appeared to be a mirror image of the Nazi rallies that incited the Holocaust. In the video, however, speaker after speaker came to the podium to advocate the repatriation from Israel to Poland of three million Israelis. This was a brave decision by the Polish commissioner, confronting Poland's past while postulating a very different future.

Poland is at the heart of change in Europe. The dissolution of the Soviet empire has helped create some of the most radical art of the twenty-first century, reflecting the shift in balance to the east. I see most exhibitions in the traditional art centres – London, Berlin and Paris – yet to get a real understanding of what is happening in Europe it would be more effective to visit a handful of artist studios in the Czech Republic, Bulgaria, Slovakia, Estonia, Serbia and, of course, Poland. In truth, the owners of these studios come to London and art fairs around the world, so I don't get to see these places as much as I would like.

I feel guilty that I have never travelled to Sofia to see Nedko Solakov (b. 1957, Bulgaria) as he is terrified of flying. Indeed, he has made a haunting early painting, *Fear* (1987), showing himself as a tiny scared torso in the porthole of a plane. Solakov is an art barometer. His Conceptualism can be understood. He has led the way in crushing the taboo against storytelling. He clearly demonstrates that colonialism is not only a European export.

Solakov and I had our first conversation in the deserted Deutsche Bank Lounge out of hours at Frieze London in 2009. It was at another art fair, Arte Fiera in Bologna some ten years earlier, that I had first come across his small and amusing drawings. There has hardly been a fair since at which I have not chuckled at one of these pictures. To begin with I just thought they were funny, but by the time we were sitting together on a banquette by a long Perspex tent window at Frieze, I knew that Solakov is not just a voyeur and commentator. He seriously wants to change our behaviour.

In an early satirical self-portrait Solakov looks like the Australian outlaw Ned Kelly. Blend this with his series of drawings that

relate the tale of his very own artist-superhero, *El Bulgaro* (2000), and you have the man next to me on the banquette. I thought originally that the El Bulgaro character was a joke at El Greco's expense. Rather than being emaciated, like the figures produced by the Greek maestro, Solakov's self-image in the guise of El Bulgaro is a jolly Falstaffian figure with a subversive tongue and pen. His mission is to salvage Bulgarian art from its obscurity. His success, as with most populist rebels, is in making a specific appeal universal. He is a champion of the small against the large, the periphery against the corrupt, crumbling centre.

Having survived harsh regimes, Central and Eastern European artists are not prepared to roll over and accept the dictates of the market-led art world. Nedko Solakov, Dominic Lang, Ivan Grubanov, Anri Sala, Adrian Paci, Roman Ondák and Timo Toots all challenge the assumptions of an easy transition from communism to capitalism. Their art questions the foundations of new societies. As soon as Bulgaria won its independence, Solakov made *Top Secret* (1989–90). Inside a filing cabinet, reminiscent of the Bulgarian secret police's own files, are cards reporting Solakov's career as a boy-wonder informer. Not only is Solakov-the-schoolboy's integrity called into question; so is the very nature of man. We are still the same people who allowed this to happen. The work interrogates our past, but also asks us how we are going to ensure that the same events do not happen again.

One is never safe from Solakov's ideas. Exactly two years after he sat with me in the early morning autumn sun in the Frieze tent, a big yellow blob sprung up on the 12-metre-long (39 ft)

Nedko Solakov
El Bulgaro
2000, mixed media and texts, dimensions variable.

El Greco's fictional alter ego, the superhero El Bulgaro, comes to rescue Bulgaria from artistic obscurity.

Nedko Solakov
Top Secret
1989-90, acrylic, drawing ink,
oil, photographs, graphite,
bronze, aluminium, wood and a
shameful secret, 14 x 46 x 39 cm
(5½ x 18½ x 15⅜ in.).

Just weeks after the Bulgarian
secret police lost control of
the country, Solakov made this
memorial to his own collaboration.

wall in the Deutsche Bank Lounge at Frieze in 2011. I like to see it as a commemorative plaque, a viral result of our talk, as it grew on the same spot. It was a virulent lemon-yellow splash of paint that filled three-quarters of the wall. There were echoes of Robert Motherwell, Franz Kline or some other aspiration to abstract purity, but it was worryingly unfinished. Along one side, in a delicious longhand, was a message from the artist: 'I ordered this yellow blob from the exhibition assistants but later on I completely forgot the reason for this.'

The Yellow Blob Story, from The Absent-Minded Man Project (1997–) makes fun of pure thought, the idea that we can communicate abstract concepts to each other. A month earlier I had introduced Solakov to a group of Deutsche Bank staff at his show at the Ikon Gallery in Birmingham.[3] The best way I could describe him was to ask the group to imagine the most difficult member of staff. 'You know, the one who sends you an email and that's fine, but five minutes later they amend it, and then amend it again, and then again.' Solakov shows us the dexterity of thinking needed to keep up with an idea. This he makes very clear in his installation *A Life (Black and White)* (1998–), which the curator Rosa Martínez has dubbed 'Malevich in motion'. I came into a room that was in the middle of being painted white by one painter, but as soon as it was nearly all white another painter came along and painted it black, and so on, and so on. Nothing ever stays the same.

That autumn, one of my walks in Kensington Gardens was interrupted by the burly saxophonist André Vida blowing mournful notes through holes in the walls of the Serpentine Gallery.

Anri Sala (b. 1974, Albania) had created false walls from blown-up versions of cardboard music scores from a street organ. Inside the gallery I found three interconnecting films and the saxophonist in the corner, as though he was trying to escape the aural claustrophobia of the installation. The whole show seemed to be tuned into the restlessness of a street organ player, the nomad's music establishing his very right to existence by the persistence of the beat. The prevailing question that kept on returning, the rhythm of the whole exhibition, was a line from a song by The Clash, repeatedly beating out of a barrel organ in one of the films: 'Should I stay or should I go?'[4]

'Should I stay or should I go?' With this choice, reiterated ad nauseam, I could not avoid thinking of the mass exodus from Albania in recent years. I give you Sala's description of his education at some length, as it not only explains why he left Albania, but is also an exposé of how the art world works:

> Museums have always been able to tell things as a linear and uninterrupted story. I think it's a Western call for order and legitimacy rather than an objective, linear, uninterrupted story. In my case, my knowledge of the world and of art has been messy and unsystematic since the beginning. During my art studies in Tirana, because of the ideological oppression and isolation, anything that didn't fit the narrative of the system – all art made after the 1920s, besides social

Anri Sala
Long Sorrow (production still)
2005, super 16 mm
transferred to video projection,
colour, stereo sound, screen
dimensions variable.

The music seeps through the
cracks in our defences against
the power of art.

realism – was banned and ignored. I remember trying to fill the gap every now and then by seeing books that had entered the country illegally. These books arrived not in chronological order but irregularly and without order. Sometimes pages were missing or text was left without the corresponding images, which had been cut out and perhaps taken by someone who'd had the book before. So I would read about something I couldn't see, and my imagination would do the rest. Even now I cannot tell whether when I saw something new and strange I liked it for its innovation and strangeness in its time or for its being subversive in my own time. Now imagine if the history went as follows: once upon a time there was first Magritte and then Picasso, then entered Duchamp, then Bruce Nauman came along and then Kandinsky, then Andy Warhol and then Joseph Albers and Yves Klein. With time I solved part of that puzzle, but as I moved to France I saw many movies and exhibitions without any order, and the puzzle became only bigger. Later when I got to know Philippe [Parreno], Liam [Gillick], Olafur [Eliasson], Rirkrit [Tiravanija], Gabriel [Orozco] or Carsten [Höller] before even knowing most of their work, imagine how all of this new input electrified my earlier mess. I don't try to put all of this in order because I suppose historical order is only one of the possible narratives. I prefer my emotional order and the creative misunderstanding that it may have produced.[5]

Sala's training under one of the most despotic regimes in Europe seems to have prepared him well for the art world. I would only dispute his first sentence: 'Museums have always been able to tell things as a linear and uninterrupted story.' Nowadays few museums give us a story; they do everything to avoid one. Their confusion, their mess, is sadly not usually as lucid or honest as Sala's. This is one of the reasons why I have opted to tell my story through the artists. We probably share elements of Sala's haphazard experience of learning about art, but in mentioning his relationship to his 'hot' contemporaries, he is alluding to theories such as those set out by Nicolas Bourriaud in *Relational Aesthetics* (1998), which tries to explain art through human relationships.[6] Of course, there are probably fewer lateral connections between artists than linear. Was Tracey Emin (b. 1963, England) arguing that horizontal connections were more

Anri Sala
No Barragan No Cry
2002, colour photograph,
63 x 78 x 3 cm
(24 ¾ x 30 ¾ x 1⅛ in.).

The title of Sala's photograph
refers to a sculpture that was
once in the garden of the Mexican
architect Luis Barragán, but the
image is also about being lost.

enjoyable than vertical ones? By transforming a tent into a patchwork noticeboard of her lovers' names, writ large in coloured letters, in *Everyone I Have Ever Slept With 1963–1995* (1995) she gave us a laugh, but do we seriously believe that Emin and Damien Hirst's network of YBA 'friends' were coherently trying to change the world they saw in the 1980s and '90s? They were not even attempting to do so. Hirst (b. 1965, England) may have taken Andy Warhol's Factory concept one step further by incorporating the very mechanics of the marketplace into his work, but Sala's generation of artists is more ambitious.

The designer of this book originally chose Sala's *No Barragan No Cry* (2002) for the cover as it looks like a confused compass. The photograph was inspired by a sculpture that was once in the garden of the Mexican architect Luis Barragán, but let's not get sidetracked. This is about being lost. The rooftop city terrace is nondescript. The horse's pedestal appears to be a security bollard, something to stop us going where we shouldn't. The poor animal is more uncomfortable than I was on the Moscow Metro, but it makes the same point. We have to be prepared to lose ourselves, to get rid of our lateral and linear bearings, in order to appreciate each individual artist. Yet the awkwardness, the obscurity of this photograph and other works by Sala remind us that losing ourselves is not enough. Bourriaud's follow-up to *Relational Aesthetics* was an end-of-history-style book called *Postproduction* (2001) that had one very entertaining idea.[7] He compared artists and other movers and shakers of the art world to DJs 'selecting cultural objects and inserting them into new concepts'.

Another Albanian, Adrian Paci (b. 1969, Albania), gives us a similarly bleak image of global travel in his video *Centro di Permanenza temporanea* (2007). While aeroplanes fly in and out of

Adrian Paci
*Centro di Permanenza
temporanea*
2007, C-print, linked to video
of the same title, 120 x 140 cm
(47 ¼ x 55 ⅛ in.).

Paci cast immigrant day
labourers, some illegal, in his
video about displacement. The
title is a reference to the Italian
detention centres that house
illegal immigrants and refugees.

one of the world's countless airports, a single line of people, migrant workers in search of a better life, walk in an orderly line up a runway towards the camera, casting short, sharp shadows in the hard sun. They come up the steps of an aircraft stairway. The camera examines their faces with the same scrutiny as the sun. They all have weather-hardened faces and their clothes are worn. In art-historical terms these are the shipwrecked sailors on Géricault's *Raft of the Medusa* (1818–19) rather than Delacroix's idealized revolutionaries pouring over the barricades in *Liberty Leading the People* (1830). It is not just the look in their eyes or their clothes that distinguish them from every other traveller. They have no luggage. The high point of the film is the shot reproduced here, when one sees that the workers have been walking across the tarmac and up the steps, and the camera pans out to reveal that there is no plane attaced to the gangway. There is nowhere to go. Finding our bearings is not always enough. Man-made boundaries and laws restrain billions of people who do not have the option 'Should I stay or should I go?'

Timo Toots (b. 1982, Estonia) lives and works in Tartu in Estonia, but I met him at the Café Mayak in Moscow in 2011. I had seen his *Media Bubble* (2008), an interactive electronic

piece, the day before at the Moscow Biennale. Once I trod on the rotating plate I became a media bubble, and the more I danced, the more I became the tool of the world press, covered in video-projected words. The 2011 Moscow Biennale succeeded where some of Bourriaud's exhibitions fail (the writer is also a curator). The rhetoric made no attempt to outshine the art. I was lucky enough to be introduced to the Biennale's Director, Peter Weibel, who has also been CEO of the Center for Art and Media in Karlsruhe since the beginning of the millennium.[8] We had a coffee and sandwich together in the almost empty café of the ARTPLAY Design Centre, far removed from the glitz of the smaller part of the show at the TSUM department store. Weibel took this split-personality destination of his exhibition in his stride. His essential premise was not that far removed from Bourriaud's. Indeed, the title of his biennial, 'Rewriting Worlds', has a vague echo of *Postproduction*. As Weibel wrote in his introduction to the catalogue, 'The contemporary art and contemporary world are part of a global re-writing program.'[9] The echoes of historical revisionism are chilling, but with our sandwiches gone and too much coffee-coloured liquid left in our paper cups, Weibel explained some of the links between artists such as Timo Toots, Charles Sandison, Shilpa Gupta, and Christa Sommerer and Laurent Mignonneau, who all use modern technology in their work. Yet he managed to give these artists a natural context alongside famous painters like Gerhard Richter and Neo Rauch, and to introduce new artists: Lada Nakonechna (b. 1981, USSR), in particular, caught my eye.

Nakonechna attacks the status quo of an art market dominated by the commercialism of Damien Hirst and Jeff Koons. She presents straightforward, almost mechanical drawings of locations around the world. In creating the drawings she treats herself as an average employee of the country she depicts, working out the cost of production. So, for instance, in a 2010 series of delightfully simple line drawings of the Swiss countryside, she writes along the bottom of the images: 'Made in Switzerland/date/9 hours work/average price per hour – 35 francs/total cost – 315 francs.' For the landscapes of her native Ukraine, the label reads: 'Made in Ukraine/date/8 hours work/average price per hour – 13 hryvnias/total cost – 104 hryvnias (104 hryvnias =

Made in Ukraine /06.02.2012/ 1 working day/8 hours/ from 8 a.m till 5 p.m / middle price per hour – 13 hr Total – 104 hr

Lada Nakonechna
Cards
2010, pencil drawing on
paper with working time.

Nakonechna's drawing of the
Ukrainian landscape is cheaper
than its Swiss equivalent to
reflect the different average
wages in the two countries.

13 francs).' The drawings are a blunt rebuttal of the equation made by artists from Warhol to Hirst that art equals money.

Russia gives its own insight into cultural commercialism. Some of the biggest collectors in the world are Russian. The oligarchs continue to drive the top end of the global art market. Yet when I went round Art Moscow, which in 2011 was on at the same time as the Moscow Biennale, the gallerists complained that the billionaires don't support their own. There is a certain justification for this, as Russian artists appear to have been among the slowest in the whole ex-Soviet Bloc to react to the change of circumstances.

This delayed artistic response to the dissolution of empire was brought home to me the following evening in Moscow when I went to an opening night at Winzavod, a cluster of galleries in upmarket industrial units. At Regina Gallery I saw a pair of small oil paintings by Egor Koshelev (b. 1980, USSR). I thought time had done a full twenty-year circle and I was looking at an early 1990s' Neo Rauch (b. 1960, Germany). One painting showed a muscular labourer in the spirit of Rauch, a worker drilling at a sculpture of a bear and an eagle. I read it as an attempt by the artist to end the polarized art world of recent years. The sculpture could be a reference to the double-headed eagle of the Russian Empire, which faces east and west, but one eagle is replaced by a Russian bear. In the other painting a family looks secure riding a bear. Koshelev is destroying the black-and-white world of capitalism/communism.

Egor Koshelev
Untitled
2011, acrylic on cardboard,
79 x 59 cm (31⅛ x 23¼ in.).

The full effect of the collapse of
the Soviet empire is only beginning
to be felt in Russian art.

Erik Bulatov
Liberté II
1991, oil on canvas,
155 x 295 cm (61 x 116 ⅛ in.).

There is a rare power in the way text combines with image in Bulatov's painting, as though they each benefit from the equal weighting.

This divide was once almost unbridgeable. In the 1970s the Moscow Conceptualists made work with no realistic hope of sales. Ilya Kabakov (b. 1933, USSR) and Erik Bulatov (b. 1933, USSR) relied for years on the response of their closely knit group of fellow artists and intellectuals, who would meet in each others' studios and flats.[10] This encouraged the purest of all Conceptualism, a system of thought devised for a situation where every word and image might get you into irreversible trouble. The artists' need to hide and reveal meaning at the same time led the leading critic of the movement, Boris Groys, to interpret Moscow Conceptualism as essentially a balancing act between text and image: 'In our present age, the individual human being no longer holds a monopoly on the creation of either pictures or texts. And it is precisely this circumstance that allows him to eliminate the opposition between image and text, for he no longer has to ask himself, which am I – writer or artist?'[11] Word and image unite in Bulatov's painting *Liberté II* (1991) and are indivisible from the grand concept of liberty itself.

Weibel did not include any of the Moscow Conceptualists in his biennial, but he did show Lada Nakonechna's work. The relatively unknown Koshelev was also not included, but Neo Rauch, now a superstar, did feature. I was surprised to see Rauch in among all the mod-con art. He looks for redemption in figurative painting, the straightest of all art forms, unlike the artist duo Christa Sommerer (b. 1964, Austria) and Laurent Mignonneau (b. 1967, France), who seek it in machines. Sommerer and Mignonneau showed *Life Writer* (2006) in a dark room at the Biennale. The sculpture consists of a basic typewriter and, like Toots's *Media Bubble*, it requires audience participation. I keyed in the sentence 'The equality of materials and media is the artistic equation of our time,' but the words did not come out like

that on the paper above the machine as it had been modified.[12]
The 'paper' was a miniature screen and the machine ate my
concept, or rather ate Peter Weibel's formula as they were his
words. Little spiders ran out all over the screen to consume the
words. The artists encourage us to type our thoughts onto the
blank page, only for them to be devoured by the artificial forms
that emerge from the machine. I am not quite sure what Groys
would make of this. One could say that the image destroys the
text, but it is a Pyrrhic victory, for eventually the blank page wins.
This spurs us on. We have to aspire to another way of life. Neo
Rauch paints relentlessly in the same fashion. As he says, 'For me,
painting means the continuation of dreaming by other means.'[13]

I apologize for going off at tangents. I have rudely left Timo
Toots dangling in the first-floor bar at the Café Mayak, once
a club for the actors at the theatre next door and now open to
all. But don't worry; Timo wasn't bored, he had his laptop with
him. Café Mayak isn't a heavy-drinking club. The staircase to
the first floor had Daniel Buren-style, thick red-and-white-
striped wallpaper. Rounding the corner of the staircase the
room seemed simple and wooden – parquet floor, the walls
lined with plain dressers, plain brown tables and the simplest
of bow-backed chairs, set off with a few colourful glass lights. I
was with a group of gallerists, including Olga Temnikova from
Tallinn, so we joined Toots at his table. I said I had enjoyed
Media Bubble and Olga urged me to see another work, *Memopol*
(2010). Toots had information about it on his laptop, so between
vodkas, which I vaguely recall had some dodgy concoction at
the bottom that looked like a glass eye, I learned about *Memopol*,
an installation that reminded me of reading those last inevita-
ble chapters of Orwell's *1984* – the conclusion that grinds the
resistance out of the lonely, rebellious individual. *Memopol* has
the tacky finish of *1984*, as I discovered when I finally got to see
it in Basel, some nine months later.[14] Outside a closed curtain
there was an official-looking sign warning visitors that it was a
private area. I did not have to share my entire life with strangers
if I did not want to, but I walked in with a group of friends. The
space was dark but packed with brightly lit panels. It reminded
me of an air-control tower. I read the instructions and followed
them, placing my passport in the mouth of the machine, which
then started to tell me about my life, in words and statistics

top
**Christa Sommerer and
Laurent Mignonneau**
Life Writer
2006, interactive typewriter,
dimensions variable.

Little spiders run out onto the
'page' to eat the participants'
words as they are typed.

bottom
Timo Toots
Memopol-2
2011, multimedia installation,
dimensions variable.

Toots's machine uses
international databases and
the internet to make Orwellian
social portraits of its users.

on the screens, and in Toots's very own Estonian Big Brother voice. It was a digital mirror: my life came spewing up. Amid my embarrassment at seeing and hearing my list of diseases, long line of car infringements and lack of any declarations of love on any social network, I wished I had come with Nedko Solakov, whom I had seen on the tram the day before. Maybe *Memopol* would have been able to get to the bottom of some of Solakov's top secrets; perhaps it could have told us whether he had really collaborated with the Bulgarian secret police. The machine was relentless – it had me in its black plastic claws. Its very synthetic nature added to the indignity.

Estonia's transition to capitalism has been apparently the smoothest of all the former Soviet republics (it is the richest per capita) and it has become one of the most technologically developed countries in the world, with the greatest collection of data. This was clearly demonstrated when, six weeks after Basel, I went to Tallinn to interview Toots. I had been invited to speak on a panel with Olga Temnikova at Tallinn's Month of Photography festival. Part of my reason for accepting was that I would be able to continue talking to Toots about *Memopol* as I had been promised he would come from Tartu to Tallinn for an interview. I loved the medieval city. For some reason Tallinn's strong and picturesque battlements made me think I was in Hamlet's Elsinore. The panel discussion, in the stylish Kumu Art Museum, went swimmingly. I was told I was going to meet Toots afterwards. I went with the other panellists to a dinner, where our PR hostess was in medieval costume. Toots was not there.

'Where's Toots?' I enquired.

'We are meeting up at the party,' replied Olga. The intoxicating smell of honey and a confused sense of time soothed me. We went on to a party in a building that seemed to be part of the city's ancient walls. Half of Tallinn was there, but not the creator of the torture instrument *Memopol*. The music in the backyard was loud and reminded me of The Clash at Anri Sala's exhibition.

'Where's Toots?' I asked.

'He was here,' I was told, 'but he has gone on to another party.'

Should I stay or should I go?

The other panellists nobly understood that we had to go on to find my interviewee, but he wasn't immediately visible at the next party. Five minutes passed before Olga told me that Toots was with Indrek Kasela, the co-director of her gallery, at a birthday dinner party.

Should I stay or should I go?

The beat of the song was right in my head. Sala made me think of the connections between artists in former Eastern Bloc countries. He is the patron saint of the wanderer; his art spoke to me then of intellectual wanderlust, the need to escape the limitations of our ever-enclosing walls. His explanations for the world, from this distance, at this time in the early morning, seemed lyrical as well as powerfully repetitive. Yet The Clash's lyrics blended with a feeling of introspection. Here I was, going from party to party with people from my daughters' generation, in search of Timo Toots, the man who created *Memopol*, a machine that finds out the truth about you. Like any successful art work, the machine made me question myself and dispute the easy computerized answers.

In another taxi across Tallin I decided why I had a weakness for artists, why I let them lead me like the stars in the night sky, which that night reminded me of the sky above the Red Square in Moscow the first time I met Toots. It was Francis Bacon (who convinced me that it impossible ever to rid oneself of the myth of the bohemian artist. I was still in my twenties when Bacon granted me an interview, on the condition that we talk about art for thirty minutes only. He insisted on buying the champagne as he only drank Krug. A single bottle cost more than my fee for the British political magazine *The Spectator*. We got through three bottles in the half-hour allotted to art. We then had lunch and disappeared for the rest of the day and most of the night to the Colony Room drinking club in Soho. Bacon was the epitome of the Anglo-Irish binger. He would work for weeks in his studio in Reece Mews and then go out drinking for seventy-two hours on the trot. On that occasion in 1985 I stayed out drinking until the early hours of the morning, but Bacon just carried

on and on. It was his way of life: it was as real to him as his own, occasionally asthmatic, breathing.

Back in Tallinn, as I walked into our fourth party of the night, I was informed that Toots was there, but my eyes were full of other sights. It was as though I had walked into a film set. There was a long table, much like the one in the pivotal scene in the film *Babette's Feast* (1987), but it was not just good flavours that were available at this Estonian, rather than Danish, dinner.[15] Every one of Baroness Blixen's puritan guests' senses would have been reeling, as the narrow table was groaning not only with food, but also with ornament. It was sensory overload. Indrek Kasela was presiding at one end like a young Bacchus, surrounded by bottles of wine and watching with detached pleasure a young girl in a long red dress and pink ostrich boa tread decorously around the debris on top of the table. I don't know how she did it, as there were only a few square inches of bare white tablecloth left. The party was like a champagne bottle that had been kept locked away in a cellar for generations. It was one long drawn-out pop of a cork. Sala's saxophonist was about to escape through the cracks.

The night flowed effortlessly on. I danced with the birthday girl, and by the time I had made it safely into a corner with the object of my Tallinn trip we were both garlanded in feather boas. Toots confessed to me his admiration for Orwell and then proceeded to act out the last moments of *1984*: 'Two gin-scented tears trickled down the sides of his nose. But it was all right, everything was all right, the struggle was finished. He had won the victory over himself. He loved Big Brother.'[16] The artist was a little like Mary Shelley's eccentric scientist Victor Frankenstein. He had invented a monster and couldn't put it back in its box. It is possible to fight the reflected image *Memopol* gives us, but I was under no illusion that I could conquer it. 'There is no privacy if you take part in life,' Toots told me, and with that we went back to the party.[17] Hamlet was dispatched. The Clash's lyrics were only something to dance to.

Should I stay or should I go?

As Charles Sandison (b. 1969, Scotland) lives with his Finnish wife in Tampere, he and Toots are separated only by the Gulf

Charles Sandison
Living Rooms
2001, projection,
dimensions variable.

Sandison's computer-
generated words flow round
the exhibition space like the
blood in our veins.

of Finland, but in my mind, when I look at their work, we travel all the way from Room 101 to Room 48a, from one British institution to another. In *1984* Room 101 contains our worst fears. Room 48a of the Victoria and Albert Museum in London hosted a lavish dinner party in 2008, the focus of which was Sandison's installation *Living Rooms* (2001). Three hundred guests of Elena and Norman Foster sat at long tables to celebrate an exhibition of artists' books, 'Blood on Paper'.[18] Sandison had projected the contents of the *Encyclopaedia Britannica* onto the Raphael cartoons that permanently line the walls. The words, made of light, transformed the cavernous hall into a literary planetarium. Phrases floated across our vision with the slow dignity of shooting stars, turning the walls and ceiling into a night sky of writing. The passage of Sandison's words was not random. The artist commands the text, taken from the galaxy of knowledge within the *Encyclopaedia*, to flow like the blood within our bodies. Words were everywhere. The guests chatted away in their finery as other people's words danced over and around them. They produced their own competitive babble. What had happened to the intended meaning? The flow of the words was like the flow of my blood, pulsating inside me. That night was about the failure of communication for me. I apologize to the person I was sitting next to: I must have been a pretty awful dinner companion.

After dinner I met up with Sandison and my nephew Harry, and we retired to Janet's, a bar round the corner in South Kensington, just a hundred yards from Francis Bacon's old studio.[19] Suddenly words that had seemed mere background decoration at the society party broke through the protective armour against meaning

that we wear too much of the time. Enclosed in the basement bar, Sandison convinced me. He said, 'There is a theory that we have lost authenticity to the "white noise" of what has already been written or spoken; words only refer to other words. I disagree, by looking for patterns and structures in the swirling ether of images, symbols, and history, we have a chance to move beyond ourselves, find a shared meaning, truth, or "authenticity".'[20] Sitting so close to Bacon's home, I felt his shadow hang over our talk. Bacon had such clear views on the breaking up of patterns. He believed in chaos, and he relied on images to penetrate our emotional hides. Words were never enough. But he fed on society – not the froth and surface like the dinner we had just been to, but naked human contact that he then revealed so startlingly in his paintings. Sandison's 'authenticity' is not too far removed from this, but he has much more faith in our ability to live in and extract from the 'swirling ether'. Bacon's alternation between splendid isolation and total immersion in human company is less satisfying in today's instant world. Sandison feeds off the constant flow of information and thought. The very ebb and flow of life is changing. Bacon said he used to think about death every day. It is possible to argue that he got his daily bearings from contemplating the abyss.

'When you gaze long into an abyss the abyss also gazes into you', Nietzsche warned.[21] Jorma Puranen (b. 1951, Finland) picks up on this warning about Romanticism's love affair with the void in his series *Icy Prospects* (2005–9; see p. 204). Puranen is an unassuming, elfish figure. He started his career as a documentary photographer and when you see his eyes magnified through his gold-rimmed spectacles, you see the resolve that has spawned the Helsinki school of photography.[22] He is the gentlest of souls, but his seductive photographs, made by pointing his camera north at the vast, empty arctic landscape from the northernmost point of Europe, mock our over-dependence on the ancient Greek idea that man is forever looking for the other half of his soul. Post-colonialism questions clean, mainline, modernist thinking, so Plato's thesis of love in *Symposium* is perhaps the greatest tie our modern popular culture has with Classical times. However I try to rationalize the soulmate idea as a superstition, I cannot sever myself from this longing. The belief in romantic love is, remarkably, still one of the mainstays of contemporary life.

Jorma Puranen
Imaginary Homecoming
1991, gelatine silver print,
90 x 120 cm (35 ⅜ x 47 ¼ in.).

Puranen restores the spirits of
the Sámi, whose names have
been wiped off maps.

It feeds every form of communication that we inflict on each other and is used by practically everyone trying to sell us anything, so maybe Sandison's *Living Rooms* and Puranen's *Icy Prospects* are not that far apart, as they both highlight our dependence on outdated ways of thinking. Sandison is looking into the information void: deep knowledge swirling inseparably with info-garbage. Standing in isolation in *Living Rooms*, one is not too far removed from Caspar David Friedrich's *Wanderer* (1818) confronting nature as abstract power. Puranen's starting-point is northern colonialism and the various followers of Friedrich's vision of the sublime who journeyed to the tip of Norway in the early nineteenth century to stare even further north.[23] One of them, the Norwegian painter Peder Balke, had a compelling compass. He liked to gaze due north to fill his void. Puranen's images are not straight photographs: he takes pictures of the reflection of the landscape in varnished boards placed at Balke's easel points. It could be a repeat of a romantic notion until one reads the series' title – *Icy Prospects*.

Puranen dismantles old codes. In *Imaginary Homecoming* (1991) he demonstrates how Finland has been not just the victim of the colonial ambitions of Russia and Sweden, but also itself a colonialist aggressor. Puranen's father was a fisherman. He used to fish off Petsamo, which is called Peahcam by the Sámi who have lived there for thousands of years. He brought back stories to his son, which led to Jorma's interest in how the land

was renamed after it was taken away from the Sámi in the late nineteenth and early twentieth centuries. The colonialism in the region was complex: the area was ceded to the Soviet Union in 1944. Puranen shows how the relationship between people and land stopped being free as flags of ownership fluttered over the region. He questions the way that maps, written in an alien language for the Sámi, could challenge the authority of their ancient spirits. The artist started making a visual record of the Sámi's loss, but found that he was almost perpetuating the crime that had been done to them for, as he says, 'the birth of photography coincided with the pioneering days of scientific exploration, mapping, codification, archiving – and all were tools of colonialism.'[24] By superimposing the photographs of long-dead Sámi over the landscape in images such as *Imaginary Homecoming* (1991), he not only gives a haunting vision of injustice, but also proposes a more natural connection between man and his environment than that expressed in the maps and documents of the region.

Back to my attempt at mapping the relationships between my selected artists from Central and Eastern Europe. I have found only one binding thread between them – resilience. There is a toughness to these artists, an understanding that to be an artist is to take on all odds. Remember, in the regimes of the former Soviet Bloc it was almost impossible to make art unless one was an official artist. Dominik Lang (b. 1980, Czechoslovakia) illustrates how even the new generation, which no longer has to bow to such pressures, has inherited the integrity and independence of mind to challenge the soft underbelly of civilization, of which the international art world is such a shining example. His father, Jiří Lang (1927–1996), barely survived as an artist under the communists.[25] Jana Válková, his mother, a government-approved philosopher who worked as a sociologist at the Institute of Criminology and Social Prevention in Prague, was the one who ensured the family's survival. At the Venice Biennale in 2011 and Art Basel in 2012 Dominik recreated parts of his father's studio

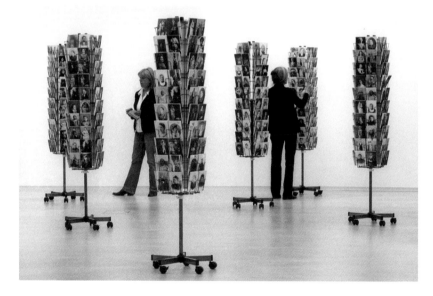

top
Roman Ondák
Measuring the Universe
2007, installation at MoMA,
New York, dimensions variable.

By getting visitors to record
their heights, Ondák reminds
us of the many different ways
of measuring our experience.

bottom
Mathilde ter Heijne
Women to Go
2005– , installation with postcard
display (postcards can be taken for
free) at the Berlinische Galerie.

Each postcard is a portrait of an
unknown woman with a biography
of a pioneering woman on the
reverse. Ter Heijne emphasizes
just how many of these historical
figures have been forgotten.

and pinned up along the walls his father's drawings for unmade sculptures, which he then made himself. This resolve is the other side of the coin from Solakov's unfinished business, *Top Secret*.

I did not immediately realize that I had experienced the work of Roman Ondák (b. 1966, Slovakia). It was in the Frieze tent in Regent's Park back in 2004; his performance *Good Feelings in Good Times* (2003) was a Frieze Project.[26] Ondák had visitors to the fair waiting in line for no reason. He started queues and other people joined him, thinking they were on to the 'latest thing'. Which queues were his queues, and which were created by the unthinking art market?

Queues were also part of the communist way of life. The frightening effect of the merging of the two cultures, the legacy of having to queue and the hype of the globalized art world, was brought home to me in Moscow in 2011. I wanted to visit the Pushkin Museum, but there were four-hour queues to get in as there was a Dalí exhibition on. Dalí is one of my least favourite artists, so I took this as a personal insult, but fortunately Christina Steinbrecher, then Art Director of Art Moscow, acted as my very striking guardian angel.[27] She had already dispatched one of her assistants to rescue me reluctantly from the charms of the Moscow Metro, but she now got a friend to line up for me for the first hour or so of the queue, and then she personally took over. The art world can be understood through its queues: it delights in creating them and supplies ways of bypassing them.

Mathilde ter Heijne (b. 1969, Germany) questions the current relationship between men and women. I talked to her in a warehouse-style gallery round the corner from the Hamburger Bahnhof, now one of Berlin's key contemporary art spaces. Ter Heijne lives between Berlin and Amsterdam, and in trying to locate herself she makes self-portrait rubber mannequins, which in some performances and films are sexually abused and literally blown up. She explores her many 'uprooted' sides, perhaps most spectacularly in *Women to Go* (2005–). Whether the installation is shown inside or outside a gallery, it can take some time to realize that the postcard racks and stands contain a powerful work of art. The over six hundred mass-produced black-and-white cards are memorials to pioneering women who lived between 1839

Birgit Brenner
Einfach genug
2010, board, digital print,
acrylic and tape, 208 x 280 cm
(81⅞ x 110¼ in.).

Brenner builds a new
confessional everyday world.

and the 1920s, but the little mini-bios one finds on the back do not match the images of unknown women on the front. Most of these women have been forgotten. As visitors to *Women to Go* are invited to take the postcards away with them, the body of the art work is eroded, symbolizing the casual way women are taken advantage of, the erasure of their individuality.

Ter Heijne makes me stop and think about the roles played by men and women in today's society and the pressures the insidious inequalities create. Birgit Brenner (b. 1964, Germany) has a similar effect.[28] I met her in Berlin through Gerd Harry Lybke, the founder of Galerie Eigen + Art. Lybke is known as Judy and would not look out of place as a circus ringmaster. I once met him coming off an aeroplane and asked him where his luggage was. He produced a toothbrush out of one pocket and a pair of underpants out of another. Judy started his gallery in Leipzig before the reunification of Germany. As it was impossible to make a living from selling art, he persuaded the state to pay him to model for his artists, even though none of these artists actually used models in their work. When the Wall came down he opened a second gallery, in Berlin, and almost instantly propelled Neo Rauch and the rest of the Leipzig school to international fame. On the sunny morning that I saw him in his modest Berlin space, he arranged for coffee to be brought out for Brenner and me in the courtyard garden so we could be left on our own.

I did not know what to expect of Brenner. She is Professor of Photography, Drawing and New Media at the Stuttgart State Academy of Art, yet it is her confessional and confrontational drawings that have made her name. I see her rough-hewn drawings and texts as a feminine rebuff to the smooth reductionism of Andy Warhol's posthumous *Diaries* (1989).[29] Whereas Warhol

reduced himself to a natural celebrant of capitalist celebrity culture, Brenner's 'diary personality' takes pleasure in failing to fit into the prescribed order. In 2008 the German historian Uwe Walter made a snapshot portrait of her, and together they titled it *Blonde with a Black Wig*. Brenner is petite with black hair, and it came to me that, just as Judy could easily be the compère from the film *Cabaret* (1972), so she has something of Liza Minnelli about her.[30] Her drawings are equally sparky, but by 2007, when she was made a professor, she had no thoughts of exhibiting them. 'I was showing my students at Stuttgart my own student work as a way of demonstrating to them that we all make mistakes,' she explained.

> I hadn't seen the drawings for fifteen years. Back then I was working with old books on obstetrics. I was interested in the very precise but poetic phrases. I started to draw with these texts, but in 1998 I began to write my own text, as writing them gave me a greater sense of risk. When I first showed them I felt naked.[31]

She looked vulnerable in telling me this, but at the same time confident. 'My drawings are not my personal diaries,' she emphasized. 'It is a story but it is not my story: I am not that

Marlene Dumas
Black Drawings
1991–92, ink on paper, slate, 111 drawings and 1 slate, 23.3 x 17.5 cm (9⅛ x 6⅞ in.) each, 230 x 291.9 cm (90½ x 114⅞ in.) overall.

Though famous as a painter, Dumas believes drawings are more 'streetwise' than paintings.

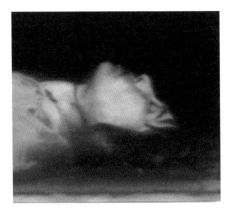

neurotic. The main character in the stories is not me. I have not attempted to commit suicide for the tenth time.'[32] The dancing line between her reality and the universal story is narrow. Yet she was precise about the difference. Most of life is too dull to be art. 'The daily stuff is the most horrible,' she said, and I was expecting some flood of information about her own life. I wanted to know why her work showed the life of the female heroine as almost unsustainable. I asked her what men had done for her to make her protagonist like this, but she looked affectionately back at me. 'Tragedies, love stories, the dramas of life only take up a little time. Ninety per cent of life is boring.' I was not totally convinced. She is capable of making the ordinary extraordinary. 'My drawings are like a storyboard,' she admitted, 'but I am not a filmmaker. I am more interested in the research, in what kind of shoes they are wearing and that everyday information.'[33] She is a bridge between different worlds.

Judy, the consummate entertainer, held a party that evening at the Grill Royal, an elegant restaurant on the River Spree, so I was able to continue my conversation with Brenner on the terrace under the shadow of the Friedrichstrasse Bridge.[34] It was a balmy June night under the stars. She talked about Sigmund Freud and his idea that embarrassment is a sign of intelligence. Shame is definitely her subject. 'For one of the characters in a piece, I knitted a red pullover over her face,' she said. 'She was female, but not really a human female. While I am writing, suddenly the characters get their own lives. My protagonists may have started as one person but at some point they are various persons.'[35] I retorted that she was many people. She was legion. I could not see whether she blushed.

Sadly, I have never had a meaningful talk with Marlene Dumas (b. 1953, South Africa), one of the great painters of her generation. She lives on the water and her studio, which is not far from her home on the concentric canals of Amsterdam, is

undoubtedly an important centre of her world. Having come so far, there is no need for her to travel; her studio is the central point of her compass. Her drawings demonstrate that she is very much attached to the life around her. They are as important a part of her practice as her paintings. 'Drawings are streetwise,' she says. It is almost impossible for painting to be 'streetwise'. Our expectations for painting are so high that it is a challenge to make it accessible in an everyday way. As a woman born in South Africa, Dumas confronts issues of both gender and race, so the difficulties of making painting modern appear almost as a side issue, but the medium is crucial to her success. 'Painting doesn't freeze time,' she says. 'It circulates and recycles time like a wheel that turns.'[36] Her subjects are timeless. One small lithograph of a head, *Supermodel* (1995), has the beauty and timelessness of *Nefertiti* (see p. 7), although we might wish to interpret it through Picasso's *Demoiselles d'Avignon* (1907). Each of Dumas's drawings works in its own right – her full-frontal approach is as direct as could be demanded by the most 'primitive' of men – but she also builds them up on the walls to make banks of images. The drawings work like the women they portray, both as individuals and in groups and crowds.

Dumas was brought up under the culturally limiting apartheid regime, which would have censored many of the drawings and paintings she has made since leaving Africa in 1976. She is a radical artist in that she has claimed the central ground for her vision of gender, race and painting, yet in one sense this is simply a reinterpretation for a modern world of Old Masters' visions. She has applied this direct reappraisal to work as recent as Gerhard Richter's Ulrike Meinhof triptych, *Dead* (1988), which was part of his *October 18, 1977* series about the imprisonment and demise of the leading members of the Red Army Faction. Richter's series worked its way inevitably up to the suicides, or possible murders, of the leaders of the terrorist group. He remained true and close to the photograph of Meinhof's corpse, originally published in the magazine *Stern*. Dumas's *Stern* (2004) is ostensibly very similar to Richter's painting. There appears to be only a thin line between them, but after gazing at them for a while, I find Dumas's depiction more human. There is still a strong stench of long-dead art, of Mantegna's *Dead Christ* (*c.* 1490), but whereas Richter seemed to mummify a newspaper

Michaël Borremans
Still
2005, oil on canvas,
40 x 50 cm (15¾ x 19¾ in.).

Borremans exploits the rich
relationship between painting
and film to challenge the
limitations of both media.

story further by wrapping it in greater context, Dumas presents
you with a dead woman who is part of our story, our life.

The first time I saw him Michaël Borremans (b. 1963, Belgium)
was standing in front of a lush purple curtain in the tiny Prince
Charles Cinema in London's West End talking about the 1966
thriller *The Quiller Memorandum*.[37] His small painting *Still* (2005)
can be read simply: it is a still from the film. It shows a rear
view of the head, nape and shoulders of one of the film's stars,
Max von Sydow. The painting is a comment on photography's
inability to stop time. We may be looking at this one shot, this
one moment, but we know that in the film time marches on. Yet
this isn't a film still; it is a luscious painting, and the eye follows
the hours' and days' worth of brushstrokes and the flashes of still
unmixed colours. If we are miserable, we can see in the picture
our failure, our inability to communicate. Von Sydow's head is
bowed in defeat. If we are happy, we might imagine the thoughts
of the man looking at the purple curtain. We are seduced by the
richness of thinking, the dignity of life. This painting is a mirror.

When the lights came up at the end of the film, which was
so richly coloured, Borremans was interviewed by the critic
Adrian Searle. He maintained that the reason he stole from

Ivan Grubanov
The Last Stronghold
2008, oil on canvas,
150 x 170 cm (59 x 66⅞ in.).

Grubanov highlights the
vulnerability of our political
and social structures.

the film was that cinema has so vastly expanded our visual vocabulary that it supplies, just as much as old painting, the basis of that vocabulary. We have a shared reservoir of imagery from films. Borremans makes films as well, but when he paints the heritage of film makes him concentrate on the inherent qualities of paint, its fragmentary and unfinished nature. As he admits, his paintings 'don't come to a conclusion in the way we expect them to. The images are unfinished: they remain open. That makes them durable.'[38] Film and painting are totally bound together as far as he is concerned. 'There are more similarities between painting and film than between painting and photography. Before film, painting was about storytelling. Now film is about storytelling, though it wasn't like that when it was invented. Today film is more like painting than ever before.'[39] There are not so many artists today who rely solely on painting.

There were two other people in the upstairs Berlin office of the gallerist Friedrich Loock, but it was as though Ivan Grubanov (b. 1976, Yugoslavia) was the only person there.[40] He spoke to me about why he thought the medium of paint had let him down. He was disillusioned by painting's inability to depict the horrors of war, which is why he called his 2008 exhibition at Loock's gallery 'The Evil Painter':

> The title was a simple and logical conclusion. I was dealing with transcendent evil – trying to develop a language complex enough to interpret this horror. I kept on dealing with the troublesome historical text – the emotions around it. The responsibility at my possible inadequacy at painting this evil meant it was small logical leap to call myself the evil painter.[41]

Grubanov's drawings of the devastation wreaked by conflict make little attempt to compete with the raw power of Anselm Kiefer's paintings of war. The depictions by Kiefer (b. 1945, Germany) of the charred earth after battle are some of the

Luc Tuymans
Easter
2006, oil on canvas,
128 x 179 cm (50⅜ x 70½ in.).

Tuymans was one of the first artists to equate the weaknesses of painting with our broader failures.

strongest images of late twentieth-century art. Kiefer shows the whole of German culture going up in flames. Likewise, Grubanov examines Serbia's history and culture. His after-image drawings reveal the sketch of an old heritage, left on the retina after the explosion of a bomb. The polarized views of the communist era are gone; the war has ended and left its ruins. His reduced viewpoint makes one ask, what is left?

Grubanov was mentored by Luc Tuymans (b. 1958, Belgium), one of the first modern painters to intentionally emphasize the weaknesses of the medium. Tuymans uses painting as a metaphor for life. He shows up its fault lines to mock our definitions of success and failure. These lines are more critical for Wilhelm Sasnal (b. 1972, Poland), also an admirer of Tuymans, as he lives through the transformation of his home country. Sasnal searches for anything relevant to this life. 'I rejected everything that was connected to the Academy of Fine Arts [in Kraków] because it had nothing to do with my life,' he recalls.[42] Although Andy Warhol's relevance to life in Eastern Europe is questionable, his ideas certainly provide a starting-point for Sasnal's own reductionism:

> History is not just a question of facts. It affects my life directly. We cannot change history but it influences our lives. That is why I do not see it as separate from the present moment. For me, it is very fluid, in the same way

that I cannot make a distinction between what is public and what is private.[43]

Warhol theoretically did not see any difference between public and private: his diaries show him at the centre of evolving history. There is an element of this existential stance in Sasnal, but it is more grown up than Warhol's teenagerish delight in the present. Sasnal's relationship with the world may not be so extreme, but he takes the responsibility very seriously.

Sasnal's *Untitled* (2004) shows four people on a hike in the hills. It is painted in black and white. One of the reasons for this choice of colour is that Sasnal copied the image from a Polish photography manual, *77 Subjects to be Photographed*.[44] The original image was used as an illustration of how to photograph people in a landscape. Sasnal's work appears almost as a celebration of his freedom from the old rules of painting. As they have their backs to us, we cannot see the expressions on the hikers' faces, but one imagines a certain pantheistic reverence for the mountain looming above them. Sasnal does not want painting to be too precious. 'Filming,' he admits, 'helps me with my painting because it prevents me from becoming a "master", from becoming too preoccupied with painting for painting's sake and to look

Wilhelm Sasnal
Tarnow
2003, oil on canvas,
155 x 189.2 cm (61 x 74½ in.).

Sasnal's compositions seem to collapse under the weight of his long gaze at such a mundane and opaque world.

Paulina Olowska
Wool mark
2010, oil on canvas,
195 x 140 cm (76¾ x 55⅛ in.).

In enlarging and painting
advertising and propaganda
images from old communist
magazines, Olowska explores
current and future fault lines.

at it from a certain distance instead.' As Peter Weibel says, 'The border between art and film has blurred. Art as film and film as art has created a new genre.'[45] There are many new genres.

I never visited Nova Popularna, the illegal pop-up bar that Paulina Olowska (b.1976, Poland) ran with a Scottish artist friend Lucy McKenzie in Warsaw in 2003. It was a temporary project. As Olowska explains, failure was built into the concept of Nova Popularna: 'from the beginning we stated that the failure of the project could be a very real actuality, for instance it was unlikely we would have commercial success as a business. We worked out that we were getting paid about 10 Euro cents an hour between us. Failure was written into the brief we set ourselves.' There is an echo here of Lada Nakonechna's concept and calculations.

Olowska's evocation of the Cold War operates in a way that is similar to but gentler than Ivan Grubanov's drawings about the break-up of the Soviet empire. Grubanov created after-images

of the destruction in Serbia, line drawings of ruined churches, smashed monasteries and centuries of civilization destroyed in the civil war of a few years duration. His simple lines are like those formed within our eyes after an explosion – incised by shock. He is trying to make a model of something perishing in front of us, but ultimately he is drawing out his and our memories.

Olowska returns to the height of the propaganda wars between the USSR and the USA. She takes images from the Russian women's magazines of the 1950s and '60s that were trying to counter American propaganda, and in particular from the Polish publication *Ty i Ja* ('You and I'). Blown up, turned into paintings of life-size women and seen through the telescope of fifty years, these fantasies and idealized projections look as clumsy as the overblown sculptures of communist political leaders – the fallen statues of Stalin. Despite the polarized systems of belief, both communist and capitalist magazines were producing images directed at the basic desire of human beings to preen themselves and create the 'right' fashionable image. Although Olowska contrasts communist and capitalist aspirations, she also welds together their shallow judgments about success and failure. The critic Monika Szewczyk sees Olowska as offering us a way out: '"Fantasy" may be the only real thing and it still has too few dimensions in our mindless times.'[46]

Fantasy and harsh reality clash in *Kuba* (2005), the most memorable work of Kutluğ Ataman (b. 1961, Turkey). It captures two years of video interviews between the artist and the diverse inhabitants of Kuba, an illegal shanty-town on the edge of Istanbul. Getting to the installation, it seemed as though I had left London far behind, although I started my walk up the stairs in an abandoned corner of the old Sorting Office on New Oxford Street.[47] As an active industrial site the building must have been at the hub of London's communication system, but it was so deserted upstairs that walking across the hangar of a space I felt like I was in David Lean's film *Lawrence of Arabia* (1962).[48] There was a hum of ever-rising noise at the far end of the room, but it was difficult to make out where it was coming from. It sounded like a cocktail party in full swing. I started to see people, but there were not enough of them to make that level of buzz. Indeed, the people were hardly talking to each

Kutluğ Ataman
Kuba
2005, installation,
dimensions variable.

Ataman invites his audience
to sit in forty hearths to watch
forty DVD portraits of forty
members of a non-conformist
Istanbul community.

other, but were sitting in beaten-up sofas and chairs. A couple were perched on the over-ripe padded arms. I suddenly realized that the buzz was coming from numerous TV screens. There was no single focus to the room: there were forty voices from forty focal points – forty decrepit black-and-white televisions. Kuba had been reduced to forty 'talking heads', but I could not have taken many more. On screen, the Kubans were preaching, lamenting, complaining, laughing, cajoling. For forty days and forty nights these forty voices wheedled to their audience. They related the problems and joys of their lives.

Although the subject of survival was often discussed in deadly earnest, Ataman is able to talk of artifice and art in such a refuge:

> Since my childhood my relationship with life has always been via some games, fictions, scripts. I always look at other people from this point of view. I actually view life as a bit of game, too. Ultimately, you may think as you wish that you're living in reality, but you still construct certain things in your mental relationship with that reality. You write yourself a script based on your perception of that reality, and you star in that script. In fact, everyone is an artist. Art is not much different from everything you create in life about yourself.[49]

Ataman highlights our need to believe in escape, to transform our life. This is made clear in another series, *Mesopotamian Dramaturgies/Journey to the Moon* (2009), about an imaginary 1950s space programme in a remote village in Anatolia. History meets the future. The photographs have a nineteenth-century archival element to them. Like Shadi Ghadirian, who injects alien contemporary apparatus into her recreations of the Iranian Qajar court (see p. 86), Ataman is fusing memory and aspiration. People look backwards and forwards to avoid the problems of the present. As neutral observers, we see there is absolutely no chance of getting more than a few feet off the ground, but I am charmed by this futile gesture. Who am I to judge people for wanting something other than the life they lead?

'The internet killed the sense of otherness. I feel lucky to have travelled with that sense of isolation,'[50] Mike Nelson (b. 1967, England) told me about his trip to Istanbul as a teenager. I was interviewing him in a blacked-out room at the gallery that represents him in London, Matt's, as it was the only quiet place we could find to talk.[51] Like the Parasol unit in London (which organized the screening at which I first saw Borremans) and Artangel (which put on the London exhibition of Ataman's *Kuba*), Matt's lies somewhere between commercial gallery and

Mike Nelson
Mirror Infill
2006, multimedia installation, commissioned as part of Frieze Projects, dimensions variable.

Nelson built a hidden exhibition between the other stands at Frieze.

public space. It seemed quite appropriate to interview Nelson in the dark, as his work revolves around dark rooms. I had just returned from the 2011 Venice Biennale, where Nelson was representing Britain. We immediately started talking about Turkey, as he had turned the interior of the British Pavilion into a ramshackle seventeenth-century Turkish house. The inspiration for *I, Imposter* (2011), this recreation of a disorientating 'home from home', can be traced back to his pre-internet trip to Turkey in 1986.[52] 'That first visit to Istanbul aged nineteen was my first experience of the world outside the UK, besides visiting France. And it was completely unanticipated, a sensory overload, immense, indescribable.'[53]

I am one of those sad individuals who immediately make connections with people's names, so when I saw Nelson in Venice, strutting around the Venetian palace at his exhibition opening, to me he seemed like the British naval hero Horatio Nelson on the deck of his ship at the Battle of Trafalgar. Now in the private gloom of Matt's he was still a sailor, with his beard, and there was still a sense of foreboding, but it was a tale of shipwreck. 'It took a couple of years to start using my visit [to Istanbul],' he admitted.

> I wouldn't say that the first visit was pleasant. It was like a bad trip as there was too much – I had never experienced such heat, smells, the sense of light, and the repetitive mosque recordings. It was an immersion with a culture so different from mine at a basic level that I was overwhelmed to the extent that I just wanted to get back home.[54]

Losing and finding oneself are no longer the polar concepts they used to be. Is this just an example of casual modern language, or does it indicate a change in the way we think of ourselves? Nelson's understanding of Istanbul is fed by Orhan Pamuk's novel *The White Castle* (1985), which demonstrates a blurring of the Eastern/Western vision of the self. The two central characters, one an enslaved scholar from seventeenth-century Venice and the other his master, an astronomer from Istanbul, fuse together until one is unsure of whether it is the East or West that is influencing the merged character. In Pamuk's work, as in Nelson's, there is an obsession with finding out 'why I am what I am', which is central to any discussion of finding/losing

one's bearings. Nelson talks of 'working in the space between things', so losing one's bearings is often as important as finding them. As we lose faith in the old maps, the old codes, there is a tendency to try and find answers in clashing theories, but straight contradictions are no longer enough. Increasingly artists are looking to line up parallel systems and practise their art between them. Keith Tyson (b. 1969, England) is a case in point.

'Art is part of every day,' claims Tyson. 'Art cannot work any longer if it is separate from everyday living.'[55] He did not have an easy start to life. There was not a book in the house. He left school early and worked in a factory, and only got into art school because the night before he went to the interview with a van full of his paintings he watched a film, which he later learned was by Russian filmmaker Andrei Tarkovsky. When asked about his interests, he talked about the film.

Tyson is the epitome of the eccentric English inventor: he is off-centre. This sympathy with ideas, however distant, is a primary motivational force. He has a passion for mathematics, which he sees merely as a way of seeing patterns. 'I am not looking for the finality of a news story,' he says. He wants to pursue 'new and unforeseen patterns…emerging from the primal soup of the information society'.[56] He is passionate in producing his math-ematical formulas and equally passionate in disproving them. Tyson is naturally numerate: he cannot avoid seeing numbers everywhere. In contrast, geometry appears to have entered into the self-contained world of Charles Avery (b. 1973, Scotland) as a reaction against the boredom of his circumstances. Avery is from the remote Isle of Mull and although his international career flourishes, he still has a studio on the sparsely populated Scottish island that has inspired so much of his work. In the 1990s I visited Avery in another studio, which doubles as his flat, in a high-rise block in the East End of London. The main thrust of his work, even then, was built around a fictional world of his own creation, but he had also embarked on a drawing that consisted of fifty thousand coloured triangles. The repetition of this basic shape echoed the basic architecture in which he was living. Most of his work since 2005, such as his series *The Islanders* (2005–), has consisted of drawings about the island in his head.

top
Keith Tyson
12 Harmonics (detail)
2011, mixed media on aluminium,
12 panels, 346 x 194 cm
(136¼ x 76⅜ in.) each.

Passionate about numbers, Tyson
explores many of the rules and
formulas that govern our lives.

bottom
Charles Avery
Untitled (Self Escaping from
Island with Thirty Six Jars
of Henderson's Eggs)
2007, pencil on paper,
62 x 106 cm (24¾ x 41¾ in.).

What has the artist chosen to
take with him in his vain attempt
to leave his world behind?

The Great Bear

Like Tyson, Avery questions the sanctity of time. 'As to the linearity of time, on the Island views on this subject are as varied as our own,' he says. 'The incomers, or colonists, largely maintain the received idea of time in our own world, which that of a linear, one-directional and eternal sequence.'[57] He makes sculptures but his main medium is drawing, which he likes for similar reasons to Marlene Dumas. As he explains, 'I'm against the idea of the masterpiece. When I do drawings, I just stop at a certain point, but there's always the sense of continuation, the sense that it could have been different.'[58] Avery's island and islanders are defined not in one sinuous Gothic-style drawing, but in a steady flow of stories and constructions.

It is this mapping process that supplies one of the starting-points for this book, and for two works in particular: Simon Patterson's *The Great Bear* (1992) and Tracey Emin's tent sculpture *Everyone I Have Ever Slept With 1963–1995* (1995). Emin, with whom I have a tempestuous relationship without her even realizing, made probably one of the worst exhibitions the British Pavilion at the Venice Biennale has ever seen when she represented Britain in 2007, and there has been some stiff competition. Allegedly, she did not produce her paintings until the very last moment to antagonize the British Council,

Simon Patterson
The Great Bear
1992, lithograph on paper,
102.7 x 128 cm (40½ x 50⅜ in.).

Patterson has made a long-lasting joke out of the London Underground map, replacing the Tube stations with the names of famous figures throughout the ages.

but in attempting to prove that the curators could not curate, she proved that the painter could not paint.

How are we connected to the world and the people in it? Building a home out of the names of all those that one has slept with is a very straight assessment. It is one way of defining Emin. She frequently stresses that the names on her tent were not just her lovers but everyone she has ever shared a bed with, including family and friends. This dilutes the joke at her former lovers' expense, but can a work of art survive as a one-liner?

The Great Bear by Simon Patterson (b. 1967, England) still makes me laugh, but the dozens of art maps it has helped spawn have changed it for me. I used to think that this altered map of the London Underground was the definitive YBA art work in that it hints beautifully at the complexity of the world, but ultimately tells us nothing except that our systems of deciphering the world are rubbish. The print gets its name from the constellation in the sky, but it has taken celebrity star-gazing to its nutty conclusion. It is emphatically showing us the stupidity of linear thinking: how we follow apparent lines of thought until we crash. We think there is a sequence until we hit two interconnecting lines and then – bang – crash – we are lost.

Having read W. G. Sebald's *The Rings of Saturn* (1995; see p. 108) and the Raqs Media Collective's and Dayanita Singh's interpretations of the German author's hybrid of fiction and autobiography, I am no longer so convinced that Patterson's map is just a succession of dead ends. It is possible to read it as a map of the mind's potential, with hundreds of possible departure points, as a map that ensures the mind does not get stuck in a rut.

The post-colonial assault on maps as instruments of imposing imperialist rule and thought also changes the way I look at *The Great Bear*. In 1992 I was convinced it was a typical YBA glorification of celebrity culture. It is a development of Andy Warhol's proclamation that in future 'everyone will be world-famous for fifteen minutes'. Be famous, for anything, and you will be on the map. But the biggest laughs one gets in following Patterson's thought lines are the jumps from mighty giants such as Socrates and Titian to the likes of the deposed King Zog of Albania

and the comic film actor Sid James. Patterson is attacking the attempt at the central control of thought, the fame barrier to true freedom of thought.

Two years after Emin's fiasco in Venice, Fiona Tan (b. 1966, Indonesia), who describes herself as 'a professional foreigner', made one of the most successful exhibitions in the history of the Biennale when she converted the Dutch Pavilion into a maze of screens to explore the mind of Marco Polo.⁵⁹ The great Venetian traveller is credited with being one of the first Europeans to reach Central Asia and China, but he became disoriented almost as soon as he returned home and was thrown into prison by the Genovese. In Tan's *Disorient* (2009) 'his' voice comes to us as though he were narrating his stories to his cellmate, as he did over seven hundred years ago. As the artist says, 'Arguably Marco Polo took his epic journey twice. The second time, he journeyed through his memories – languishing in prison, recalling and remembering with as much detail and accuracy as he could muster every memorable episode from a quarter of a century of travel.'⁶⁰

I am not trying to compare my ordinary peregrinations around the world, courtesy of modern transport, with the travels of Marco Polo, but Tan's point is relevant to all of us.⁶¹ It is not what we see that matters, but how we interpret it as we play it over and over again in our minds. My perception of things has been dramatically changed by artists from all corners of

Fiona Tan
Disorient (video still)
2009, HD video installation, dimensions variable.

Marco Polo embarks on his famous journey for a second time in his memory during his imprisonment in Italy.

the globe. Each new art work that I let into my world changes my way of looking.

Gavin Turk (b. 1967, England) is a friend, yet although we both live and work in London, my abiding image of him is not the lunch with his team in his cavernous garage of a studio in the East End, nor even lugging *Gentleman Jim* (2005) down the stairs at the Royal Institute of British Architects early in the morning after a Frieze dinner in his honour, although the latter occasion, in 2007, had its irony.[62] *Gentleman Jim* is a life-size fairground waxwork figure of Turk dressed up as a drunken sailor that stands in a glass vitrine. If you get too close to the glass box, *Jim* roars with laughter at you. The figure is loosely based on the drunken sailor in James Joyce's *Ulysses*. It is also the embodiment of the nomadic outcast artist, a part that Turk plays again and again, while at the same time inserting his face and body into images by, and of, the modern artist greats, the most imposing being Warhol and Beuys. But then Turk morphs again to appeal to a different audience by depicting himself as Sid Vicious or imitating Warhol's image of Elvis.

No; the image of Turk that keeps recurring in my simple brain is that of his head bobbing down the fast-flowing River Rhine during his traditional swim at Art Basel in June 2010. From the bank of the river his head seemed to change shape. One moment it was a complete oval, an egghead à la Magritte; the next the late sun's reflections distorted it into a Picasso; and then, glory of glories, Duchamp's urinal. There was another mirage shimmer and his head was a Carl Andre brick. Talking to his friends as he serenely flowed downstream, he looked as if he were enjoying a Turkish bath on a travellator. The whole scenario reminded me of how he uses his head, and sometimes his body too, as the battleground of his art. For *Distortion* (2009) at the 2009 Venice Biennale, he modelled numerous self-portrait busts in clay, which he kept wet and soft. When his guests arrived for the evening, he issued them with hammers and invited them to attack his sculpted self-image. His fellow British sculptor Antony Gormley (b. 1950, England) was reportedly seen to karate-chop one of the heads.[63] Turk claims the swim in the Rhine during Art Basel as an annual rite of the art world, just as every year he attends a dinner hosted by his Viennese gallery on the opening night of the fair.[64]

Turk took part in Charles Saatchi's 'Sensation' (1997), the exhibition that rubber-stamped the YBAs as an international phenomenon.[65] He exhibited alongside Hirst, Emin and Patterson, and is precisely the kind of artist that Charles Avery is complaining about, as he appears to worship the history of art obsessively and to only make art that refers to other works made previously. This is one of the reasons why the image of him floating down one of Europe's main rivers is so apt. He sees the pillars of art history in a new way: he makes us laugh at them and he helps us keep thinking about them, keep them alive. He made a series of drawings in homage to Carl Andre's brick sculpture *Equivalent VIII* (1966) to bring home the fact that art is all around us. Andre's bricks shocked the British public when they were shown at the Tate Gallery in 1976. They represent an important step in the attempt to close the perceived gap between art and life. Turk goes one step further and does what most British men have done at some point in their lives: he makes patterns with the bottom of a tea mug. Turk, being Turk, makes patterns like Andre's bricks and gives them the same name: his *Equivalent VIII* (2004) was made by placing his wet mug on paper and letting the tea soak into the surface round the bottom rim to create a series of circles. As he says, 'What is a more basic British building block than the brick itself? The British cup of tea!'[66] These designs are not made with pencil or any material normally associated with art. They are simply tea stains.

Turk plays on the narrow line between success and failure. His art works rely on your belief. He famously came unstuck with his examiners at London's Royal College of Art. At his degree show the sole exhibit was *Cave* (1991), a single circular blue memorial plaque on the wall with a 40 cm (16 in.) diameter. It boldly declared: 'Borough of Kensington Gavin Turk Sculptor Worked Here 1989–1991.' He failed his degree, but instantly became the best-remembered graduate of the year.

Seeing Turk gliding down the Rhine, his head in the sunlight flickering between a Magritte, a Duchamp and an Andre, and yet always remaining Turk, I did feel guilty. I should have been in the water with him and his friends. Luckily my hosts in Basel had supplied me with an excuse: I told Gavin I could not

Gavin Turk
Pop
1993, waxwork in vitrine,
279 x 115 x 115 cm (109 ⅞
x 45 ¼ x 45 ¼ in.).

Turk plays the role of Sid Vicious
in the pose of Elvis à la Warhol.
History changes before our eyes.

possibly drag my muddy feet through the immaculate flat I was staying in.[67] There is one consolation: if I had dived into the green-brown water, I would have missed the sight of him from the bank and the tricks the sun and my mind played with his head. My job is as a voyeur.

Whereas Turk has been swept along in the YBA tidal wave, Cornelia Parker (b. 1956, England) is from my own generation of sculptors who were pushed aside by Damien Hirst's success. She has had to fight hard. Indeed, much of her art involves persuading unlikely people to help her make her work. She blew up a garden shed – that den of male chauvinism, man's last hiding place – but she did not lay down the explosives herself: she persuaded the British army to do it for her. She then reassembled the shards of wood as *Cold Dark Matter: An Exploded View* (1991). 'I never have a definite answer; I am more interested in the beginning rather than an end,' she says, and one is not quite sure what this memorial to an explosion is trying to achieve. It was a brilliant moment to explode 'chauvinism' to smithereens, but the long shadows of the shattered planks, cast by the

Cornelia Parker
Words That Define Gravity
1992, performance:
a dictionary definition of
'gravity' made in lead then
thrown off the White Cliffs
of Dover.

Is Parker testing Boris Groys's theory that text and image are of equal importance or just demonstrating the difficulty of communicating an idea?

sinister lighting of the installation, remind us of past violence rather than suggesting future hope.

Thirty Pieces of Silver (1988–89), when suspended from the Tate's ceiling and shining under the spotlights, is seductive, but again it plays on our anxieties. Parker frequently claims that the main material for her sculpture is her anxieties, but it is more universal than that. She is playing on the fears of her audience, too. She used them to make *Thirty Pieces of Silver*, a blatant reference to Judas's betrayal of Jesus. 'I was living in a condemned ACME home and studio just off the M11 at the time,' she recalls, but the studios were destroyed.[68] Parker felt she was sold out by the people who had initially protested with her against the building's demolition. Her response was to hire an old-fashioned steamroller and squash the symbolic hoard of silver she imagined all her traitors had gained from the transaction.

There is a certain defiance about Parker's stance in the making of *Words That Define Gravity* (1992). She stood at the top of the White Cliffs of Dover, one by one throwing over the edge all the words that make up a dictionary definition of 'gravity', which she had written out in long hand and then sculpted in lead. This art work sets itself an impossible task. It is an allegory for itself, an allegory for a work of art. Although Parker is trying to define gravity and has deliberately made the works heavy, she looks as though she expects the leaden words to fly gracefully on angel wings and spell out a deep understanding of the concept of gravity in the sky. The difficulty of communication is compounded later on when she collects the battered lead words from the bottom of the cliff and suspends them from threads to hover above a gallery floor. Parker mangles her words to explain that 'The words got made illegible by real gravity.'[69] Why does she use the word 'real'? I believe she is also referring to the gravity that pulls and repels us to works of art, an inner gravity.

By disconnecting 'concepts' from the 'high' aspirations of society, Parker continually redefines Conceptualism. In a similar way, Nedko Solakov has made his and our fears the subject of his work. He has even made a series of ninety-nine drawings called *Fears* (2006–7). One can never be complacent with either Parker or Solakov. They seem to be constantly at our elbow, twiddling

and adjusting our neurosis levels. And even though Solakov does not fly, he pops up everywhere. I have found myself next to him on a crowded Basel tram and a Venetian vaporetto. On both occasions he had that deliciously knowing look, as though he had me under surveillance.

The master of neurosis that is Maurizio Cattelan (b. 1960, Italy) was born in Padua, at the other end of the Brenta Canal from Venice. 'Failure has become a constant background to my work,' he says. 'The antithesis of failure is failure in advance – you never actually fail.'[70] His father was a truck driver and his mother a cleaner who died of cancer when the artist was in his early twenties. For much of the 1990s Cattelan appeared to be trying to avoid work, or at least showing his work. In 1992 the sole evidence of his existence at an exhibition near Turin was a rope of knotted bedsheets hanging out of the window; the work was called *A Sunday in Rivara* (1992). The following year he bricked up the door of his Milanese gallery, Massimo de Carlo, so that visitors could not gain access. In *Another Fucking Ready Made* (1996) he stole another artist's work for one of his own shows.[71] He mocked the incestuous reverence for the Venice Biennale by holding his own event, the *6th Caribbean Biennial* (1999), on the island of St Kitts. In an interview during the planning process he proclaimed: 'Art is a collision of different systems and levels of reality. And I wish our biennial could reflect all this. On the other hand, complexity is hard to grasp, so our project might turn out as a total flop. Which is okay, because failure is closer to reality than art itself.'[72]

Although Cattelan now lives in New York and Milan, the mother of all biennials was on his doorstep as he grew up. He was selected for the Arsenale in Venice in 1993 and promptly rented out his section to an advertising agency. The agency put up an advert hoarding for a new scent. As the title of his 'contribution', *Working Is a Bad Job* (1993), suggests, the artist claims he was motivated not by the whim of making fun of the art world, but by the fear of poverty and the desire to make money.

In the 1990s I took Cattelan's humour to be a mere extension of the YBAs' populist sensationalism, but in retrospect it can be seen as more down to earth. The line between art and advertising

Maurizio Cattelan
Mini-Me
1999, rubber, resin, synthetic hair,
paint and clothing, 45 x 20 x 23 cm
(17¾ x 7⅞ x 9 in.).

Cattelan's miniature alter ego is
suicidal at the prospect of being
neatly categorized, and of not
being neatly categorized.

Anish Kapoor
Yellow
1999, fibreglass and pigment,
600 x 600 x 300 cm
(236¼ x 236¼ x 118⅛ in.).

With his deft use of scale,
Kapoor recreates the primal
experience of standing in
front of a large cave and being
swallowed up by emptiness.

had collapsed and it was a difficult time for artists. But now his 'sell-out' looks prophetic. The Venice Biennale at the time was a largely prescribed affair, with the art world all squeezing down the same alleyways and attempting to cross the same bridges. As the 'boom' years evolved it became worse, with water taxis battling to get their ever-richer cargoes to the same party. Yet since 2009 the increased number of pavilions and satellite exhibitions has meant that serious visitors to the Biennale are now criss-crossing Venice in a much freer way.

In one of his sculptural self-portraits, *Mini-Me* (1999), Cattelan's miniature alter ego sits on a bookshelf unsure of his position.[73] He is perched between books on Gerhard Richter, Tony Cragg and Anthony Caro, and his little legs are dangling against tomes on Lucio Fontana and Sol LeWitt, which fortunately but illogically break up the far too numerous books on the self-publicists Gilbert and George. Is the figure going to jump? Like all of us, as a mere mortal human being, he feels out of place in this library of heavy and pretentious thought. It is his vulnerability that comes across. We have to risk failure in order to communicate.

I conclude with a chance meeting near my home. In 2008 I was walking my dog in Kensington Gardens and was greeted by Anish Kapoor (b. 1954, India). I wish I could claim some deep-blue pigment abyss opened up beneath us, or even aggrandize the occasion to the scale of Gustave Courbet's *The Meeting* (1854), but it was all very British.[74] We exchanged pleasantries while he kept an eye on his children and I tried to make sure my dog was behaving. As I walked away, I thought again about my recent encounter with his work at the Haus der Kunst in Munich.[75] I had stood in front of *Yellow* (1999), which is basically a large, yellow, gracefully curved hole in the wall. The experience had echoes in Friedrich's paintings of the confrontation between man and the sublime power of nature, but Kapoor's work is more carefully tuned. I wanted to compare myself to a caveman standing in front of a great big cave, but yellow is not normally the colour of contemplation. Yellow repels. It pushes us away. Kandinsky had it down as the colour of madness. Kapoor activates our need to find our bearings. The hole pulls us in, the colour pushes us away. I felt I could locate myself somewhere between the contemplation and the madness.

AFTERWORD
● MY ART COMPASS

'I know what I like.' Of course you do! But art and you both change. Your art compass guides your relationship with art, or rather the tiny fraction of art with which you will have a meaningful relationship.

So far in this book I have used my compass to create my survey of art around the world, but to really understand how the compass works it is best to look at the earlier part of the process, when I am looking at artists and actually trying to get my bearings.

Although my compass is remarkably simple, it reacts differently to each artist in a strange way. Its polar points gain different values. As the chapters of this book reflect, there is invariably an element of the straightforward geographical compass. This is most clearly demonstrated in a comparison between two photographs: Jorma Puranen's *Icy Prospects No 27* (2006) and the Essop twins' *Cape Town, South Africa* (2009). Although the Finn is gazing into the 'Romantic' far north and the Essop twins are falling off the world's edge at Africa's southern tip, my allowance for their different locations is only a small part of the story. The breaking down of these geographical distinctions is equally important.

The workings of my compass can best be explained by an unfinished conversation with my new-found friends on Peacock Lane in Delhi – the Raqs Media Collective. When I told them the title of this book, Shuddha immediately said that they were planning to make a compass on similar lines to their clock pieces. While I have been writing, I have been waiting to hear a progress report. Nothing! But I have not been able to stop myself from working

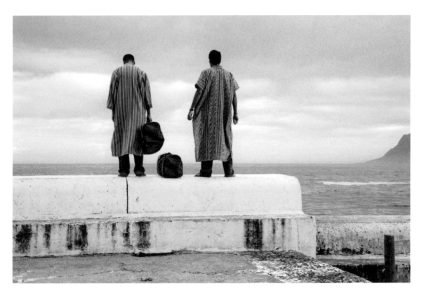

top
Jorma Puranen
Icy Prospects No 27
2006, C-print photograph,
163 x 201 cm (64⅛ x 79⅛ in.).

Despite the seduction of this
scene Puranen is dismantling
the old Romantic codes.

bottom
Hasan and Husain Essop
Cape Town, South Africa
2009, photograph: pigment inks
on cotton rag paper, 64 x 92 cm
(25¼ x 36¼ in.).

At the opposite end of the world,
the Essop twins explore a very
different concept of identity.

on their idea in my head. Like a rogue and pirate element of the Raqs brain, I have been thinking about an emotional art compass, which while not actually replacing north, south, east and west, at least dilutes the geographical implications and lets emotions and concepts seize temporary control of these compass points.

If life were neat, I would help explain the workings of my compass by discussing four young artists, each illustrating a compass point, but instead I am going to write about three young artists, as though to demonstrate that new art does not fit into prescribed patterns. But in writing about them I am going to illustrate the different poles I have used.

The selection of artists for this book is not totally subjective, but I would definitely have failed if I had tried to be completely objective. Artists feed off our sense of balance: some appeal to the gaping hole within us, others literally help us to complete ourselves. In absolute contrast they can also shake our compla- cent vision of the world. The other two common points of my art compass are related to an artist's relationship with his or her core. Does the individual rule supreme, or is he or she subsumed within society? These four main compass points (Balance/ Unbalance and Self/Society) totally failed me during my first encounter with Merike Estna (b. 1980, Estonia).

When Estna's gallerist first showed me her work in Tallinn, I was indifferent to the pastel, ice-cream shades of paint and to what I considered was a young artist playing her artistic scales in public.[1] It was paint. So what? *Lea Bridge Road* (2011) flipped my thoughts. It is a painting of Estna's old London bedroom, which she also used as her studio. On the bed *Painting Today* (2009), art critic and teacher Tony Godfrey's book on contem- porary painting, sits on the pillow. It occupies one side of the bed with the authority of a much-desired lover. 'I am quite obsessed with painting,' admits Estna.[2] Her love affair with paint is extended. She insists that she was merely painting the shadow from the bedside lamp falling onto the wall behind the bed, but there is a delicious ambiguity to the dark shape that dominates the top half of her painting. It is as though the wall of her intimate living and working quarters has opened up into a wild open landscape. 'Heathcliff! Heathcliff!'[3] I almost

hear the romantic cry of the artist to her forbidden lover out on the moors, in the outside world. This is a painting that is dead-centre on my compass. It is about a European woman's view of herself. She lives and works in a clean and charming single room, but she has a full relationship with the great outdoors. She is not contained within the confines of her cell: the world has opened up to her through her relationship with Mr Heathcliff Paint.

Estna hit a reference point with me that scored a bull's eye in its declaration of love for painting. I then started to try and rationalize my appreciation with a constantly flickering compass. As for east to west, as for Balance/Unbalance, she has again got it both ways. The shadow on the wall has a faint echo of Titian, a foreteller of the breakdown of the borders between abstraction and landscape. As an Englishman, I cannot help but see a connection to eighteenth-century landscape painters like Gainsborough, or to landscape gardeners like Capability Brown. There is an element of the 2,500-year-old fight between harmonious mathematical order and Dionysian chaos. But for Estna it is just paint! Her next series of work was abstract. Without the *Lea Bridge Road* painting, I would not have looked at her multicoloured patterns with quite so

Merike Estna
Lea Bridge Road
2011, oil on canvas,
120 x 152 cm (47 ¼ x 59 ⅞ in.).

This image of Estna's room/ studio is a record of her love affair with painting.

Jorge Méndez Blake
All the Borges' Books
2012, wooden box with engravings
and mirror, 100 x 40 x 70 cm
(39 ⅜ x 15 ¾ x 27 ⅝ in.).

By removing all books by Borges
from Manhattan's public libraries,
Méndez Blake highlights the
vulnerability of civilization.
Did anyone notice?

much interest. One of my standard north/south tests is: where does an art work lie on the axis between intellect and sensation? The pattern pictures at first sight seem pure unadulterated, seductive, hedonistic sensation. Where's the brain? Estna explained she wished to make a book filled with the eight types of patterns she was using at the time. She is just trying to make beautiful sense of the world. Her work now induces the whole gamut of emotions. Looking at her paint is like watching Raqs's video *Whenever the Heart Skips a Beat* (see p. 116). With the flow of her paintbrush she makes the poles on my compass move as fast as the emotions in place of the hours on Raqs's transformed clock faces.

Estna is very aware of the problems of painting in a competitive environment that currently does not favour the medium. For one of her series, she cut holes in her paintings' canvases until there was little left but the frames. It is an attack on the market's preoccupation with the positioning of art, but while this might interest me, it does not engage me fully. Equally she has made a minute-long video, *A Big Painting and a Small Painting* (2011), which shows two paintings dancing. The artist is literally dancing with the paintings. All you see is the canvases moving with her feet in ballet pumps peeping out the bottom. It is enchanting, seductive, and it enriches a total understanding of her work, but it would seem very slight if seen in isolation. Estna is caught in an intriguing balancing act. She is pulled by one compass point, which demands constant innovation, while its pole is seducing her with the traditional values of painting.

Yet again my compass did not splutter into life strongly enough when I first encountered the work of Jorge Méndez Blake (b. 1974, Mexico) at Frieze in New York. I missed his work on my first few tours of the fair, but my New York counterpart, Liz Christensen, didn't, and she and the Deutsche Bank Americas committee bought a drawing.[4] My full interest was triggered when I read in Méndez Blake's catalogue that he had made a work called *Fiction is the Beginning of Exile* (2006). I was fascinated, as the title argues against such diverse storytellers as Cao Fei, Charles Avery and Nedko Solakov, who see little or no boundary between fiction and reality.

Ji Hyun Kwon
Self
2012, photographs, unsized.

Ji's photographs capture her
relationship with the world as
she wakes up each morning.

When I met Méndez Blake and had a drink with him on the
Frieze terrace, he brought home to me Teresa Margolles's
message about death on the streets of Mexico being one of
America's biggest exports.[5] Yet he obviously lives much of the
time in his head. Indeed, his studious intensity, set off by his
small black glasses, makes him the very image of a twentieth-
century intellectual, not unlike Walter Benjamin, Franz Kafka
or even his hero, Jorge Luis Borges. Many of Méndez Blake's
works are about books and his fear that we are increasingly
becoming alienated from them or, worse, indifferent to them.
He is holding up a mirror to society rather than the individual.
In *All the Poetry Books* (2010) he proposed removing every book
of poetry from various Los Angeles and Long Beach libraries,
almost as though to check whether anyone would notice that
the poetry in their lives had disappeared. At Frieze New York
he opted for the more manageable task of removing every text
by Borges from Manhattan's thirty-nine public libraries and
crating up the borrowed books at his gallerist's stand.[6] He locked
the books away, but the frightening part is that no one noticed.
On my basic art compass Méndez Blake is heading far north
with his heavy sense of social responsibility, but it is more

Mathilde ter Heijne
Human Sacrifice
2002, sound installation:
dummies with speakers on
platform, dimensions variable.

Ter Heijne advocates a
constant purging of ideas
about oneself.

difficult to place him on the east/west axis as his sense of scholarly fairness is offset by a vision of a world with a distorted sense of proportion, a world with a gaping hole in its psyche, a world without beauty.

Ostensibly I could argue that it was the same compass points that eventually steered me to an understanding of Méndez Blake's work that hooked me into *Self* (2012), a photographic series by Ji Hyun Kwon (b. 1980, Korea). What am I? What am I expected to be? What should I be? The self-portrait photographs the artist takes every morning as she wakes up ask these questions. We have to come to terms with life afresh each morning. In that moment we are at our most vulnerable, our consciousness in flux. For an earlier series, *The Guilty* (2009), Ji asked people to write their fears on their faces before she took their portrait. She herself felt guilty that she had let her parents down by giving up a good career as a lawyer to become an artist. So the series seems an obvious case for the east/west battle between the ego and the community, and yet, as with the work of Méndez Blake, it is quite difficult to place. There is a straight Warholian obsession with the self, but on deeper reflection the subject of her work is precisely the issue of where we place our understanding of the self on this axis – should society with all its inhibitions overrule the right for individuals to express themselves at any cost?

Art sometimes is little more than an expression of the friction between self and society. The two most clear examples of this are supplied by Mathilde ter Heijne and Cai Guo-Qiang. Ter Heijne reveals the savage assault that society makes on the female self in works such as *Mathilde, Mathilde* (1999) and *Human Sacrifice* (2002). Cai literally explodes himself in *Self-Portrait: A Subjugated Soul* (1989; see p. 97). This explosion of self is also the ultimate modernist act, the reduction of the self to ground zero so that it can be reincarnated. Not only, as Ernst Gombrich says, is there no such thing as art, just artists, but each time these artists make a new work of art, they need to reinvent themselves. To benefit fully from all this activity we need to constantly adjust the compass within us, to examine the pulls of different poles in order to keep ourselves open and continuously reinvent ourselves.

NOTES

PREFACE

1 Nefertiti (c. 1370–c. 1330 BC), wife of Pharaoh Akhenaten, is considered one of the great beauties of the ancient world. Her most famous bust is in the Neues Museum, Berlin.
2 Alistair Hicks, *The School of London: Resurgence of Contemporary Painting*, Oxford: Phaidon, 1989.
3 Friedhelm Hütte and Alistair Hicks, *Contemporary Art at Deutsche Bank London*, Frankfurt: Deutsche Bank, 1996. Most recently I was involved as part of the team renaming sixty of the Bank's headquarters' floors after artists: Britta Färber and Alistair Hicks (eds), *Art Works: Deutsche Bank Collection Group Head Office, Frankfurt*, Ostfildern: Hatje Cantz Verlag, 2011.
4 Johann Wolfgang von Goethe (1749–1832), John Ruskin (1819–1900) and Clement Greenberg (1909–1994) laid down the art 'laws' of their day.
5 Ernst Gombrich, *The Story of Art*, Oxford: Phaidon, 1950, p. 5.

WEST

1 Gabriel Orozco, quoted in Briony Fer, 'Crazy about Saturn: Gabriel Orozco Interviewed by Briony Fer', in *Gabriel Orozco*, exh. cat., Mexico City: Museo del Palacio de Bellas Artes, 2006, p. 65.
2 Ibid., p. 113.
3 Ibid.
4 Nan Goldin, *Couples and Loneliness*, Kyoto: Korinsha Press, 1998, p. 76.
5 'Group Show', organized by Harry Scrymgeour, Yvon Lambert, London, 2007.
6 Darger was the original 'outsider' artist. 'Dargerism: Contemporary Artists and Henry Darger', American Folk Art Museum, New York, April–September 2008, included Amy Cutler, Henry Darger, Jefferson Friedman, Anthony Goicolea, Trenton Doyle Hancock, Yun-Fei Ji, Justine Kurland, Justin Lieberman, Robyn O'Neil, Grayson Perry, Paula Rego and Michael St John.
7 Amy Cutler, quoted in Ana Finel Honigman, 'Telling Tales', *Artnet.com*,

2004, available at: http://www.artnet.com/magazine/features/honigman/honigman6-18-04.asp [accessed February 2012]
8 Ibid.
9 Kara Walker, interviewed by Ali Subotnick, *Make*, 92, 2002, pp. 25-27.
10 Allan deSouza, 'My Mother, My Sight' in *Allan deSouza: A Decade of Photoworks, 1998-2008: The Lost Pictures*, exh. cat., New York: Talwar Gallery, 2008, unpaginated.
11 Luis Alvarez, a Puerto Rican art collector and then a director at Deutsche Bank, New York, hosted a dinner for Eduardo Sarabia at the Regency, Miami, 29 November 2011.
12 Eduardo Sarabia, in conversation with the author, Miami, 4 December 2011.
13 Teresa Margolles, in 'A Conversation between Taiyana Pinetel, Teresa Margolles and Cuauhtémoc Medina', in Cuauhtémoc Medina (ed.), *Teresa Margolles: What Else Could We Talk About?*, Barcelona: RM Verlag, 2009, p. 85.
14 Francis Alÿs, in Mark Godfrey, Klaus Biesenbach and Kerryn Greenberg (eds), *Francis Alÿs: A Story of Deception*, exh. cat., London: Tate Publishing, 2010, p. 139. The Tehuelche Indians, who had lived in Patagonia for thousands of years, were wiped out in the late nineteenth century. The ñandú, which they used to hunt, is a flightless bird like an ostrich.
15 As the Low Countries were also occupied by the Spanish, in the form of the Habsburgs, this may be presumptuous.
16 Bill Viola, quoted in Sarah Douglas, 'The ArtInfo Interview: Bill Viola', *ArtInfo*, November 2005, available at: http://www.jamescohan.com/artists/bill-viola/articles-and-reviews/ [accessed May 2012]
17 Bill Viola, quoted in Wilfred Brandt, 'Bill Viola Interview', *Three Thousand*, 4 October 2010, available at: http://www.jamescohan.com/artists/bill-viola/articles-and-reviews/ [accessed May 2012]
18 'Post-hasteism' is a term coined by Hans Ulrich Obrist, Shumon Basar and John Grima. It was unleashed on an unwary audience during the Global Art Forum at Art Dubai in March 2012.

19 Elad Lassry, quoted in Mark Godfrey, 'On Display', *frieze*, 143, November–December 2011, p. 92, available at: http://www.frieze.com/issue/article/on-display/ [accessed February 2012]
20 Ibid., pp. 93-94.
21 Marcel Dzama, in conversation with the author, Brunswick, Germany, 2011.
22 Ibid.
23 Ibid.
24 Marcel Dzama's *Infidels* (2009) has a classical soundtrack. There is also a pop version, however, which is easier to find on YouTube: *Department of Eagles; No One Does It Like You* (2009).
25 Jeff Wall, quoted in Lee Robbins, 'Lightbox, Camera, Action', *ARTnews*, November 1995, p. 222.
26 Clement Greenberg, 'Modernist Painting', in *Forum Lectures*, Washington, DC: Voice of America, 1960.
27 Gregory Crewdson, quoted in Richard J. Goldstein, 'Gregory Crewdson' (unedited transcript of video interview), *Bombsite*, September 2010, available at: http://bombsite.com/issues/999/articles/3666 [accessed January 2012]
28 Carlos Garaicoa, quoted in Lorenzo Fusi, 'A Conversation with Carlos Garaicoa', in *Carlos Garaicoa: Capablanca's Real Passion*, exh. cat., Los Angeles: Museum of Contemporary Art, 2005, p. 114.
29 Carlos Garaicoa, quoted in Orlando Hernández, 'Unfaithful Readings', in *Capablanca's Real Passion*, p. 117.
30 Sandra Gamarra, quoted in Eduardo de Souza, 'Sandra Gamarra: Eduardo de Souza talks with Sandra Gamarra', *NY Arts Magazine*, November 2007, p. 76.
31 María Rosa Jijón, in conversation with the author, Venice, 2 June 2011.
32 Guillermo Kuitca, quoted in Julie L. Belcove, 'Guillermo Kuitca', *W Magazine*, 1 November 2009, pp. 168-75.
33 Unknown author, *Architectural Magazine*, 1834, quoted in Eleanor Nairne, 'Pablo Bronstein', *frieze*, 143, November–December 2011, available at: http://www.frieze.com/issue/review/pablo-bronstein/ [accessed December 2011]
34 Kamrooz Aram, email to the author, New York, 11 January 2012.

35 Beatriz Milhazes, quoted in Arto Lindsay, 'Musical Expression: Arto Lindsay in conversation with Beatriz Milhazes', *Parkett*, 85, 2009, p. 136.
36 Marcelo Moscheta, quoted in Scott Indrisek, 'Marcelo Moscheta', *Modern Painters*, December 2010, p. 53.
37 Gabriel Orozco, transcript of a conversation with Benjamin Buchloh, in *The Experience of Art: 51st International Art Exhibition*, Venice Biennale, 2005, p. 179.
38 Rirkrit Tiravanija, 'Fear Eats the Soul', Gavin Brown's Enterprise, New York, 2011.
39 Gregor Muir, 'Elizabeth Peyton: The Prince Albert Pub, London', *frieze*, 24, September–October 1995, p. 70.

 SOUTH

1 Edward Said, quoted in W. J. T. Mitchell, 'The panic of the visual: A conversation with Edward W. Said', *Boundary 2: An International Journal of Literature and Culture*, 25.2, Summer 1998, p. 11.
2 Edward Said, *Orientalism*, New York: Pantheon Books, 1978.
3 Lawrence Durrell, *The Alexandrian Quartet*, London: Penguin, 1961; Paul Scott, *The Raj Quartet*, London: Heinemann, 1966-75.
4 Hans Ulrich Obrist's 'Marathons' consist of a series of ten- to thirty-minute interviews with other intellectuals. Obrist is Co-Director of Exhibitions and Programmes and Director of International Projects at the Serpentine Gallery, London.
5 Okwui Enwezor, *Snap Judgments: New Positions in Contemporary African Photography*, exh. cat., New York: International Center of Photography (Steidl), 2008, p. 33.
6 'Africa Remix: Contemporary Art of a Continent', curated by Simon Njami, was first shown at Museum Kunstpalast, Düsseldorf, in 2004, before travelling to the Hayward Gallery, London, Centre Pompidou, Paris, and Mori Art Museum, Tokyo.
7 Zwelethu Mthethwa, quoted in Isolde Brielmaier, 'A Conversation with Zwelethu Mthethwa', in *Zwelethu Mthethwa*, New York: Aperture, 2010, p. 93.
8 Ubuntu, and its variations in the many languages across southern Africa, is a philosophy that has an expansive view of the self.
9 Enwezor, *Snap Judgments*, p. 33.
10 Zwelethu Mthethwa, quoted in Rory Bester, 'Interview with Zwelethu Mthethwa', in Jan-Erik Lundstrom and Katarina Pierre (eds), *Democracy's Images: Photography and Visual Art After Apartheid*, Umeå, Sweden: BildMuseet, 1998, p. 82.
11 Samuel Fosso, quoted in Leslie Camhi, 'Samuel Fosso: Man of a thousand faces', *International Herald Tribune Style Magazine*, Spring 2009, p. 35.
12 Ibid.
13 Samuel Fosso, in *Samuel Fosso*, Milan: 5 Continents Editions, 2008, p. 25.
14 Shirin Neshat, quoted in John LeKay, 'Shirin Neshat', *Heyoka Magazine*, 4, Spring 2006, p. 1.
15 Okot P'Bitek, 'The Sociality of Self', in Emmanuel Chukwudi Eze (ed.), *African Philosophy: An Anthology*, Oxford: Blackwell, 1998, p. 74.
16 Pablo Picasso, in conversation with Marius de Zayas, 1923, quoted in Stephen Coppel, *Picasso: The Complete Vollard Suite Prints*, London: British Museum Publications, 2012, p. 32.
17 Wangechi Mutu, quoted in Lauri Firstenberg, 'Perverse Anthropology: The Photomontage of Wangechi Mutu, A Conversation with the Artist', in Friedhelm Hütte and Christina März (eds), *Wangechi Mutu: My Dirty Little Heaven*, exh. cat., Berlin: Deutsche Guggenheim (Hatje Canz), 2010, p. 40.
18 Enwezor, *Snap Judgments*, p. 29.
19 Wangechi Mutu, quoted in Barbara Kruger, 'Wangechi Mutu: Portrait by Albert Watson,' *Interview*, April 2007, p. 119.
20 Marcia Kure, email to the author, New York, 25 June 2011.
21 Ibid.
22 El Anatsui, in conversation with Chika Okeke-Agulu, in *El Anatsui at the Clark*, exh. cat., Williamstown, MA: Sterling and Francine Clark Institute, 2011, p. 10.
23 Ibid., p. 11.
24 Kader Attia, quoted in Laurie Ann Farrell, 'Interview', in *Kader Attia: Signs of Reappropriation*, Savannah College of Art and Design, 2009.
25 Ibid.
26 Ibid.
27 Zineb Sedira, *Out of the Blue*, exh. cat., Glasgow: Gallery of Modern Art, 1997, p. 23.
28 Zineb Sedira, 'Beneath the Surface', interview by Hans Ulrich Obrist at INIVA, London, 2009; repr. as 'Zineb Sedira In Conversation', in Okwui Enwezor et al., *Zineb Sedira: Beneath the Surface*, Paris: Kamel Mennour, 2011, p. 18.
29 Ironically, the English metaphysical poet John Donne (1572-1631), a contemporary of Descartes, expresses this more expansive view of the self as eloquently as anyone in his poem 'Meditation XVII' (1624): No man is an island / Entire of itself; / Every man is a piece of the continent, / A part of the main. / If a clod be washed away by the sea, / Europe is the less. / as well as if a promontory were. / As well as if a manor of thy friend's / Or of thine own were: / Any man's death diminishes me, / Because I am involved in mankind, / And therefore never send to know for whom the bell tolls; / It tolls for thee. So this clash that I am presenting as one between continents has probably been inherent within every culture, east, west, north and south.
30 Yto Barrada, quoted in Jennifer Higgie, 'Talking Pictures', *frieze*, 142, October 2011, pp. 187-88.
31 Maha Maamoun, email to the author, Cairo, March 2010.
32 Zohra Bensemra, quoted in Enwezor, *Snap Judgements*, p. 39.
33 Edward Said, 'The Art of Displacement: Mona Hatoum's Logic of Irreconcilables', in *Mona Hatoum: The Entire World as Foreign Land*, exh. cat., London: Tate Publishing, 2000, p. 17.
34 Mona Hatoum, interviewed by Claudia Spinelli, in Michael Archer, Guy Brett and Catherine de Zegher (eds), *Mona Hatoum*, London: Phaidon, 1997, p. 141.
35 Mona Hatoum, press release, Museum of Contemporary Art, Los Angeles, 2001, available at: http://www.moca.org/museum/exhibitioninfo_printablephp?useGallery=1&id=333 [accessed February 2012]
36 Yehudit Sasportas, quoted in Andrea Scrima, '"I've always inhabited two worlds": A conversation with Yehudit

Sasportas', *ArtMag*, available at: http://db-artmag.de/archiv/2006/e/8/1/502-2.html [accessed December 2011]

37 Yehudit Sasportas, interviewed by Mark Gisbourne, in Hilke Wagner, *Yehudit Sasportas: The Laboratory*, exh. cat., Kunstverein Braunschweig (Prestel), 2008, p. 87.

38 Ibid., p. 88.

39 Ori Gersht, quoted in Julia Weiner, 'We have a responsibility to hold on to dark memories', *Jewish Chronicle Online*, 16 February 2012, available at: http://www.thejc.com/arts/arts-features/63639/we-have-a-responsibility-hold-dark-memories [accessed March 2012]

40 Ibid.

41 The exhibition was 'Whose Map Is It? New Mapping by Artists', INIVA, London, 2010.

42 Ebtisam Abdulaziz, in conversation with the author, Dubai, 17 March 2010.

43 Ibid.

44 Ramin Haerizadeh, in conversation with the author, Dubai, 20 March 2012.

45 Ibid.

46 Hesam Rahmanian, in conversation with the author, Dubai, 20 March 2012.

47 Rokni Haerizadeh, in conversation with the author, Dubai, 20 March 2012. Haerizadeh uses the old title for the *Arabian Nights*, which simply refers to the number of tales told.

48 Ramin Haerizadeh, in conversation with the author, Dubai, 20 March 2012.

49 Ibid.

50 Shadi Ghadirian, quoted in Nazila Fathi, 'Iran's giant shoe box of faded photographs, full of the unexpected', *New York Times*, 30 May 2007, available at: http://www.nytimes.com/2007/05/30/arts/design/30phot.html?_r=2&oref=slogin [accessed February 2012]

51 Shadi Ghadirian, quoted in Ruchira Gupta, 'Shadi Ghadirian', available at: http://www.tasveerarts.com/photographers/shadi-ghadirian/interviews/?p=15 [accessed February 2012]

52 Kamrooz Aram, email to the author, 5 April 2012.

53 *Captain Pugwash* was a BBC children's cartoon created by John Ryan about a cut-out pirate.

54 Okwui Enwezor, 'Exodus of the Dogs', in Jo Ractliffe et al., *Jo Ractliffe: Terreno Ocupado*, exh. cat., Johannesburg: Warren Siebrits, 2008, p. 84.

55 Jo Ractliffe, quoted in Sue Williamson, 'Jo Ractliffe: The Third Meaning', in Sue Williamson and Ashraf Jamal, *Art in South Africa: The Future Present*, Cape Town: David Philip, 1996, p. 76.

56 The image of the bare-bosomed woman appears in Ractliffe's photograph *Details of tiled murals at the Fortaleza De São Miguel, depicting Portuguese explorations in Africa 2* (2007).

57 Hasan and Husain Essop, press release for 'Powerplay', Goodman Gallery, Cape Town, 2008, available at: http://www.essoptwins.com/exhibitions/power-play-2008/ [accessed January 2012]

58 The Essop twins' work made a particular impression on me at Art India in 2011, and at Art Dubai and Les Rencontres d'Arles in 2012. Their work was also included in the exhibition 'Figures & Fictions: Contemporary South African Photography', Victoria and Albert Museum, 2011.

59 Hasan and Husain Essop did two degrees at the Michaelis School of Fine Art at the University of Cape Town: their BA in 2006 and their postgraduate diploma in 2009.

60 'Hasan & Husain Essop', Biennale de l'Art Africain Contemporain, Dakar, 2010, available at: http://biennaledakar.org/2010/spip.php?article90 [accessed January 2012]

61 *The Wanderer above the Sea of Fog* (1818), in the Hamburger Kunsthalle, is Caspar David Friedrich's most famous work and has influenced countless contemporary artists, but Friedrich made many more paintings of solitary men confronting nature.

 EAST

1 'Cai Guo-Qiang', Deutsche Bank Lounge, Art Hong Kong, May 2012. Art Hong Kong turned into Art Basel Hong Kong in 2013.

2 Tatsumi Masatoshi helps Cai Guo-Qiang with many of his installations.

3 Hauser & Wirth has galleries in Zurich, London and New York.

4 Cai Guo-Qiang, talk to Deutsche Bank Staff, ICC, Kowloon, 18 May 2012.

5 Ibid.

6 Cai Guo-Qiang, email to the author, 7 June 2012.

7 Cai Guo-Qiang, in conversation with the author, Hong Kong, 17 May 2012.

8 Yan Pei-Ming, quoted in Guo Xiaoyan, 'Childhood, Landscapes, Faces and Reversal of Unexpected Fate', in Jérôme Sans and Guo Xiaoyan, *Yan Pei-Ming: Landscape of Childhood*, exh. cat., Beijing: UCCA, 2009, unpaginated.

9 Yan Pei-Ming, quoted in Jérôme Sans, 'The Energy of Painting: An Interview with Yan Pei-Ming', in Sans and Guo, *Landscape of Childhood*.

10 Reuters, 'China slams art magazine for honoring Ai Weiwei', 13 October 2011, available at: http://www.reuters.com/article/2011/10/13/us-china-artist-idUSTRE79C1BZ20111013.

11 'Artists and Mapping Historiographies', panel discussion, Art Dubai, 17 March 2010.

12 I subsequently learned that only Monica and Shuddha had been in Dubai, so my memory was understandably unable to create a convincing picture of Jeebesh, who had not been there.

13 In an effort to placate the ghost of my 'good grandmother', Shuddha sent me the name of a book that writes about Lutyens's links to Freemasonry: Andreas Volwahsen, *Imperial Delhi: The British Capital of the Indian Empire*, Munich: Prestel, 2003. He also précised the relevant passage for me: 'Lutyens, who headed the design team for New Delhi, was not a mason, but he did chair the jury for the international competition to design a grand masonic lodge in London, and his wife, Lady Edith Mary Lutyens, is said to have been (along with Annie Besant) a pioneer "lady" Freemason. It is tantalizing to think of the entire city of New Delhi to be a giant masonic diagram – it seems resonant to the way in which secrecy and power work in this city.'

14 The works in Raqs's ongoing series involving clocks are usually called *Escapement* but actually started with the twelve-clock piece *Location(n)*, which was first shown in São Paulo at the Emocão Artificial Festival in 2003.

15 Raqs Media Collective, 'Words in art: India's Raqs Media Collective see all words as equal', *Art Radar Asia*, 12 January 2011, available at: http://artradarjournal.com/2011/01/12/words-in-art-indias-raqs-media-collective-see-all-words-as-equal/ [accessed December 2011]

16 While specifically referencing a clock at the kink in London's King's Road called World's End, this is playing on the world's end, the apocalyptic end of time.

17 Raqs Media Collective, 'Words in art'.

18 Raqs Media Collective, in conversation with the author, New Delhi, 28 January 2012.

19 Wong Hoy Cheong, email to the author, Kuala Lumpur, 7 November 2010.

20 Ibid.

21 Huang Yong Ping, quoted in Hans Ulrich Obrist, 'Huang Yong Ping', in Philip Tinari and Angie Baecker (eds), *Hans Ulrich Obrist: The China Interviews*, Hong Kong: Office for Discourse Engineering, 2009, p. 179 (interview conducted in Paris, April 2002).

22 Dayanita Singh, in conversation with the author, New Delhi, 28 January 2012.

23 Dayanita Singh, quoted in Sangeeta Barooah Pisharoty, 'Prose as pictures', *The Hindu*, 17 December 2011, available at: http://www.thehindu.com/Arts/magazine/article2723350.ece [accessed February 2012]

24 Sarnath Banerjee, *The Harappa Files*, Noida, India: Harper Collins, 2011.

25 Sarnath Banerjee, in conversation with the author, London, 19 June 2012.

26 Walter Benjamin, *Berlin Childhood around 1900*, Cambridge, MA: Harvard University Press, 2006.

27 Raqs Media Collective, quoted in Mike Caloud, 'Sarai – Part 2'. See also Elena Bernadini, 'Raqs Media Collective: Nomadism in Art Practice', available at: http://www.raqsmediacollective.net/images/pdf/84596231-6f50-48ed-8c41-429a03b57124.pdf [accessed December 2011]

28 Shilpa Gupta is apparently no relation to the more celebrated Subodh Gupta (b. 1964, India) of the pots and pans fame.

29 'Indian Highway', curated by Julia Peyton-Jones, Hans Ulrich Obrist and Gunnar B. Kvaran, Serpentine Gallery, London, 10 December 2008– 22 February 2009, Astrup Fearnley

Museum of Modern Art, Oslo, 4 April– 21 June 2009, and touring.

30 Shilpa Gupta, quoted in Nancy Adajania et al., *Shilpa Gupta*, exh. cat., Delhi: Vahedra Art Gallery (Prestel), 2010, p. 20.

31 Bose Krishnamachari, quoted in Mohd Ahmad Sabih and Enoch Cheng, 'Interview with Bose Krishnamachari', *Asian Art Archive*, January 2010, available at: http://www.aaa.org.hk/newsletter_detail.aspx?newsletter_id=780 [accessed September 2011]

32 Bose Krishnamachari, *India Arts Trust Online Magazine*, May 2010, available at: http://www.theartstrust.com/online_magazine_Article.aspx?articleid=18 [accessed September 2011]

33 Shanay Jhaveri, 'As His Hair Scatters and Regrows', in *Nikhil Chopra: Yog Raj Chitrakar*, Mumbai: Chatterjee & Lal, 2010 unpaginated.

34 Raqs Media Collective, in conversation with the author, New Delhi, 28 January 2012.

35 Ibid.

36 Ibid.

37 Ibid.

38 Cao Fei, in conversation with author, with translator Zhang Wei, Beijing, 23 May 2010.

39 Ibid.

40 China Tracy aka Cao Fei, 'i.Mirror', in Hou Hanru, Hans Ulrich Obrist and Hu Fang, *Cao Fei: Journey*, Paris: FRAC Ile-de-France/Le Plateau, 2008, p. 21.

41 Cao Fei, 'COSPLAYERS', in Hou, Obrist and Hu, *Journey*, p. 13.

42 Yang Yongliang, 'A few issues concerning concepts in my work', unpublished artist statement sent to the author by Magda Danysz from Gallery 18, Shanghai, 7 September 2011.

43 Hou Hanru, 'Politics of Intimacy – On Cao Fei's Work', in Hou, Obrist and Hu, *Journey*, pp. 49–50.

44 Yukiko Duke, 'Conversation with Tabaimo', in *Furo*, exh. cat., Stockholm: Jewish Theatre, 2006, unpaginated.

45 Ibid.

46 Lee Yongbaek, in conversation with the author, Seoul, 4 September 2011.

47 Ibid.

48 Ibid.

49 Ibid.

50 Ming Wong, *Wedding Banquet* (2011), Para Site, Hong Kong, 26 May 2011.

51 One of the most lively events of the international debating society Intelligence Squared is their annual debate in Hong Kong, which has become one of the social events during the week of the art fair.

52 Yang Fudong, quoted in Hans Ulrich Obrist, 'Yang Fudong', in Tinari and Baecker (eds), *The China Interviews*, p. 371.

53 Yang Fudong, quoted in Marcella Beccaria, 'Yang Fudong: The Foreigner and the Search for Poetic Truth', in *Yang Fudong*, exh. cat., Turin: Museo d'arte contemporanea, Castello di Rivoli (Skira), 2005, p. 25.

54 Shao Yinong and Mu Chen, in conversation with the author, Hong Kong, 28 May 2011.

55 Bernd and Hilla Becher both heavily influenced the direction of photography through their teaching at the Düsseldorf Academy. Bernd was Professor of Photography there from 1976 to 1996.

56 Nandan Ghiya, *deFacebook v.1.2-: Search Results and Download Errors by Nandan Ghiya*, Exhibit 320, Art Stage, Singapore, 2012.

57 Cao Fei, quoted in Hans Ulrich Obrist, 'Cao Fei', in Tinari and Baecker (eds), *The China Interviews*, p. 68.

58 Miwa Yanagi, interviewed by Dominique Gonzalez-Foerster and Hans Ulrich Obrist, in *Miwa Yanagi: Deutsche Bank Collection*, Frankfurt: Deutsche Bank, 2007, p. 47.

59 Francis Bacon painted a series of paintings in the 1950s after Velázquez's *Innocent X* (1650). In some of them the popes have their mouths open, as though they are screaming about the human condition and/or about being contained within their prescribed space.

60 Bill Henson, quoted in Sebastian Smee, 'The shadowy existence of Bill Henson', *Art Newspaper*, 169, May 2006, p. 40.

61 Ibid.

62 'Zeitgeist' at the Martin-Gropius-Bau in Berlin in 1982 and its sister exhibition, 'A New Spirit in Painting' at the Royal Academy in London in 1981, celebrated a figurative revival, based around such German heroes as Georg Baselitz, Anselm Kiefer and Sigmar Polke, but adding an international spin with Francesco Clemente, Enzo Cucchi and Julian Schnabel.

63 Yangjiang Group, 'After Dinner Shu Fa at Cricket Pavilion', Eastside Projects, Birmingham, 17 March–5 May 2012.
64 The Ming Dynasty ruled from 1368 to 1644. I am afraid I am not enough of a Chinese furniture buff to know whether the chairs are from this period or, as is more likely, later works in the same tradition, but they are old enough to make Zheng's point.
65 Zheng Guogu, interviewed by Hu Fang, in *Zheng Guogu: Jumping out Three Dimensions, Staying outside Five Elements*, Guangzhou: Vitamin Creative Space, 2007, unpaginated.
66 Although three directors of Art Basel were appointed in 2007, since 2008 there have been only Annette Schönholzer and Marc Spiegler. However, they have now been joined by Magnus Renfrew, the founding director of Art Hong Kong.
67 Jia Aili, quoted in Karen Smith, 'A walk in the world of Jia Aili', *NY Arts Magazine*, September–October 2007, available at: http://www.nyartsmagazine.com/?p=1646 [accessed October 2013]
68 Lee Eunsil, in conversation with the author, Seoul, 3 September 2011.
69 Lee Youngbin, in conversation with the author, Seoul, 4 September 2011.
70 Ibid.
71 Lee Youngbin, translated and emailed to the author by Hwang Yookyung, 6 April 2012.
72 China and Hong Kong are desperately short of public museum spaces. The donation of over a thousand paintings to the new gallery M+ in Kowloon should make a dramatic impact.
73 Duan Jianyu still makes paintings with chickens in them but no longer calls them *Artistic Chickens*.
74 Zhang Wei, 'Let the Wisdom of Life Decide', in *Duan Jianyu: The Seduction of Village*, Hong Kong: Blue Kingfisher, 2011, unpaginated, available at: http://www.duanjianyu.cn/article_view_en.asp?displaypage=4&sort_id=30&id=88&url=index_en.asp?id1=30@sort1=2 [accessed January 2012]
75 Raqs Media Collective, in conversation with the author, New Delhi, 28 January 2012.

 NORTH

1 Every half an hour or so poor Ekaterina Kuznetsova from Art Moscow got a call from me to say I was at a different station. Eventually she managed to track me down. Thank you.
2 Laure Prouvost, http://www.facepaintchimp.com/2010/11/a-visiting-artist-lecture-by-laure-prouvost-at-leeds-met-advice-and-inspiration/ [accessed October 2011]
3 'Nedko Solakov: All in Order, with Exceptions', Ikon, Birmingham, 21 September–13 November 2011.
4 The Clash, 'Should I Stay or Should I Go?', *Combat Rock*, 1981.
5 Anri Sala, in conversation with Hans Ulrich Obrist, in Mark Godfrey et al., *Anri Sala*, London: Phaidon, 2007, p. 31.
6 Many of the artists mentioned by Sala are key figures in Nicolas Bourriaud, *Relational Aesthetics*, Paris: Les Presses du Réel, 1998. Bourriaud coined the term in 1995, in *Traffic*, exh. cat., CAPC Musée d'art contemporain de Bordeaux, 1995.
7 Nicolas Bourriaud, *Postproduction: Culture as Screenplay: How Art Reprograms the World*, New York: Lukas & Sternberg, 2002.
8 Johann Nowak, a gallerist whose love of the use of new technology by artists takes him around the world, introduced me to Peter Weibel, the Director of the Biennale, who since 1999 has been Director and board member of the Center for Art and Media Karlsruhe.
9 Peter Weibel, 'Rewriting Worlds: Art and Agency', in *4 Moscow Biennale of Contemporary Art: Rewriting Worlds*, exh. cat., Moscow: Institute of Contemporary Art, 2011, p. 29.
10 Although in the context of the Moscow Conceptualists it is Ilya Kabakov who is important, he has worked for many years with his wife, Emilia.
11 Boris Groys, 'Moscow Conceptualism Twenty-Five Years Later', in IRWIN (eds), *East Art Map: Contemporary Art and Eastern Europe*, London: Afterall Books, 2006, p. 409.
12 Peter Weibel, 'Rewriting Worlds', p. 27.
13 Neo Rauch, quoted in Jans Thorn-Prikker, 'Neo Rauch; For Me, Painting Means the Continuation of Dreaming

by other Means', available at: http://archive.is/ZUX7h [accessed October 2013]
14 'gateways: Art and Networked Culture', House of Electronic Arts, Basel, 2 June–19 August 2012.
15 *Babette's Feast* (1987), directed by Gabriel Axel, is based on the brilliant short story by Karen Blixen (aka Isak Dinesen).
16 George Orwell, *1984*, New York: Signet Books, 1955, p. 226 (first published London: Secker and Warburg, 1949).
17 Timo Toots, in conversation with the author, Tallinn, 29 October 2011.
18 'Blood on Paper: The Art of the Book', Victoria and Albert Museum, London, 2008.
19 Janet's Bar, which has a picture of Janet Street-Porter and her famous teeth outside, is on Old Brompton Road. Reece Mews, where Bacon spent the last half of his life, runs off from there. Ironically there is no blue plaque outside his studio. The plaque is on the headquarters of the National Art Collections Fund building at 7 Cromwell Place, where Bacon also owned a studio. His dealer, Valerie Beston of Marlborough, thought he needed a bigger place, but he never moved in, preferring the chaotic confines of his mews attic.
20 Charles Sandison, in conversation with the author, Paris, 2002. These precise words come from an interview, but he said almost the same to me. See Charles Sandison, 'Good and Evil', *Designboom*, 2002, available at: http://www.designboom.com/portrait/sandison_good.html [accessed February 2012]
21 Friedrich Nietzsche, Aphorism 146, in *Beyond Good and Evil*, London: Penguin, 2003, p. 102.
22 Jorma Puranen was Professor of Photography at the University of Art and Design, Helsinki, from 1996 to 1998, and so was one of the key founders of the Helsinki school. I met him through the ever-ebullient Timothy Persons.
23 Jorma Puranen, email to the author, 31 July 2012. Puranen talks about the Norwegian painter Peder Balke (1804–1887) who 'travelled all the way to northern Norway, the same areas where I have worked. His landscapes

and seascapes are not naturalist, but rather dramatic and hallucinatory visions of northern nature. Louis Philippe, the King of France (1830–1848), commissioned Balke to produce a series of seascapes, a room full of small paintings, which even today will be found at the Louvre. Another important painter before the time of photography's domination is François Biard (1799–1884), who travelled to the far north. He participated in an expedition to Lapland and Spitsberg, a journey again supported by Louis Philippe in 1838. Louis Philippe was hated by the French, but he was a key figure to produce narratives of Lapland. Louis Philippe himself visited Lapland in 1795 after having escaped Paris during those turbulent times, perhaps not to lose his head. I once visited Versailles where one of Biard's key paintings is being kept. I photographed details of it, depicting Louis Philippe sitting inside a Lappish tent, surrounded by indigenous Sámi people. This painting truly epitomizes cultural clash.'

24 Jorma Puranen, in conversation with the author, Paris, 12 November 2011.

25 I am not trying here to dwell on the comparison between the East and the West's support for artists. Of course, in the same period in Western Europe there were thousands of artists who failed to eke out their existence through their art. I am just concerned here with the impact on the current generation.

26 Roman Ondák's *Good Feelings in Good Times* (2003) was first shown outside the Kölnischer Kunstverein in 2003, and afterwards re-enacted at Frieze London in 2004, when it was purchased by Tate.

27 Christina Steinbrecher was Art Director of Art Moscow in 2011, but in 2012 she took up the post as Director of the VIENNAFAIR.

28 My fellow curators at Deutsche Bank Claudia Schicktanz and Danielle Pippardt admired Birgit Brenner's work and so introduced me to it.

29 Andy Warhol, *The Andy Warhol Diaries*, ed. Pat Hackett, London: Simon & Schuster, 1989.

30 *Cabaret* (1972), directed by Bob Fosse and starring Liza Minnelli, was based on Christopher Isherwood's

Mr Norris Changes Trains, London: Chatto & Windus, 1935; and *Goodbye to Berlin*, London: Chatto & Windus, 1939. The film was set in Berlin in 1931, four years after Francis Bacon had learned about the low life/high life of the German capital.

31 Birgit Brenner, in conversation with the author, Berlin, 11 June 2010.

32 Ibid.

33 Ibid.

34 The party was held by a group of dealers and I was actually invited by Asia Zak of Zak Branicka.

35 Birgit Brenner, in conversation with the author, Berlin, 11 June 2010.

36 Marlene Dumas, quoted in Terry R. Myers (ed.), *Painting*, London: Whitechapel Gallery, 2011, pp. 94–95.

37 Borremans's presentation of *The Quiller Memorandum* (1966), directed by Michael Anderson, was an event organized at the Prince Charles Cinema off Leicester Square, London, by Ziba Ardalan in conjunction with David Gryn during his exhibition 'The Performance: Paintings by Michaël Borremans' at the Parasol Unit, London, 4 May–30 June 2005.

38 Michaël Borremans, quoted in David Coggins, 'Interview: Michaël Borremans', *Art in America*, 2009, available at: http://www.artinamerica magazine.com/features/michael-borremans/2/ [accessed October 2013]

39 Ibid.

40 Apologies here to Friedrich Loock, Grubanov's gallerist, and Britta Färber, my fellow curator at Deutsche Bank, who were very much there in the room. Neither is easy to ignore, it is just that Grubanov made me feel he was talking straight to me.

41 Ivan Grubanov, in conversation with the author, Berlin, 10 June 2010.

42 Wilhelm Sasnal, in Achim Borchardt-Hume and Wilhelm Sasnal, 'A Conversation about Painting,' in *Wilhelm Sasnal*, exh. cat., London: Whitechapel Gallery, 2011, pp. 7–8.

43 Ibid., p. 7.

44 Henryk Latos, *77 Termatow Fotograficznych*, Warsaw: Wydawnictwa Artystyczczne i Filmowe, 1975.

45 Peter Weibel, 'Rewriting Worlds', p. 27.

46 Monika Szewczyk, 'The fantasy of Paulina Olowska', *A Prior*, 13, 2006, p. 127.

47 'Kuba: Kutluğ Ataman', Artangel, The Sorting Office, New Oxford Street, London, March–June 2005.

48 In *Lawrence of Arabia* (1962), directed by David Lean, Omar Sharif, playing Sherif Ali, appears on a camel out of the desert in a long sequence that was caught on camera by accident.

49 Kutluğ Ataman, quoted in Emre Baykal, 'You Tell Me about Yourself Anyway!', in *Kutluğ Ataman: You Tell Me about Yourself Anyway*, Istanbul: YKY, 2008, p. 26.

50 Mike Nelson, in conversation with the author, London, 18 July 2011.

51 One of the patrons of Matt's, the superhuman Freddie Pierre-Pierre, had organized an evening where Deutsche Bank staff met Matt's artists. A liberal flow of good champagne ensured that artists and bankers were more than happy in each others' company.

52 *I, Imposter* was the work that Mike Nelson made in Venice in 2011. He reconstructed and reworked his contribution to the 2003 Istanbul Biennale in the British Pavilion at Venice.

53 Mike Nelson, in Dan Cameron and Rachel Withers, *Mike Nelson: I, Imposter*, exh. cat., London: British Council, 2011, p. 128.

54 Mike Nelson, in conversation with the author, London, 18 July 2011.

55 Keith Tyson, *12 Harmonics*, video, Deutsche Bank, London and Brighton, 2011.

56 Jacob Wamberg, 'Supercollider', in Michael Juul Holm, Anders Kold and Jeanne Rank (eds), *Keith Tyson: Large Field Array*, exh. cat., Humlebæk: Louisiana Museum of Modern Art, 2006, p. 10.

57 Charles Avery, quoted in Tom Morton, 'An Interview with Charles Avery by Tom Morton', in Ziba Ardalan (ed.), *The Islanders: An Introduction: Charles Avery*, London: Parasol Unit (Koenig Books), 2008, p. 161.

58 Charles Avery, quoted in Maryam Eisler and Hossein Amirsadeghi (eds), *Sanctuary*, exh. cat., London: Thames and Hudson (in association with TransGlobe Publishing), 2012, p. 90.

59 Fiona Tan is the daughter of a Chinese father and an Australian mother. She was born in Indonesia,

grew up in Australia and, after studying in Germany, has lived in Amsterdam since 1988.

60 Fiona Tan, in conversation with Saskia Bos, in Bos et al., *Disorient: Fiona Tan*, exh. cat., Heidelberg: Kehrer Verlag, 2009, p. 122.

61 Yes, irony is intended: no ordinary person in their right mind peregrinates.

62 The irony was compounded as Gavin recruited me and other late-stayers at the party, including another artist, Ola Kolehmainen, to remove *Gentleman Jim*, this embodiment of drunkenness.

63 I did not witness this. I was told about the hammer-wielding might of Gormley by Dominic Berning, who works with and acts as an agent for Gavin Turk. Berning swam in the Rhine with Turk, along with British artists Nicky and Rob Carter.

64 Ursula Krinzinger, of Krinzinger Galerie, Vienna, holds a dinner after the opening of Art Basel. Many gallerists do the same at fairs around the world, but not many have been doing it for forty years.

65 'Sensation: Young British Artists from the Saatchi Collection', Royal Academy, London, 17 September–28 December 1997. The exhibition travelled on to the Berlin Hamburger Bahnhof, 30 September 1998–30 January 1999, and Brooklyn Museum of Art, New York, 2 October 1999–9 January 2000.

66 Gavin Turk, in conversation with the author, London, 3 August 2009.

67 There is no room in Basel during the fair; its hotels get booked up months in advance. I am very lucky that some family friends, Bernadette and Stefan Schmid and their son Florian, invite me to stay every year.

68 Acme Studios is a London-based charity which aims to give artists affordable studios.

69 Cornelia Parker, quoted in Kenneth Baker, 'Artist Cornelia Parker doesn't stop with lightning and fire – she's even eyed outer space', *San Francisco Chronicle*, 16 December 2005, available at: http://www.sfgate.com/entertainment/article/Artist-Cornelia-Parker-doesn-t-stop-with-2573114.php [accessed October 2013]

70 Maurizio Cattelan, quoted in Bruce Millar, 'Top Cat', *Tate Magazine*, 8, November–December 2003, p. 42.

71 Cattelan tried to use the work and belongings of Paul de Reus for the exhibition 'Crap Shoot' at de Appel in Amsterdam in 1996, but the police actually stopped him before the works could be installed.

72 Maurizio Cattelan, 'Blown Away – Blown to Pieces, Conversation with Jens Hoffman and Massimiliano Gioni', in *6th Caribbean Biennial – A Project by Maurizio Cattelan*, Paris: Les Presses du Réel, 2001, unpaginated.

73 Mini-Me, the despotic alter ego character in the *Austin Powers* films, first appeared in 1999, so Cattelan was instantly exploiting popular culture.

74 I am certainly not wanting to pretend I am the grand patron in Courbet's *The Meeting* (1854). Indeed, Kapoor was dressed more like Alfred Bruyas than me.

75 'Anish Kapoor', Haus der Kunst, Munich, 2007. My friend Arlene Cohrs took me to this exhibition. Although I saw both *Yellow* (1999) and *Svayambh* (2007) later at the Royal Academy show in 2009, they were so much better installed, and more poignant, in the Haus der Kunst, built in the Nazi era.

 AFTERWORD

1 Olga Temnikova, of Temnikova & Kasela in Tallinn, first showed me Estna's work.

2 Merike Estna, in conversation with the author, London, 8 May 2012.

3 Heathcliff is the romantic hero of Emily Bronte's novel *Wuthering Heights* (1847).

4 Liz Christensen, Art Adviser and Curator for Deutsche Bank, New York.

5 Frieze New York took place for the first time in a large tent on Randall's Island, off the coast of Manhattan, 3–7 May 2012.

6 Jorge Méndez Blake was represented at Frieze New York in 2012 by Meessen De Clercq.

BIBLIOGRAPHY

An honest bibliography has to be painfully short. Reading is an essential way of finding out about contemporary art around the world, but sadly the vast majority of catalogues and books are no more than a form of vanity publishing. Newspaper editors are not employing serious critics to write about the latest art, believing that their readers only want reviews of the big museum shows. It is a vicious circle, reinforced by curators, who invariably exhibit the choice of their market-led patrons and trustees. The attempts of magazines and websites to fill the gap are usually under-resourced. Often the most useful information can be gleaned from artist and gallery websites - at least here there is no attempt to hide the bias.

TWENTY-FIRST-CENTURY SURVEYS

Not many people have been outrageous enough to attempt global surveys of contemporary art outside the prescribed formats of Documenta and the biennials. Sadly, though these events feature much good art, often their overriding themes fail to give any clear alternative to the dominant conservative vision of the art market. Ikea catalogues give a better overview of the way we live than most of the biennial handbooks that try to cram everything in, but there are delicious exceptions, such as Peter Weibel's guide to the 2011 Moscow Biennale. I have relied heavily on the artists' own words, and so am most indebted to Hans Ulrich Obrist's 'Marathon' interviews and his near sleepless schedule that sees him circumnavigate the globe. I have made heavy use of his China interviews. The catalogues of geographically themed shows are another important resource.

● Bourriaud, Nicolas, *Relational Aesthetics*. Paris: Les Presses du Réel, 1998; first English translation 2002.
–, *Postproduction: Culture as Screenplay: How Art Reprograms the World*. New York: Lukas & Sternberg, 2002.
● Christov-Bakargiev, Carolyn, *Documenta 13*. Ostfildern: Hatje Cantz, 2012.

● Enwezor, Okwui, *Documenta 11 – Platform 5*. Ostfildern: Hatje Cantz, 2002.
–, *Snap Judgments: New Positions in Contemporary African Photography*, exh. cat. New York: International Center of Photography (Steidl), 2008.
● IRWIN (eds), *East Art Map: Contemporary Art and Eastern Europe*. London: Afterall Books, 2006.
● Madden, Kathleen (ed.), *Indian Highway*, exh. cat. London: Serpentine Gallery (Koenig Books), 2008.
● Njami, Simon (ed.), *Africa Remix: Contemporary Art of a Continent*, exh. cat. Düsseldorf: Museum Kunstpalast (Hatje Cantz), 2005.
● Tinari, Philip, and Angie Baecker (eds), *Hans Ulrich Obrist: The China Interviews*, Hong Kong: Office for Discourse Engineering, 2009.
● Weibel, Peter, *4 Moscow Biennale of Contemporary Art: Rewriting Worlds*, exh. cat. Moscow: Institute of Contemporary Art, 2011.

ARTIST MONOGRAPHS AND CATALOGUES

We have reproduced an image (see p. 191) of Maurizio Cattelan's shrunken alter ego sitting on a bookshelf among monographs and weighty catalogues, so it is appropriate that Nancy Spector's leather-bound tome on Cattelan shines through as a successful example of how to make a book about an artist. Luckily the artists themselves ensure that there is no standard formula for making such a book. I have enjoyed Nedko Solakov and Gavin Turk's blockbuster approach to recording some of the vagaries of their minds, alongside the straightforwardly informative approach of Francis Alÿs's Tate or Wilhelm Sasnal's Whitechapel catalogues. I must also mention Mathilde ter Heijne's novel approach: she uses making a book about herself as an excuse to interview the people she most admires.

● Adajania, Nancy, et al., *Shilpa Gupta*, exh. cat. Delhi: Vahedra Art Gallery (Prestel), 2010.
● Ardalan, Ziba (ed.), *The Islanders: An Introduction: Charles Avery*, exh. cat. London: Parasol Unit (Koenig Books), 2008.

● Beccaria, Marcella, and Yang Fudong, *Yang Fudong*, exh. cat. Turin: Museo d'arte contemporanea, Castello di Rivoli (Skira), 2005.
● Blazwick, Iwona, *Cornelia Parker*. London: Thames and Hudson, 2013.
● Borchardt-Hume, Achim (ed.), *Wilhelm Sasnal*, exh. cat. London: Whitechapel Gallery, 2011.
● Bos, Saskia, et al., *Disorient: Fiona Tan*, exh. cat. Heidelberg: Kehrer Verlag, 2009.
● Buchloh, Benjamin, Yve-Alain Bois and Briony Fer, *Gabriel Orozco*. London: Thames and Hudson, 2006.
● Cameron, Dan, and Rachel Withers, *Mike Nelson: I, Imposter*, exh. cat. London: British Council, 2011.
● Collins, Judith, and Iain Sinclair, *Gavin Turk*. Munich: Prestel, 2013.
● Dawsey, Jill, and Ulrike Munter, *Mathilde ter Heijne: If it's me, it's not me*, exh. cat. Ostfildern: Hatje Cantz, 2008.
● deSouza, Allan, et al., *Allan deSouza: A Decade of Photoworks, 1998-2008: The Lost Pictures*, exh. cat. New York: Talwar Gallery, 2008.
● Duke, Yukiko, *Furo*, exh. cat. Stockholm: Jewish Theatre, 2006.
● Enwezor, Okwui, et al., *Zineb Sedira: Beneath the Surface*. Paris: Kamel Mennour, 2011.
● Garaicoa, Carlos, *Carlos Garaicoa: Capablanca's Real Passion*, exh. cat. Los Angeles: Museum of Contemporary Art, 2005.
● Godfrey, Mark, Hans Ulrich Obrist and Liam Gillick, *Anri Sala*. London: Phaidon, 2007.
● Godfrey, Mark, Klaus Biesenbach and Kerryn Greenberg (eds), *Francis Alÿs: A Story of Deception*, exh. cat. London: Tate Publishing, 2010.
● Godfrey, Tony, *Merike Estna*, exh. cat. Tallinn: Temnikova & Kasela, 2012.
● Goldin, Nan, and Taka Kawachi, *Nan Goldin: Couples and Loneliness*. Kyoto: Korinsha Press, 1998.
● Holm, Michael Juul, Anders Kold and Jeanne Rank (eds), *Keith Tyson: Large Field Array*, exh. cat. Humlebæk: Louisiana Museum of Modern Art, 2006.
● Hoptman, Laura, et al., *Live Forever: Elizabeth Peyton*, exh. cat. London: Phaidon, 2008.
● Hou Hanru, Hans Ulrich Obrist and Hu Fang, *Cao Fei: Journey*.

Paris: FRAC Ile-de-France/
Le Plateau, 2008.
● Hu Fang and Zheng Guogu,
Zheng Guogu: Jumping out Three Dimensions, Staying Outside Five Elements. Guangzhou: Vitamin Creative Space, 2007.
● Hütte, Friedhelm, and Christina März (eds), *Wangechi Mutu: My Dirty Little Heaven*, exh. cat. Berlin: Deutsche Guggenheim (Hatje Cantz), 2010.
● Jhaveri, Shanay, *Nikhil Chopra: Yog Raj Chitrakar*. Mumbai: Chatterjee & Lal, 2010.
● Martin, Courtney J., and Laurie Ann Farrell, *Kader Attia: Signs of Reappropriation*, exh. cat. Savannah College of Art and Design, 2009.
● Medina, Cuauhtémoc (ed.), *Teresa Margolles: What Else Could We Talk About?* Barcelona: RM Verlag, 2009.
● Mthethwa, Zwelethu, Okwui Enwezor and Isolde Brielmaier, *Zwelethu Mthethwa*. New York: Aperture, 2010.
● Ractliffe, Jo, et al., *Jo Ractliffe: Terreno Ocupado*, exh. cat. Johannesburg: Warren Siebrits, 2008.
● Said, Edward, *Mona Hatoum: The Entire World as Foreign Land*, exh. cat. London: Tate Publishing, 2000.
● San Martin, Francisco Javier, et al., *Raymond Pettibon*, exh. cat. CAC Málaga, 2006.
● Sans, Jérôme, and Guo Xiaoyan, *Yan Pei-Ming: Landscape of Childhood*, exh. cat. Beijing: UCCA, 2009.
● Singh, Dayanita, and Aveek Sen, *Dayanita Singh: House of Love*. Cambridge, MA: Peabody Museum Press, 2010.
● Solanki, Veeranganakumari, and Nandan Ghiya, *deFacebook v.1.2- : Search results and download errors by Nandan Ghiya*, exh. cat. New Delhi, 2011.
● Spector, Nancy, *Maurizio Cattelan: All*, exh. cat. New York: Solomon R. Guggenheim Museum, 2011.
● Wagner, Hilke, *Yehudit Sasportas: The Laboratory*, exh. cat. Kunstverein Braunschweig (Prestel), 2008.
● Watkins, Jonathan (ed.), *Nedko Solakov: All in Order, with Exceptions*, exh. cat. Ostfildern: Hatje Cantz, 2011.

MAGAZINE AND WEBSITE ARTICLES

It is almost impossible these days to make a distinction between magazines and websites. Though I am not a faithful reader of any particular magazine or its virtual equivalent, it is surprising how in seeking prime source material about artists, I have tended to gravitate towards relatively few periodicals, such as *Bomb*, *frieze*, the *Art Newspaper*, the *Asian Art Archive*, *Blouin ArtInfo* and, of course, Deutsche Bank's *ArtMag*.

● Belcove, Julie L., 'Guillermo Kuitca', *W Magazine*, 1 November 2009, pp. 168–75.
● Camhi, Leslie, 'Samuel Fosso: Man of a thousand faces', *International Herald Tribune Style Magazine*, Spring 2009, p. 35.
● De Souza, Eduardo, 'Sandra Gamarra: Eduardo de Souza talks with Sandra Gamarra', *NY Arts Magazine*, November 2007, p. 76.
● Douglas, Sarah, 'The ArtInfo Interview: Bill Viola', *ArtInfo*, November 2005, available at: http://www.jamescohan.com/artists/bill-viola/articles-and-reviews/
● Essop, Hasan and Husain, press release for 'Powerplay', Goodman Gallery, Cape Town, 2008, available at: http://www.essoptwins.com/exhibitions/power-play-2008/
● Godfrey, Mark, 'On Display', *frieze*, 143, November–December 2011, available at: http://www.frieze.com/issue/article/on-display/
● Goldstein, Richard J., 'Gregory Crewdson' (unedited transcript of video interview), *Bombsite*, September 2010, available at: http://bombsite.com/issues/999/articles/3666
● Lindsay, Arto, 'Musical Expression: Arto Lindsay in conversation with Beatriz Milhazes', *Parkett*, 85, 2009, p. 136.
● Muir, Gregor, 'Elizabeth Peyton: The Prince Albert Pub, London', *frieze*, 24, September–November 1995, pp. 70–71.
● Raqs Media Collective, 'Words in Art: India's Raqs Media Collective see all words as equal', *Art Radar Asia*, 12 January 2011, available at: http://artradarjournal.com/2011/01/12/words-in-art-indias-raqs-media-collective-see-all-words-as-equal/
● Robbins, Lee, 'Lightbox, Camera, Action!', *ARTnews*, November 1995, pp. 220–23.
● Sabih, Mohd Ahmad, and Enoch Cheng, 'Interview with Bose Krishnamachari', *Asian Art Archive*, January 2010, available at: http://www.aaa.org.hk/newsletter_detail.aspx?newsletter_id=780
● Smee, Sebastian, 'The shadowy existence of Bill Henson', *Art Newspaper*, 169, May 2006, p. 40.
● Smith, Karen, 'A walk in the world of Jia Aili', *NY Arts Magazine*, September–October 2007, available at: http://www.nyartsmagazine.com/index.php?Itemid=712&id=5970&option=com_content&task=view
● Szewczyk, Monika, 'The fantasy of Paulina Olowska', *A Prior*, 13, 2006, p. 127.

SOURCES OF ILLUSTRATIONS

A=ABOVE, B=BELOW, C=CENTRE,
L=LEFT, R=RIGHT

8 Egyptian Museum and Papyrus Collection, Berlin
11 Courtesy Purdy Hicks Gallery, London. © Susan Derges
12 Deutsche Bank Collection, London. Photo John Wildgoose
16A, 16B Courtesy the artist and Marian Goodman Gallery, New York
19 Courtesy the artist and Metro Pictures, New York
20 Courtesy Matthew Marks, New York. © Nan Goldin
21 Collection Nerman Museum of Contemporary Art, Johnson County Community College, Overland Park, KS. Courtesy Leslie Tonkonow Artworks + Projects, New York. © Amy Cutler
22 Courtesy Regen Projects, Los Angeles. © Raymond Pettibon
23 Installation view of 'Kara Walker: My Complement, My Enemy, My Oppressor, My Love', Walker Art Center, Minneapolis, 2007. Courtesy Sikkema Jenkins & Co., New York. Photo Gene Pittman. © Kara Walker
25A Courtesy the artist
25B Courtesy Talwar Gallery, New York/New Delhi. © Allan deSouza
26 Courtesy the artist and Proyectos Monclova, Mexico City
27 Courtesy the artist
28A Courtesy the artist and LABOR, Mexico City
28B Courtesy David Zwirner, New York/London
31A, 31B Courtesy the artist and LABOR, Mexico City
32 Courtesy the artist and kurimanzutto, Mexico City. Photo Michel Zabé
33 Courtesy the artist and Blain/Southern, London. Photo Kira Perov
34 Courtesy the artist and David Kordansky Gallery, Los Angeles
37 Courtesy Sies + Höke, Düsseldorf and David Zwirner, New York
38A Courtesy the artist
38B Courtesy the artist; Luhring Augustine, New York; White Cube, London. © Gregory Crewdson
40, 41 Howard Farber Collection, New York. Courtesy the artist and Continua Gallery, San Gimignano
42L, 42R Courtesy Galeria Leme, São Paulo. Photo Juan Pablo Murrugara
43 © María Rosa Jijón
45A Courtesy the artist and Hauser & Wirth, Zurich/London. © Guillermo Kuitca
45B Courtesy Herald St, London and Franco Noero, Turin
46A Courtesy the artist and Green Art Gallery, Dubai
46B Courtesy James Cohan Gallery, New York/Shanghai. © Beatriz Milhazes

48 Courtesy Galeria Leme, São Paulo
49A Installation view of 'Rivane Neuenschwander: A Day Like Any Other', New Museum, New York, 2010. Inhotim Collection, Brazil. Courtesy the artist; Tanya Bonakdar Gallery, New York; Stephen Friedman Gallery, London; Fortes Vilaça, São Paulo. Photo Jean Vong
49B Installation view of 'Rivane Neuenschwander: A Day Like Any Other', New Museum, New York, 2010. Inhotim Collection, Brazil. Courtesy the artist; Tanya Bonakdar Gallery, New York; Stephen Friedman Gallery, London; Fortes Vilaça, São Paulo. Photo Benoit Pailley
51 Courtesy David Zwirner, New York/London
52 Courtesy Sadie Coles HQ, London. © Elizabeth Peyton
59 Courtesy the artist and Jack Shainman Gallery, New York
60 Courtesy jean marc patras/galerie, Paris. © Samuel Fosso
63 Courtesy Gladstone Gallery, New York/Brussels. © Shirin Neshat
64 Courtesy the artist and Gladstone Gallery, New York/Brussels
65 Courtesy Susan Inglett Gallery, New York
67 Installation view of 'Artempo. Where Time Becomes Art', Palazzo Fortuny, Venice, 2007. Courtesy Axel Vervoordt Gallery, Antwerp
69A Courtesy Kader Attia
69B Courtesy the artist and kamel mennour, Paris. © Zineb Sedira
71 Courtesy the artist and Sfeir-Semler Gallery, Beirut/Hamburg
74A Courtesy the artist
74B REUTERS/Zohra Bensemra
76 Courtesy the artist and Mummery + Schnelle, London
78A, 78B Courtesy Casino Luxembourg. Photo Christian Mosar
81A, 81B © Oraib Toukan
82 Courtesy The Third Line, Dubai
84, 86 Courtesy Gallery Isabelle van den Eynde, Dubai
87 © Shadi Ghadirian
88 Courtesy the artist
90 Courtesy the artist and Green Art Gallery, Dubai
91 Courtesy Goodman Gallery, Johannesburg/Cape Town
93 Courtesy the artist and Goodman Gallery, Johannesburg/Cape Town
96 Courtesy Cai Studio, New York. Photo Hiro Ihara
99 Courtesy David Zwirner, New York/London and Galleria Massimo De Carlo, Milan. Photo André Morin. © Yan Pei-Ming, ADAGP, Paris, 2013
100 Courtesy the artist
102 Deutsche Bank Collection, commissioned by Deutsche Bank AG. Photo Hiro Ihara
105, 106 © Wong Hoy Cheong
107 House of Oracles, Walker Art Center, Minneapolis. Courtesy Gladstone Gallery, New York. © Huang Yong Ping

108 Courtesy the artist and Frith Street Gallery, London
109 Courtesy Project 88, Mumbai. © Sarnath Banerjee
111 Courtesy Continua Gallery, San Gimignano/Beijing/Le Moulin. Photo Ela Bialkowkska
112A, 112B © Bose Krishnamachari
115 Costumes Loise Braganza. Courtesy the artist and Chatterjee & Lal, Mumbai. Photo Shivani Gupta
119 Courtesy the artist and Project 88, Mumbai
121 Courtesy Magda Danysz Galleries, Paris/Shanghai
122 Courtesy Vitamin Creative Space, Beijing/Guangzhou. Photo Wang Chao. © Cao Fei
124A, 124C, 124B Courtesy Gallery Koyanagi, Tokyo. © Tabaimo
126 Courtesy Hakgojae Gallery, Seoul
128, 129 Courtesy the artist and Vitamin Creative Space, Beijing/Guangzhou
130 Courtesy ShanghART, Shanghai
131 Courtesy 10 Chancery Lane Gallery, Hong Kong
132 Courtesy Exhibit 320, New Delhi
133 Courtesy Loock Galerie, Berlin. © Miwa Yanagi
135 Courtesy Roslyn Oxley9, Sydney. © Bill Henson
138A Courtesy the artist and The National Gallery of Australia, Canberra
138B Private collection. Courtesy the artist and Rampa Istanbul
141 Courtesy the artists and Vitamin Creative Space, Beijing/Guangzhou
142 Courtesy the artist and Vitamin Creative Space, Beijing/Guangzhou
145A, 145B Courtesy the artist and Platform China, Beijing/Hong Kong
146A Courtesy Gallery Em, Seoul
146B Courtesy Hakgojae Gallery, Seoul. © Lee Youngbin
149 Courtesy the artist and Vitamin Creative Space, Beijing/Guangzhou
152A Courtesy MOT INTERNATIONAL, London/Brussels. © Laure Prouvost
152B Courtesy Annet Gelink Gallery Amsterdam and Foksal Gallery Foundation Warsaw, produced with support from Hermès. © Yael Bartana
154 Rooseum Center for Contemporary Art, Malmö, 2004. Courtesy Continua Gallery, Beijing/San Gimignano. © Nedko Solakov
155 Van Abbemuseum, Eindhoven. Courtesy Continua Gallery, Beijing/San Gimignano. Photo Anatoly Michaylov. © Nedko Solakov
156, 158 Courtesy Hauser & Wirth Zurich/London; Johnen Galerie, Berlin; Marian Goodman Gallery, New York; Galerie Chantal Crousel, Paris. © Anri Sala
159 Courtesy Galerie Peter Kilchmann, Zurich. © Adrian Paci

161 © Lada Nakonechna
162 Courtesy Regina Gallery, London/Moscow
163 Courtesy Arndt, Berlin
165A © 2006, Laurent Mignonneau & Christa Sommerer
165B Kumu Art Museum, Tallinn. Courtesy the artist
169 © Charles Sandison
171 Courtesy the artist and Purdy Hicks Gallery, London
172L, 172R Courtesy hunt kastner, Prague
173A Courtesy Galerie Martin Janda, Vienna
173B Courtesy the artist. Photo Ralf Herzig
175 Courtesy Galerie EIGEN + ART, Leipzig/Berlin. Photo Uwe Walter, Berlin. © VG Bild-Kunst Bonn 2011 and DACS 2014
176 De Pont Museum of Contemporary Art, Tilburg, The Netherlands. Courtesy the artist
177L © Gerhard Richter 2013
177R Courtesy the artist and Frith Street Gallery, London
179 Courtesy Zeno X Gallery, Antwerp and David Zwirner, New York/London. Photo Peter Cox
180 Courtesy the artist and Loock Galerie, Berlin. Photo Jörg von Bruchhausen
181 Courtesy David Zwirner, New York/London and Zeno X Gallery, Antwerp
182 Courtesy the artist and Hauser & Wirth, Zurich/London. Photo Barbara Gerny © Wilhelm Sasnal
183 Courtesy the artist and Metro Pictures, New York
185 © Kutluğ Ataman
186 Courtesy the artist; Matt's Gallery, London; Franco Noero, Turin; 303 Gallery, New York
189A Courtesy Pace Gallery, Beijing/London/New York. © Keith Tyson
189B Courtesy the artist
190 © Simon Patterson
192 Courtesy Frith Street Gallery, London
195 Gavin Turk/Live Stock Market
196 Courtesy the artist and Frith Street Gallery, London
199 Courtesy Maurizio Cattelan's Archive. Photo Attilio Maranzano
200 Installation view of 'Anish Kapoor', Haus der Kunst, Munich, 2007-8. Courtesy the artist and Lisson Gallery, London/Milan/New York/Singapore. Photo Dave Morgan
204A Courtesy the artist and Purdy Hicks Gallery, London
204B Courtesy the artists and Goodman Gallery, Johannesburg/Cape Town
206 Courtesy Temnikova & Kasela, Tallinn. © Merike Estna
207 Courtesy the artist
209 © Ji Hyun Kwon
210 Collezione La Gaia, Bruna and Matteo Viglietta. Courtesy the artist. Photo Bernd Borch

ACKNOWLEDGMENTS

First I would like to thank my editors, Julian Honer, Theresa Morgan and Matthew Taylor. They have worked tirelessly to remove the all-pervasive art speak, and persistently reminded me when I slipped back into the evil ways. Allie Boalch has been equally supportive on the visual side, in bringing in the pictures. Thank you to Alex Wright for designing the book's interior and front cover, and to Niki Medlik for her help with the latter. I thank my family, Rebecca, Saskia and Siena, and much extended family, for putting up with me while writing. I thank my mother who believes this book might make her 'understand' contemporary art. I would like to thank Nicola Shane, not only for her encyclopaedic brain, but also for checking the text. I thank fellow curators and collectors, but most of all artists. I particularly apologize to the artists I wanted to include in this book who were edited out. I enjoy my work so much that I am in danger of not appreciating enough of the people who work hard with me, and this is when I must just resort to a list:

Omar and Yasmin Abu-Sharif, Pirkko Ackermann, Adu and Ingrid Advaney, Dimitri Agishev, Leyla Alaton, Claudia Albertini, Sandy and Jane Angus, Savita Apte, Matthias Arndt, Mohammed Arsalan, Ziba de Weck Arsalan, Yasmin Atassi, Jeremy Bailey, Catherine Belloy, Dominic Berning, Sara Bernshausen, Nikki Berriman, Eleanor Blunden, Achim Borchardt-Hume, Ben Brown, Ruby Brown, James Camplin, Yane Calovski, Özkan Cangüven, Kate Cavelle, Christina Chandris, Lilian Chee, Liz Christensen, Benjamin Clarke, Arlene Cohrs, Sadie Coles, Jenny Cooper, Steven Coppel, Magda Danysz, Nelius Degroot, Derya Demir, Siobhan and Alexander Dundee, Ayperi Ecer, Pamela Echeverria, Judith Elliott, Serene El-Masri, Okwui Enwezor, Caroll Erin, Isabelle van Eynde, Britta Färber, Ali Fassa, Mary Findlay, Gabriela Galceran-Ball, Anahita Gharabaghi, Andrew and Virginia Goodsell, Sree Goswami, Nicholas Goulandris, Sophie Grieg, Nina Flohr, Christofer Habig, Jane Hamlyn, Lareena Hilton, Hou Hanru, Hu Fang, Kaori Hashiguchi, Camille Hunt,

Nigel Hurst, Friedhelm Hütte, Hwang Yookyung, Isabella Icoz, Geetika Jain, Colm Kelleher, Kimsooja, Udo Kittelman, Alberto Klaas, Ola Kolehmainen, Atsuko Koyanagi, Ursula Krinzinger, Jose Kuri, Lisa Larkins, Neil Lawson-May, Lee Jiyoon, Paul Liss, David Llewellyn, Sasha Llewellyn, Friedrich Loock, Caroline Luce, Gerd Harry Lybke, Sarah McCrory, Lyndsy McColgan, Elliot McDonald, Salman Mahdi, Diana and Hisham Matar, Barbara Mocko, Ilma Nausedaite, Ales Ortuzar, Francis Outred, Mehtap Ozturk, Shireen Painter, Craig Parfitt, Jean-Marc Patras, Diana Perry, Timothy Persons, Shwetal Petal, Verusca Piazzesi, Adriano Picinati Di Torcello, Frederique Pierre-Pierre, Danielle Pippardt, Julien Prevett, William Ramsay, Rob Rankin, Chris Rawson, Shaun Regen, Svenja Reichenbach, Marie Ribbielov, Adrian Riches, Iain Robertson, Charlie Ross, Brian Ruszczyk, Claudia Schicktanz, Annette Schönholzer, Sophie Scopes, Bernadette, Stefan and Florian Schmid, Harry and Sacha Scrymgeour, Amanda Sharpe, Annie and John Short, Ann Slavik, Matthew Slotover, Nancy Spector, Marc Spiegler, Emma Son, Lydia Stachejko, Christina Steinbrecher, Karl Stürm, Leyla Tara, Caroline A. Taylor, Olga Temnikova, Johanne Tonger-Erk, Ayşe Umur, Don Ventura, Jonathan Watkins, Mike West, Michael Weston, Alicia Wilson, Manfred Wiplinger, Luzille Zacaria, Asia Zak, Zhang Wei, Manfred Zisselsberger.

INDEX